4

Foreword

8

Epiphany of Love and Truth Within Art
ZIBA ARDALAN

22

A Cup, Nectar Brimmed
The Enduring Appeal of Persian Poetry
NARGUESS FARZAD

33

The Spark Is You
Parasol unit in Venice

105

Nine Iranian Artists in London
The Spark Is You

176

Artist Biographies

196

List of Works

4
Foreword

ZIBA ARDALAN

The two separate exhibitions, *The Spark Is You: Parasol unit in Venice* and *Nine Iranian Artists in London: The Spark Is You*, focus on the works of 13 contemporary Persian/Iranian artists, viewed through a prism of classical Persian poetry. As an Iranian myself and for some decades active as a curator of contemporary art, navigating the world's current artistic scene, I have in recent years been seeking a specific context in which to curate a group exhibition of works by Iranian artists, irrespective of their generation or where they now live. I have lingered over thoughts such as, if the soul is Persian, then the work too will be Persian. Then, upon realising that the 15th anniversary of Parasol unit would coincide with the 200th anniversary of *West-oestlicher Divan* (West-Eastern Divan), a book of lyrical poems by Johann Wolfgang von Goethe, my dream began to take on a clearer shape and this project to look viable.

During the process of preparing these two exhibitions to show simultaneously in London and Venice, the works of the artists were selected after much research and objective consideration of their creative and expressive qualities. I have done my very best to understand the work of each artist and to make sure that their commitment is driven by a vision way beyond the ordinary. Through their work I believe these artists invariably and eloquently reveal that the nature of their artistic practice is interwoven with their love of the creative process and the search for truth. Though some of the works may show no obvious reference to the poetic, they are nonetheless somehow touched by the spirit of Persian culture in their use of metaphor and parable.

In his *West-Eastern Divan*, Goethe intelligently highlighted the extraordinary history and culture of Persia, particularly its enchanting tradition of poetry, at a time when the majority of Europeans were infatuated with the idea of 'Orientalism'. In some ways and in line with Goethe's writing, the works in these two exhibitions were selected because they too strive towards greater understanding. The artists try through their work to reach out to other nations and cultures and to encourage mutual respect between all people. The two world-class cities Venice and London, each with a long history of such openness, are ideal locations for *The Spark Is You* exhibitions and will we hope prompt another layer of international dialogue. Overall, this welcoming and thrilling undertaking has generated an enormous amount of positive energy, inspiration and ideas for further exploration.

Working and writing around the concept of these two exhibitions, I took a considerable amount of time for reflection. What does it mean to be *Persian*? Or, indeed, what does it mean to be a *Persian artist*? What makes such an identity and why is it at times so incredibly gratifying and challenging to be *Persian*? With each attempt to answer such seemingly endless and complex questions, I came to the conclusion that it needed a different approach. Further explorations brought me face to face with the immensity of the Persian culture, the most enthralling of which is probably our tradition of poetry. Is it possible that the richness of poetry ingrained in every Persian soul in some way influences our outlook on life and for Persian artists how they reflect on the creative process?

In organising these two fascinating exhibitions and their accompanying publication, I had the good fortune to share many intellectual exchanges and received considerable support and insights from the artists who accepted my invitation to take part. With nine artists represented in each exhibition, the dialogue between their works has been intense and challenging. From different generations and disparate parts of the world, or perhaps due to their inherent sensibility, these artists each respond uniquely to the modern world and express ideas based on their own personal perceptions. Even so, a common thread seems to run through their works, in the sense that they all reveal the poise and resilience of a balanced and intellectually nurtured mind in which the heritage of history and poetry are evident.

The exhibition at the splendid Conservatorio di Musica Benedetto Marcello di Venezia provides an extraordinary opportunity for harmonious exchanges between visual art and music, which made it an important element in the decision to hold this show in Venice. Few other cities in the Western hemisphere have such an intense historical relationship with and openness to the East. While London, a city that has long attracted countless young people from around the world, is certainly the right environment for presenting the works of younger Iranian artists.

Any such undertaking requires the interest and engagement of a great number of individuals and the organisation of this important exhibition was no exception. Over almost three years *The Spark Is You* has grown from an exhilarating idea, or perhaps a distant dream, into what became a monumental and remarkable effort and I am overwhelmingly grateful for all the conversations, information, advice and, most importantly, the time that the artists, Parasol unit Trustees, Friends, professional contacts and my energetic team have selflessly put at my disposal. Indeed, the joys and pleasure of bringing together two such magnificent exhibitions have more than compensated for

all our hard work. I know we have all learned a great deal from it and in the process become closer.

First, I cannot thank enough all the participating artists who so readily accepted my invitation to take part in *The Spark Is You* exhibitions in Venice and/or London. Their collaboration has been incredibly smooth and remarkably insightful. I am particularly indebted to those who created new works for the exhibitions. They are all invariably of great interest, and the underlying vision and artistic tenets offer invaluable guidelines for us all. In this context it is my pleasure to thank Nazgol Ansarinia and Ralph Rugoff for having introduced me to several of the artists whose works are presented in these two exhibitions.

No exhibition can ever be realised without the willing cooperation of the lenders, particularly when the time frame of an exhibition is rather long. My gratitude goes to all of them for their unconditional generosity and it is my pleasure to thank here, the Collection of Max Protetch, Collection Olivier G. Mestelan, Collezione Righi, Bologna, the Estate of Farideh Lashai, as well as the individual artists and their galleries, particularly Gagosian Gallery and Green Art Gallery, Dubai.

From the inception of this project, enormous support from organisations and private individuals has poured in. We should all be thrilled and proud to realise that in today's uncertain world, great efforts are being made to maintain the civility and dignity of society and that there are people who support and encourage openness, tolerance, dialogue, and respect for all cultures. In this context, I would like to commend Juni Farmanfarmaian for her Herculean endeavours in propagating enthusiasm and in the process for having raised a substantial sum towards the project. It also gives me great joy to thank Cockayne – Grants for the Arts and The London Community Foundation, Soudavar Memorial Foundation, Farah Asemi and Hassan Alaghband, Marwan and Tatiana Shakarchi, Kambiz and Nazgol Shahbazi, Claudia Steinfels and Christian Norgren, Berna and Tolga Tuglular, Massimo and Ilaria Tosato, Laura Colnaghi Calissoni, Key Capital, Kevin and My Phuong Lecocq, Mohammed Afkhami Foundation, General Atlantic Foundation, Iran Heritage Foundation, Cyrus Ardalan and Juni Farmanfarmaian, KayhanLife, Dr Yvonne Winkler, Petri and Jolana Vainio, Haro Cumbusyan and Bilge Ogut-Cumbusyan, Ruth Whaley, Iran Society, and Simon Trollope.

Several writers have contributed short essays on the work of the participating artists. For their vision and insights, which are extremely helpful to our better understanding of the artworks, my heartfelt thanks go to Oliver Basciano, Maryam Monalisa Gharavi, Mahan Moalemi, Maria Porges, Sarah Thomas, and John Yau.

Narguess Farzad, Chair of the Centre for Iranian Studies and Senior Fellow in Persian at SOAS University of London, has graciously contributed a comprehensive essay on classical Persian poetry. Her insights are hugely appreciated and I have no doubt they will communicate to any reader the importance of poetry in the culture and psyche of the Iranian people. I am truly indebted to her for sharing her knowledge with us.

Organising our education programmes for adults, families and children required considerable dedication and I thank all the speakers and performers for their time and ingenuity in creating such innovative events. As they are all Iranians, this was a perfect opportunity for them to speak for their culture.

The President, Executive Director, and Director of the Conservatorio di Musica Benedetto Marcello di Venezia, Giovanni Giol, Carmelo Sorgon, and Marco Nicolè have been most helpful and generous in ensuring the success of the Venice presentation. I cannot thank them enough for their flexibility and would like them to know what an honour and pleasure it has been for us to hold *The Spark Is You: Parasol unit in Venice* exhibition in such splendid surroundings.

VeniceArtFactory, Lightbox, and We Exhibit, particularly Luca Berta, Francesca Giubilei, Teresa Sartore and Mara Sartore, have been highly professional and helpful working partners in this project and I owe them my heartfelt thanks. I am immensely grateful for their knowledge and versatility in what can be a challenging process.

For the past fifteen years, I have been able to count on the superb professional skills of our esteemed copy editor Helen Wire, and the brilliant design team at Moiré, Marc Kappeler, Simon Trüb, and their colleagues. On this uniquely wonderful occasion their seamless collaboration is truly appreciated.

Finally, my small and amazing team at Parasol unit, Kirsteen Cairns, Neil Jefferies, Jonathan Kelly, Helen Lewandowski, Dhiyandra Natalegawa, Juliette O'Leary, and Karl Schenker, have worked with boundless enthusiasm towards the realisation of these two exhibitions. They deserve all my heartfelt thanks and recognition, not only for organising the exhibitions, but also for producing this publication and the comprehensive education programme. I am so hugely proud of them and know their knowledge and courage is highly commendable.

Dr Ziba Ardalan
Founder/Artistic and Executive Director

8
Epiphany of Love and Truth Within Art

ZIBA ARDALAN

I want to approach truth as closely as is possible, and therefore I abstract everything until I arrive at the fundamental quality of things.[1] Piet Mondrian

Quoting a twentieth-century Dutch artist may seem an unusual starting point for an essay on two group exhibitions devoted to the works of contemporary Iranian artists through a lens of classical Persian poetry. But the creative process, itself inherently interwoven with a love of such poetry, is likewise driven by a search for truth, and few artists could express that better than Piet Mondrian. The quotation refers to a universal phenomenon that speaks eloquently for any creative soul and knows no frontiers. Within such a paradigm it may also be reasonable to say: if the soul is the incorporeal essence of a living being, then creativity is the essential nourishment that enriches the human soul. In the past it has proved to be so in most cultures and civilisations and will surely continue to be so.

When it comes to the long and, for many stretches of time, glorious Persian civilisation and its vast culture – which is in part what is under discussion here – there seems to be no well received, loved and practised art form other than poetry that has so deeply permeated the fabric of the society, and survived the countless brutal upheavals and invasions experienced by Persia over several millennia. It is this profoundly rooted and remarkable cultural signifier that inspired the two exhibitions, *The Spark Is You: Parasol unit in Venice* and *Nine Iranian Artists in London: The Spark Is You*, sited in two world-class cities known through our history for their openness. It is my hope that the two separate presentations will come into dialogue with each other and generate wider exchanges among the audience and the public in general at a time when such interactions seem most needed.

Within Persian civilisation, poetry has always been far more than simply an art form, as the insightful and comprehensive essay by Narguess Farzad attests in this publication. Poetry is ingrained in and nourishes every single Iranian soul. Furthermore, it offers symbolic guidelines for life in thinking and reasoning, it lifts the spirit, counsels in difficult times, and finally is the companion who ensures one is never alone. Originally passed on by word of mouth, poetry was eventually preserved in

written form and flourished during the ninth century and continued over several centuries into what is now known as classical Persian poetry. Early in their schooling, Iranian children learn, recite and converse in poetry, which in turn teaches them to reflect in figurative and metaphoric language. The *Fal-e Hafez* (Omens of Hafez) written by Hafez (1315–1390), Persia's beloved fourteenth-century poet, are some of the most rewarding pastimes in Iran, through which people commonly seek solace during challenging times. The written word has become almost a form of counselling or wisdom dispensing, which encourages readers to be patient and resilient in the face of difficulties. It is often said that Hafez's wisdom has helped many people to find a path out of some impasse. While Persia – in good part due to its geography and the enviable qualities of its culture and natural resources – has been repeatedly subjected to invasion and conquest, its beloved poets and their art forms have remained invincible. *Shahnameh* (The Book of Kings), written by Ferdowsi (*c.* 940–1020 CE) in the latter part of the tenth century, is known as the longest most comprehensive epic poem ever written by a single poet. It intelligently documents the historical past of Persia at a time when the country was dominated by the Arab reign, and it must therefore have taken considerable courage for Ferdowsi to commit to paper facts that would otherwise have been lost.

Persian poets were usually knowledgeable and respected wise people. Omar Khayyam (1048–1131) was a mathematician, philosopher, astronomer and poet; Rumi (1207–1273) was a jurist, scholar, theologian and poet; and Nezami-Aruzi (1110–1161), a great poet who also wrote *Chāhār Maqāla* (Four Discourses) describing the qualifications and duties of four officers essential to the success of any reigning monarch. Finally, Hafez, whose poetry in praise of the joy of love – both divine and earthly – has inspired people around the world, including Johann Wolfgang von Goethe, whose book of lyrical poems, *West-Eastern Divan*, was written in homage to Hafez. In turn, the 200th anniversary of that book of poetry has inspired us at Parasol unit to present *The Spark Is You* exhibitions. It is, then, with thankfulness for all these remarkable poets, including Goethe, that we celebrate the creative work of our contemporary Iranian visual artists in the two exhibitions *The Spark Is You: Parasol unit in Venice* and *Nine Iranian Artists in London: The Spark Is You.*

In the twenty-first century it may seem more relevant to talk about the 'Global North' and 'Global South' rather than the 'West-East' divide but, as many of us know, the latter was a European construct to allow the demarcation of power in the sixteenth-century world and lasted for 500 years until World War II. Obviously, in recent years and with the return of the 'East' and claims of world hegemony, other forms of divide may come to exist. For now, we celebrate Goethe's attempt to bridge the political divide through the beauty of knowledge, art and friendship.

It is usually agreed that Iranians value people and friendships beyond many other things in life. They are well known for their outgoing nature, generosity, hospitality and willingness to engage easily with people of different cultures. Interestingly enough, and perhaps because of the numerous political invasions and upheavals that have befallen them, they have kept mentally and intellectually sound, agile, and able to retain their inquisitive and innovative minds. It is no secret that Iranians are infatuated with their own identity and consider that no part of the world can compete with their own. It seems to them that no one could ever erase their past or their roots, which are suffused with the tradition of poetry. They are born with these values, with access to a collective memory that gives them the strength and motivation to survive and thrive in any society.

But a reality check exists, of course, and the question is where do Iranian people really stand in today's world? What do more than 80 million people in Iran and several other millions scattered around the world represent? And, finally, with this long history – both glorious and tumultuous – whether being Iranian, particularly for those living abroad, can still be a reality or is it simply an idea?

During the exhibition preparation, the many studio visits and subsequent conversations, I have listened carefully to the concerns of the artists. One important point came up repeatedly, proving that in art the 'West-East', or even the 'North-South' divide still exists. For example, these artists often wonder why exhibitions of their works in Western institutions are usually given an historical/religious context rather than considered simply as the expression of a contemporary artist working today. Whereas the religious beliefs of Western artists are not regarded as part of their creative identity.

Such thoughts have made me think what a Herculean task it would be for any non-Iranian curator to grasp the collective history of artists from Iran and subsequently what a complex and difficult duty it would be to mount an exhibition of their works. For it is unlikely that anyone working with Iranian artists

could remain insensitive to or unaware of their poetic soul. Within the process of organising this exhibition I too, like many other Persians, have found a path to truth through poetry, particularly that of Hafez and Rumi, which continues to unite us all.

GHAZALEH HEDAYAT

Working along similar lines to Mondrian in her creative process, Hedayat's artistic endeavour requires her to become deeply involved in the dialectic between her own soul and thoughts, often with unpredictable outcomes that can be as visceral as Mondrian's are cerebral. Trained in photography and fine art, Hedayat reaches simultaneously and unapologetically towards both figuration and abstraction, and in a remarkable *tour de force* brings them into vivid converse, only to demonstrate that they often lead to effacement. Of her work, she says, *'I have been working with different mediums, such as photography, video, installation, but there is one common ground among them all: silence.'*[2]

In *(un)threading*, 2018, [pp. 128–133] a series of close-up photographic portraits of herself from behind, the artist scratches the surface of the C-print images from top to bottom with countless delicate horizontal lines, possibly in an attempt to obliterate the recognisable image. It is probably not important to Hedayat whose image she works on, as her endeavour can easily translate from the personal to the collective. In her ongoing series *The Strand and the String*, 2008–2018, [pp. 120–126] she works within a 60 × 60 cm (23¾ × 23¾ in) format, employing human hair and linen thread in a grid. Considering Hedayat's earlier statement, the abstract nature of the grid is more likely a practical zone in which she has ample space and flexibility to manoeuvre into her thoughts and ideas. These can be read as personal or impersonal, metaphorical or physical, and finally, ideological or factual – very much as Persian poetry encourages some drifting of thoughts.

SAHAND HESAMIYAN

Aside from their commanding presence and the fact of often being inspired by elements of traditional Persian architecture, there are certain intriguing philosophical and spiritual components imbedded in Sahand Hesamiyan's works. Their assertive manifestation is also characteristic, regardless of whether the scale of a work is large or small. Hesamiyan typically streamlines the exterior form of his pieces, which perhaps contributes to their somewhat quiet presence, nevertheless one perceives in them hidden complexities that encourage further interest in the creative concept of each work. The opulence of his works will have been influenced, either directly or indirectly, by the

magnificence of various traditional forms of Persian architecture, such *as muqarnas* (ornamental vaulting) and *mandalas*, that of course remain vividly present in the unconscious of any contemporary Iranian artist.

Whether positioned indoors or outdoors, Hesamiyan's sculptures take command of whatever space they are in, and interact with their surroundings and any viewers. This often makes me think of Heidegger's existential philosophy of *Dasein* even though that concept does not relate to inanimate objects. Nonetheless, one still reacts to Hesamiyan's works because of the peculiar energy they emanate. Viewers are there, taking part, but the power of the work is what prompts them to move and respond within that particular environment. In all their straightforwardness and magnificence, Hesamiyan's works can prompt some powerful and uncanny feelings.

Take for instance the work *Forough*, 2016, [pp. 70–75] which is made in the form of two large open cones (each approximately three cubic metres). Made of stainless steel with their open extremities coated in gold leaf, the sheer presence of this piece is not only commanding, but also celebratory. It is almost inconceivable for the work to have been made as a single piece, because dialogue between the two entities is an inherent part of the concept. That is what I mean when I talk of the energy manifested in Hesamiyan's works and their interactive nature. In the Persian language, the female name Forough means brightness, or enlightenment as indicated in Mahan Moalemi's text, and the inspiration for the work is apparently the lotus flower, which has symbolic meaning in several Asian cultures and religions. In Persepolis, for example, several reliefs are decorated with lotus flower motifs, and a depiction of Darius the Great on the throne shows him holding a lotus flower in his left hand. Despite its opulence and imposing appearance, *Forough* has vivid yet hidden poetic connotations which testify to the inquisitive mind of the artist and the depth of his consideration.

MITRA FARAHANI

I do not recall in recent years having seen any art that, despite leaving plenty of room for interpretation, has so sharply and accurately portrayed the world's current situation, and indeed preceded it, than Mitra Farahani's *David & Goliath N°45*, 2014, [pp. 66–67] based around Caravaggio's painting, *David with the Head of Goliath*, c. 1606. In less than 15 minutes as the video plays, we encounter practically every quality we can think of: truth/deceit, beauty/ugliness, incongruity/consistency, confusion/clarity, innocence/guilt, violence/gentleness, emotion/cold-bloodedness, order/disorder, discrepancy/agreement,

obedience/disobedience, restriction/liberation, pendantry/
carelessness, and much more. We see them all in a single paint-
ing and the behaviour and attitudes of successive groups of
museum-goers as they come to view the painting.

In the splendid setting of Villa Borghese in Rome, tour guides —
in an overly didactic and pedantic manner — take groups of visitors
through the galleries. Speaking Japanese, French, Russian, English
and Italian languages in succession, they do not miss a stop at
Caravaggio's dramatic double portrait depicting David (looking
like a young Caravaggio) holding the severed head of Goliath
(older Caravaggio). When they comment on, or rather interpret,
the painting in their mother tongue we get a peek through the
many layers that make up the essence of individual human beings:
education, culture, feeling, collective behaviour and under-
standing, conscious and unconscious acquired education. Para-
doxically, it is during this multi-language explanation that the
quiet voice of the artist herself, speaking in Persian, is intermit-
tently heard. Farahani questions not only the concept of duality
in human nature, but also asks about the notion of truth. Can
history be told objectively? Should one simply acknowledge
history without prejudice and let it go by, as if it were a breeze?
Who should be entitled to talk about history? Who is more
important in the context of history, the victor or the vanquished?
And who are they really, those victors and vanquished? Farahani
keeps asking questions, which once more attest to the complex-
ity and difficulty of deciding what is the truth.

FARIDEH LASHAI

History or rather some remarkably challenging aspects of
human history are revisited in one of the last works made by
Farideh Lashai before her death in 2013. *When I Count,
There Are Only You ... But When I Look, There Is Only a Shadow*,
2012–2013, [pp. 84–85] is by any standard not only a moving
story, but also a work which incorporates the extremes
of violence, pain and horror that result from any war or human
conflict. Based on Francisco Goya's well-known suite of engrav-
ings, *Los desastres de la guerra* (The Disasters of War) executed
between 1810–1820, Lashai almost two hundred years later
reviewed the works of the Spanish master and in turn created
another powerful and disturbing work which makes it manifest
that human violence, cruelty and injustice have no limiting
time frame or borders. For her work, Lashai created a grid with
80 prints from the 82 Goya engravings, from which the figures
had been removed, leaving only bare and desolate background
landscapes. A tender piano piece by Chopin plays as a digital
spotlight moves slowly from one image to another, causing the
missing figures to reappear, momentarily animated, showing

perhaps that human violence follows no precise pattern or logic. Whether the work was prompted by Lashai's own personal battle with a devastating disease and her desperation in the face of reality, or it was a last and strong statement of a truth that she wanted to make about the political situation and her own life, the work is a daunting, grief-stricken and sorrowful summation of reality that touches one's soul, and perhaps also speaks of human *Fortuna*. Lashai found a most poetic way to create a haunting experience that leaves viewers in deep thought.

HADI TABATABAI

The subject of Tabatabai's art is basically *what you see is* NOT *what you see* and to implement his ideas, he plays astutely on human perception within the simple straightforwardness of the grid. These are simple structures which paradoxically can represent duality. As a physical entity a grid is clear evidence that repetition strengthens the intent, however as a metaphysical idea it can inspire a search for truth. So, it is not surprising that a grid incorporates opposites, such as order/disorder, and therefore can be mentally and visually disorientating despite its seemingly simple and logical manifestation. This could have been one of the reasons why the concept of a grid was critical to the discourse of modernity at the beginning of the twentieth century, particularly for the Russian avant-garde artists, but for other artists too, such as Piet Mondrian. Later on and in the 1950s and 60s, other artists, among them Agnes Martin, Frank Stella and particularly Sol LeWitt, focused on the conceptual potential and infinite possibilities of the grid. These artists often went beyond the power of simple lines and employed the evocative properties of colour, or at times no colour, which LeWitt opted for.

In some ways the inherent ambivalence in the structure of a grid, which LeWitt and now Tabatabai extensively and intelligently explore, is not totally foreign to Persian poetry, where written words are simply signifiers for what lies beneath, and the level of ambiguity can multiply exponentially with many external variables, such as the expanse of the work, but also the number of readers or viewers. Therefore, it is interesting to highlight here that the notion of duality exists in the mind of almost every Iranian artist invited to take part in this exhibition.

NAZGOL ANSARINIA AND
SIAH ARMAJANI

Forty years difference in their age and based more than 10,000 km apart, Nazgol Ansarinia and Siah Armajani seem to have similar interests – working on projects that engage them in dialogue with their respective surroundings and their

own profound artistic thoughts and beliefs. Although the
resulting works are physically different, they are nevertheless
similar in that human action and behaviour play a central role
in them — not unlike the work of Hadi Tabatabai. Siah Armajani's
structures, such as his bridges, gazebos and reading-rooms,
are works of art, yet they are built to be meeting places too.
Whereas Ansarinia's practice is primarily based on sharp
observation of the city with which she is most familiar, Tehran.
A good part of her work focuses on memories of a physical
place that had once existed and perhaps had also been a meeting
place. *Membrane*, 2014, [p. 52] is for instance a large, paper-thin
3-D scan of impressions left over time on a now-demolished wall,
on which each impression is a signifier of life within the parame-
ters of this recorded evidence. Such a *sense of place* within which
human beings, though absent in the work, are the most promi-
nent actors is the very element that connects, in some intriguing
way, the practices of these two artists and has once again made
me think of Heidegger's existential theory of *Dasein*.

Armajani came into art straight from an education in philosophy
and his art is particularly influenced by Martin Heidegger's
writing, 'Building Dwelling Thinking', that was instrumental in
the development of Armajani's innovative series of works called
Dictionary for Building as well as some other large-scale pro-
jects and his numerous works on the theme of bridges. Ansarinia
was educated in graphics and design but it is more her own
approach to life, her astute observation, that seems to have made
philosophical thinking a major characteristic of her work.
Other interesting dichotomies, though oddly similarities too,
appear in the works each of these two artists have made on
the topic of so-called anarchists. Armajani highlights the *raison
d'être* of the 'political anarchist' (he himself was one in his youth)
and celebrates them in several of his installations; whereas,
Ansarinia underscores the 'economic anarchist', denouncing them
as signs of greed and financial gain in her works, such as *The
Mechanisms of Growth*, 2017, in her *Demolishing Buildings, Buying
Waste series* [pp. 110–115]. These works take a strong stance
on 'real-estate anarchists' who in recent decades have brought
dramatic changes to various Iranian cities, particularly Tehran,
often leaving the residents confused and depleted of their
collective memories.

NAVID NUUR

An acute observer of his environment who reacts constructively
and generously to what he is ultimately interested in. That is
pretty much what drives Navid Nuur's practice. His art and his
mind are geared towards the study of human experience,
that eventually translates into a work of art, which may only be

a temporary manifestation. It can be challenging to write
about Nuur's work, because the inanimate world is simply not
his subject, nor perhaps even his interest. Rather, his passion
is directed towards ideas and the vivid reactions he has to
them, which lead on to him giving them a physical reality. It is
almost impossible to keep up with Nuur's artistic develop-
ment as a linear phenomenon, because every conversation with
him takes on a different and fascinating topic that ultimately
results in works which are totally disparate in nature. Over the
years I have known Nuur and his practice, including exhibiting
his work at Parasol unit, I have learned not to fix my mind on any
one aspect of his work. Instead, and increasingly, I let myself
be taken by surprise, project by project, exhibition by exhibition,
and simply wonder what I will see next. In this wonderland of
the unexpected, we viewers reap rewards and emerge from
each of his exhibitions with greater insight. It is perhaps safe
to say that in the mind and eyes of Nuur, any artwork exists
only subliminally until someone looks at it.

It is at first a *tour de force* to find any connection between
Nuur's *The Tuners*, 2005–2019, [pp. 97–102] and his *Broken Blue
Square*, 2017, [pp. 148–149]. *The Tuners* includes three very large
paintings of colourful scribbles, like those left behind by people
who try out new pens in a shop. Nuur shows these paintings in
an unorthodox way, outdoors at the Conservatoria di Musica in
Venice, perhaps to create another degree of challenge. His
Broken Blue Square, shown indoors at the *London* exhibition is
an eerie rectangle of sky-blue light formed by some 30 neon
tubes filled with crushed glass and argon gas. The sight gives pure
pleasure as one experiences some enchanting phenomena
and a work of art at the same time. Nuur's art banks on hidden
human resources and possibilities, and like Persian poetry has
apparently limitless potential.

Y.Z. KAMI

His often large paintings of people are quiet zones *par excellence*
for reflection. Yet, there is a dichotomy between their intimi-
dating scale and the intimate and private facial expression of
each sitter, which invariably leaves viewers in a state of vacillation
and self-doubt. How can these exquisitely painted faces be read,
when the image seems to dissolve as one approaches? How can
one access them, when their typically downcast eyes gently but
decisively avoid eye contact? Kami's portraits are indeed places
for reflection, but they are also environments that can prompt us
to accept our own flawed perception and unresolved emotions.

In Kami's 'portraits', time stands still, as if the subject had no
choice but to leave behind all other activities, and one wonders

whether this is a momentary stillness or perhaps the silence of eternity? Doubt reigns in his paintings, as it does in Armajani's work, *Edgar Allan Poe's Study* [pp. 57–60] which lets viewers decide for themselves the state of things. In some ways this is not unlike the Fayum portraits that impressed Kami early on in his career and may also have inspired him to give painted form to the deep emotional stillness and individuality he senses in his subjects. As a student of philosophy and an enthusiastic reader of Persian poetry, particularly that of Rumi and Hafez, Kami was probably significantly influenced by the vast wisdom of human reflection and reaction, for the elusive faces in his paintings induce a delicate mix of feelings in their viewers, and speak of a mind replete with limitless contemplation and deliberation.

Fayum were small-scale portraits usually painted on wooden boards. These realistic depictions of people were meant to accompany the mummified dead person on their eternal journey. Despite their wide-open eyes making full contact with viewers, Fayum portraits can set off some uncanny and distant feelings; whereas Kami's paintings of people, on linen, are quite dissimilar and generate strong feelings in the viewer. They are painted as if they exist in a state of flux, which belies their intense and engaging presence. Their striking tremor speaks of the artist's own deep reflection and hesitancy, as if he is telling us that in the reality of our world what we perceive is often intangible, what might appear manifest could be ambiguous, and what looks authentic could be illusory. Such characteristics, aside from his incredible painting skill, are some of the most extraordinary aspects of Kami's paintings, that in many ways remind us of the poetry of Rumi and Hafez.

MORTEZA AHMADVAND

Aside from concepts of flux, uncertainty and metamorphosis, all apparently essential components of Morteza Ahmadvand's practice, a remarkable degree of philosophical thinking underpins each of his works. In both *Becoming*, 2015, [pp. 37–41] and *Cradle of Religions*, 2019, [p. 109], Ahmadvand seems to plead for compromise and unity, the kind of good sense often passionately recommended in the poetry of Hafez and Rumi. *Becoming*, is an installation with three wall-mounted TV screens surrounding a large sphere on the floor. Each screen shows one of the Abrahamic religious symbols – a cross, a Star of David, and a cube representing the Kaaba. The symbols slowly transform, each one revolving until they have all become the same shape: a sphere, which symbolises unity and becoming one. The *Cradle of Religions* is made of three identical swinging metal spheres, suspended side-by-side. Again, an Abrahamic symbol is fixed at the top of each supporting rod. The work follows conceptually Newton's Cradle theory by which momentum and energy can be contained

and conserved. Once the stationary sphere at one end is lifted and released, it hits the middle sphere through which the force is transmitted to the sphere at the other end, which in turn swings out and back to repeat the motion in reverse.

Aside from often seeming to be based on traditional and straightforward concepts and pleading for togetherness and unity, Ahmadvand's works inhabit an area of complexity and philosophical thinking, which reminds us that nothing in our world is permanent and there will always be opportunities to remediate mistakes of the past. In many ways their message is in tune with Persian poetry.

Ahmadvand's *Cradle of Religions* has another attribute, gigantism. Like Koushna Navabi's *Biskweet-e-Madar*, the scale of his work creates a haunting feeling. Indeed, its size inspires awe rather than the familiar playfulness we associate with small objects, such as the Newton's Cradle, or Balls, commonly used to demonstrate Newton's theory of momentum and conservation.

KOUSHNA NAVABI

Haunting could be a sober adjective to describe Koushna Navabi's works in the two exhibitions, *The Spark Is You: Parasol unit in Venice* and *Nine Iranian Artists in London: The Spark Is You*. Although usually enticingly executed, the message in her works can be enigmatic and disturbing. Navabi's works are not usually overtly political or protesting, beyond her choice of certain subjects that can be anything from private feelings to collective experiences, and yet in some ways they could be considered political.

By any standard *Untitled (Tree Trunk)*, 2017, [pp. 140–145] is a disturbing manifestation of inner feelings. Using kilim, a traditionally hand-woven textile whose origins date back well into the fifth and fourth centuries BCE, is a clear sign of identity, particularly as the hanging figure represents the dismembered body of a female. Of her frequent use of handiwork in the art she makes, Navabi has said, '... *embroidery featured largely in my childhood. During the [Iranian] revolution, my mother and I endured the curfew knitting by candlelight. This memory and its associations are often revisited in my work, which encompasses both sculpture and painting to explore diverse aspects of identity, estrangement, and artifice.*'[3]

Biskweet-e-Mādar (Mother Biscuit), 2019, [pp. 88–93] is a strangely beguiling work, not entirely devoid of surreal and hyperreal undertones. The work reflects on the sense of loss and the devastating sentiments it can generate. It is about something which has left us altogether, will never come back,

no matter how much we want to imagine it back. More than a drama once lived through, the work expresses the artist's feelings and her reactions to a bygone childhood within a particular environment, the memories and expectations of which are revived through a symbolic and familiar object, image or taste that within the reality of today can appear uncanny. As in many of the works in these two exhibitions, the issues expressed are not purely personal, rather they speak of much wider concerns and collective memories and therefore have universal connotations. To me, what is most disturbing here is the way Koushna Navabi deals with the issue of loss. She has not only hugely exaggerated the size of the biscuit box and the biscuits – a hyperreal outcome that generates unsettling feelings in most viewers – but she has also enveloped the box in fabric on which a replica of the biscuit box itself has been exquisitely embroidered. The whole process resembles the preparation of a coffin for a funeral procession, especially as she has cast the biscuits in concrete the size of tombstones, which either lie on the floor or lean against the wall. Navabi has transformed an object of affection into an installation that is shockingly morbid.

To better understand Navabi's thinking, I at times recalled certain scenes in Alfred Hitchcock's films or tried to realise some distant nightmare come true. Within the context of the other works in these two exhibitions, I tried to find connections with Farideh Lashai's version of Goya's *Disasters of War*, but soon realised some striking differences: it might be in the distance that Navabi takes from her familiar objects and memories that one can find the answer.

HOSSEIN VALAMANESH

Encountering Hossein Valamanesh's work at the Museum of Contemporary Art in Sydney, and subsequently meeting him in Adelaide, South Australia, was another reminder of the enduring legacy of Persian poetry as well as the way it encourages engagement with new territories, whether physically or metaphorically. Acknowledging his Iranian origin and cultural heritage while also involving himself in new discoveries, Valamanesh often creates works that are a fusion between his Iranian heritage, now a distant past, and the largely untapped cultural and natural mysteries of his welcoming host country, Australia.

His *Lotus Vault #2*, 2013, [pp. 172–175] exemplifies the merging of such thoughts at its best. The beautiful 210 × 525 cm (82¾ × 206¾ in) work made of cut lotus leaves, which he sourced in Adelaide, recalls some of the patterned brick vaults of Jāmeh Mosque in Isfahan, one of the most awe-inspiring of such edifices ever built, added to and expanded over 1,200 years.

SAM SAMIEE

It might be fitting to end this essay with a few words about Sam Samiee's work. Always bound to present an intriguing installation, his source materials and creative process are invariably innovative, complex and dynamic. For his presentation in the London exhibition, Samiee has opted for two composite works, *The Fabulous Theology of Koh-i-noor (Theologia Theatrica de Koh-i-noor),* and *The Fabulous Theology of Darya-i-noor (Theologia Theatrica de Darya-i-noor)*, both from 2019 [pp. 152–163]. As is the norm with Samiee's installations, little is known beforehand about the final work other than its title, concept and the works that are likely to be included in it. The process of creating each installation can take a couple of weeks of intense thinking and experimentation and no two installations of a work will look the same. It is probably safe to say that Samiee's work is a never-ending intellectual challenge to the artist himself as well as to its viewers.

The term *Theologia Theatrica* has been variously defined as 'fabulous theology' or 'theatrical theology' in which humanity participates or is simply a viewer in God's drama. But here we are not dealing with nature, but with a man-made imagination. And by extension Samiee employs the term to investigate the background and the journey of two fetishes, each with its somewhat different and dramatic history that interestingly enough connects the East and West. The two large and coveted diamonds *Koh-i-noor* (Persian for Mountain of light), now in the United Kingdom, and *Darya-i-noor* (Sea of light), presently in Iran, come with their own colourful backstory of adventures and traversed years of wars, violence and intrigue. In some ways they symbolise a masculine desire to dominate the world, or land and ocean, which ultimately defines the measure of their power.

Creatively a twenty-first century man, Samiee connects this duality with another well-known one in Persian culture, the collection of folk tales known as *One Thousand and One Nights* which elevates the femininity and perspicacity of women. Throughout history and pre-history, Persian women have always been known for their strength, intelligence and femininity. Shahrzad and her sister Dinazad the two prominent characters in the *One Thousand and One Nights* tale were also called Sangehavak and Arvehavak. In Persian, the word *Sang* means stone, signifier of land and mountain, and *Arv* means river, signifier of water and sea. Thus, in his two fabulous installations, Samiee lays down two incredibly intriguing myths, connects them, and leaves the audience free to create their own myth, just as the reading of poetry allows one the freedom to interpret for oneself its associative meaning.

The works by the artists in the two exhibitions, *The Spark Is You: Parasol unit in Venice* and *Nine Iranian Artists in London: The Spark Is You*, differ in some ways considerably from one another, obviously because they have been created by artists with different sensibilities. They use a diverse range of media and, some of the artists express themselves through figuration, while others think in terms of abstraction. Again, while some of the works stem from personal spheres, others deal with collective experiences. Every work, though, expresses an interest in communication and dialogue.

In a wider context there are many other points of similarity, the works having been created by artists from a culture that honours all humanity and places great value on being *Persian*. The diversity and complexity of the artworks also demonstrate the richness and variety of thoughts and ideas of these artists. Much of which has been passed on to them through a remarkable history permeated with a love of their culture and an immense knowledge of poetry, all perquisites and privileges for any creative soul to be true to itself. In many instances the artworks engage with other cultures, which clearly demonstrates the openness and generosity of their intent.

The works of these artists have impressed me with the many values that constitute their soul and spirit. They have come into dialogue with another creative soul, Piet Mondrian, who always stayed true to his creative process. In such dialectics, it is my hope that I too have come into dialogue with those I truly respect, they who are in many ways our role models and are no longer with us, Hafez, Rumi, Goethe, Mondrian and Lashai, and those who fortunately are with us now, almost all of the artists in the two exhibitions *The Spark Is You: Parasol unit in Venice* and *Nine Iranian Artists in London: The Spark Is You*.

Wherever we are, whether we imagine Iran as a glorious idea or live its current reality and hardships, we must never lose faith in it, because this is a country that has survived through several millennia, often guided by the wisdom of fabled poets and forever permeated with a love of poetry. It is a great moment for all of us, who in some ways are the sparks of this universe, to realise this important gift and recite our most poignant love poems for the openness, generosity and wisdom of our world.

1 Piet Mondrian letter to Dutch art critic H.P. Bremmer, 29 January 1914.
2 Ghazaleh Hedayat, http://mopcap.com/artist/2011-ghazaleh-hedayat/
3 Koushna Navabi, http://mopcap.com/artist/2009-koushna-navabi/

22
A Cup, Nectar Brimmed
The Enduring Appeal
of Persian Poetry

NARGUESS FARZAD

At the beginning of Act III of *Hassan ... the Golden Journey to Samarkand*, a play by linguist, diplomat and writer James Elroy Flecker (1884–1915), which had its London debut in September 1923, Hassan, 'the best confectioner in Baghdad', tells the caliph Haroun al-Raschid, whose life he has just saved, about the magic and miracle of poetry. He tells the caliph that this gift from God is a deliverance from Hell, providing the powerless and the supplicant with temporary solace from the drudgery of life. With dewy eyes, Hassan continues that butchers and cobblers are reduced to tears when they listen to the poetry that is sung in the streets in the evenings. Intrigued by this assertion, the caliph is eventually convinced and murmurs in agreement, 'In poems and in tales alone, shall live the eternal memory of this city, when I am dust and thou are dust.' A moment later, reflecting on his own close brush with death, the caliph asks Hassan, 'If there shall ever arise a nation whose people have forgotten poetry or whose poets have forgotten the people, though they send their ships around Taprobane and their armies across the hills of Hindustan, though their city be greater than Babylon of old, though they mine a league into earth or mount to the stars on wings – what of them?' Hassan replies in a terse and sombre tone, 'They will be a dark patch upon the world.'

There would be a chorus of agreement with such a universal truism that a country without poets, and a cultural landscape without poetry, is indeed a barren land.

Poetry has been humankind's most potent mode of expression for many millennia, and a tool for what Seamus Heaney described as the 'imaginative transformation of human life' in one way or another, 'while encompassing and transforming painful reality'. First transmitted orally, then chiselled onto stones and carved on clay tablets, etched on bone and transcribed on bark and vellum, and now tattooed on bodies and pixelated as screen savers, poetry exercises its restorative power.

Poems of old often supplemented scriptures or facilitated the worship of the divine, and in the process they also told stories

of heroic feats, battles between good and evil, and quests for immortality. Whether the *Epic of Gilgamesh*, the earliest surviving aetiological myth known, written more than four thousand years ago, or the pithy aphorisms of Atticus, the Instagram poet sensation of the moment, it seems that in our hour of need we turn to poets to interpret the meaning of love, lighten the tyranny of alienation, and be a companion in our solitude. Poems help us memorialise separations and reconciliations, rise above betrayal and injustices, and come to terms with our own mortality and that of our loved ones.

Poetry is at the heart of many literary and oral traditions, but at its finest and most illuminating, in some cultures, it is elevated to the position of the sacred.

In the inventory of countries that value poetry above other expressive arts, Iran and the wider Persian-speaking lands come near the top. The history of this vast region has been shaped time and again by the arrival of conquering forces: whether from the West in the form of Alexander of Macedon, or the East in the guise of the Mongolian Genghis Khan, and all the other aggressors in between. However, despite the devastations wrought upon almost all facets of local culture, the affection – nay, obsession – of Persian speakers for poetry has remained more or less intact.

The renewal of a cultivated identity and the blossoming of a national literature fused with rich elements absorbed from the myriad cultures that have transited through this land, was first and foremost due to the role of poets and the patronage of discerning rulers. The yoke of Abbasid rule over Persia, at the north-eastern edges of the empire, began to be cast off in the early to mid ninth century, and a post-Islamic Persianate culture began to develop during what historians refer to as the 'political loosening of Khorasan', particularly with the consolidation of the rule of the House of Saman (c. 920 CE), whose territories expanded from the edges of the Gobi Desert to the Persian Gulf, and from the tributaries of the Indus to the banks of the Tigris.

The names of some of the most significant Persian poets of the Islamic era are associated with the House of Saman, followed by the Ghaznavids, and thereafter, for more than a thousand years, with every subsequent dynasty that ruled over the new Perso-Islamic empire. The patronage of poets, artists, and musicians ensured that the heroic epics, lyrical songs, and spiritual verse narratives that were composed over the centuries were not only recorded in splendid books and sumptuous illuminated manuscripts but memorised and recited by ordinary people; the odes to love that are at the heart of Persian literature saturated the consciousness of Persian-speaking lands, ensuring that poetry comes to Persian speakers 'as naturally as leaves to a tree'.

For centuries, writers of Persian verse adhered to the fast and rigid rules of prosody and composition. Metrical cadences that please the ear of the audience, and elaborate internal and end rhymes became the buttresses that held the structure of a poem intact. The rigidity of these poems, however, is counterbalanced by the eloquence of the language and the faultless use of metaphors and imagery, which all combine to produce elegant and euphonic expressions.

In the twelfth century, Nezami-Aruzi, a writer and poet who was born in Samarkand and served at the court of the mighty Ghaznavids, wrote a detailed and elaborate early manual of poetic composition entitled the *Chāhār Maqāla*, the Four Discourses. In this book, Nezami describes the functions of the four fundamental officers of the state, and the qualifications and responsibilities that are needed to ensure the successful reign of any monarch. He categorises the holders of these posts as secretaries, the poet-laureate, astrologers, and the council of physicians.

In the second discourse of the *Chāhār Maqāla*, which details the role of the poet-laureate, Nezami lists the attributes of good poetry and, interestingly, the importance of substance rather than form. The English translation of this section by Arthur J. Arberry, the highly respected scholar of Persian literary traditions who died in 1969, illustrates what was expected of the poet and poetry.

> Poetry is that art whereby the poet arranges imaginary propositions, and adapts the deductions. With the result that he can make a little thing appear great and a great thing small, or cause good to appear in the garb of evil and evil in the garb of good. By acting on the imagination, he excites the faculties of anger and concupiscence in such a way that by his suggestion men's temperaments become affected with

exultation or depression; whereby he conduces to the accomplishment of great things in the order of the world.

In that descriptive introductory passage, Nezami places great value on the role of the poet, whose duties seem also to include the management and pacification of self-centred, tempestuous, and even occasionally hung-over rulers. In one of the examples Nezami-Aruzi offers, he relates an episode when the diplomatic power of the poet Rudaki and the soothing effects of his verse combine to resolve a dispute between a ruler and his army.

According to this story, one summer the Samanid Amir Nasr II decamped to the countryside of Herat and enjoyed it so much that he extended his stay, and even two years later he still did not seem to be in any hurry to return to Bokhara, his magnificent capital. Dismissing the anguish and homesickness of his troops, the ruler made it clear that plans for departure were not up for discussion. Having spent such a long period away from home and their kith and kin, the army commanders were well aware of the unrest brewing among the troops and turned in desperation to Rudaki, hoping he would be able to resolve the situation. They pleaded with him to persuade the ruler to leave Herat and return home, and promised him a princely reward of gold if his efforts were successful.

One night after an exquisite meal had been served and fine wine imbibed, the poet found the Amir in a particularly convivial mood. The feasting continued into the early hours, and just before the 'morning draught' – that last goblet of wine – was served, Rudaki, who was an accomplished musician and possessed a melodic voice, picked up his harp and began to sing an elegy he had composed for the occasion. The metrical poem that Rudaki sang, is still known by almost everyone in Iran, Tajikistan, Afghanistan, and parts of Uzbekistan, and it begins with the memorable line *Bu-ye ju-ye muliyān āyad hami / The scent of river Oxus drifts our way*. Pausing for a moment to ensure he had the Amir's full attention, Rudaki continued to sing: *yā-de yā-re mehrabān āyad hami / The memories of longed-for friends drift to mind*.

According to Aruzi's account, Rudaki's captivating voice reverberated in the campsite as he sang that even if the journey back to Bokhara was perilous and the crossing of the Oxus River hazardous, all would pale into insignificance, if the ruler's white, noble horse were to lead the homecoming. Rudaki's poem concludes with the imagined depiction of euphoric chants and rejoicing in the capital city when the Amir, like the moon, returns to Bokhara's sky that had been bereft of his light, or *like the cypress that finally returns to its meadow*.

The Amir's reaction and what happened next are summarised by the great Persophile historian and writer Percy Sykes (1867–1945), in his 1910 travelogue *The Glory of the Shia World*:

> No poem, perhaps, ever produced such sudden effect, as the Amir leaped on to the saddled horse, which was always kept ready for an emergency, without even donning his boots, and left his astonished courtiers to follow as best they might.

Iraj Bashiri, in an article on Rudaki, compares this episode in the life of the tenth-century Persian poet and his cunning device for persuading the ruler to return to Bokhara, to that of Haydn and the performance of his Symphony No. 45 in F-sharp minor, known as the *Farewell Symphony*. Haydn's patron, Nikolaus I, Prince Esterházy, was spending longer and longer periods at a magnificent summer palace he had built in rural Hungary, which had become known as the Hungarian Versailles. The prince's long periods of residence at the summer palace meant that members of his orchestra were parted from their families for considerable stretches of time. Desperate to return home, the musicians pleaded with Haydn, their *Kapellmeister*, to resolve the situation. Prior to one evening's performance, Haydn instructed the musicians to snuff out the candles on their music stands as soon as their solo pieces were completed at the end of the fourth and final movement of the symphony, and to leave the hall, one by one. Soon, nearly all the members of the orchestra had left, leaving only two musicians, Haydn himself and his concertmaster, in the dark and silent hall. Thanks to Haydn's subtle message, Prince Esterházy at long last grasped the unhappiness of the orchestra, and the following day, the court began preparations to return to the prince's family seat of Eisenstadt.

Although such anecdotes portray the classical Persian poets such as Rudaki as artful conciliators, thus securing their place in the collective memories of the people of the region, the longevity and continued popularity of poets relies first and foremost on the effectiveness, vitality, and never-diminished relevance of their compositions.

Any index of poets from the golden period of classical Persian poetry will boast a great many names but will give pride of place to luminaries such as Ferdowsi, Attar, Nezami of Gandjeh, Mowlana Rumi, and Sa'di, whose *divans* or *chef-d'œuvre* continue to be reprinted and enjoyed by casual readers, as well as studied academically. However, if we place the manifestation of love at the core of this body of literature, it is only right that we should focus on the most acclaimed and magnificent composer of Persian lyrical odes in the mediaeval period: the inimitable Hafez of Shiraz.

Khāwjeh Shams ud-Din Muhammad, known by his pen name, Hafez, 'the one who knows the Koran by heart', or, the holder of the epithets *lisān ul-Ghaib* (tongue of the hidden) and *tarjumān al-asrār* (interpreter of mysteries), was born in Shiraz around 1315, making him a contemporary of Geoffrey Chaucer (c. 1343–1400), the first prominent poet of the English language, and Dante Alighieri (c. 1265–1321), Italian poet of the late Middle Ages. However, while the written language of Chaucer and Dante, and their literary references, are not easily comprehensible to modern-day speakers of English and Italian, respectively, speakers of Persian can usually understand the ghazals of Hafez, as the fourteenth-century Persian of Shiraz is not that different from the language spoken by Iranians today. The enduring popularity of the poet is best summed up by the acclaimed Hafez scholar and authority on Persian mysticism, Leonard Lewisohn, who has suggested that Hafez's immortality has been achieved precisely because of this very contemporaneity.

Despite the local veneration of the Shirazi poet and his near-universal fame, verifiable biographical details and accounts of his life are relatively scant. Arthur Arberry has characterised fourteenth-century Shiraz as the city of 'saints and poets', alluding to its multiplicity of mosques, Sufi shrines, gardens, bustling bazaar activities, and no doubt many taverns. Shiraz had escaped the full force of the Mongol destruction of Iran and had become a much-acclaimed centre of the arts and literature.

It is therefore not surprising that with the increase in contact between the East and the West in the sixteenth-century, European scholars began to learn more about Hafez and, before long, translations of the Persian poet's sonorous lyrics appeared in many European languages. The first translations in English of the bard of Shiraz were penned by the eighteenth-century philologist and judge Sir William Jones. This translation by Jones of the famous Ghazal number 3 of Hafez was published in 1771, entitled *A Persian Song*.

Sweet maid, if thou wouldst charm my sight,
And bid these arms thy neck infold;
That rosy cheek, that lily hand,
Would give thy poet more delight
Than all Bocara's vaunted gold,
Than all the gems of Samarkand.

Although rhythmic and engaging, with touches of exoticism, the softly romantic translation by Jones does not convey the historical or geographical settings of the Persian lyric, nor does

the depiction of the poet's subject of affection as 'sweet maid'
– there is no gender in Persian, so the beloved can be a he or
a she – provide the English-language reader with an accurate
representation of the persona of the beloved.

Jones's 'creative translation' was soon followed by many more
attempts by others in varied formats, including imitations
of the Persian, parallel prose versions of the original, and free
renditions of the essence of the poem. To be fair to the English
translators of classical Persian poetry in general, and of Hafez's
ghazals in particular, the complex play with polysemic Persian
words, strict metrical arrangements, reliance on rhyme, abun-
dance of allegory, and ambiguity of allusions, let alone the
divergence of aesthetic principles of composition and the impos-
sibility of separating the profane from the divine, make this
one of the most challenging tasks of translation.

Although William Jones was the first notable translator of
Hafez, the European poet and critic most intimately associated
with the poet-saint of Shiraz is Johann Wolfgang von Goethe,
whose *West-oestlicher Divan* (West-Eastern Divan), a collection
of lyrical poems published in 1819, accorded Hafez a permanent
and much eulogised place at the heart of European romantic
literature, and soon after in world literature. The impact of
Goethe's poignant dialogue with Hafez, conducted across the
ages, brought the fourteenth-century contemplative Persian
poet to the attention of Tennyson and Emerson in the United
States, while the 'Hafezian language of Love' and the settings
of rose gardens and enchanted songs of the nightingale began
to percolate through the works of English romantics such as
Keats, Byron and Shelley. The year 2019 marks the two-hundredth
anniversary of the publication of Goethe's *West-Eastern Divan*,
and the occasion will be celebrated by literary and musical
events and celebrations in many cities across Europe.

Goethe had found the themes that dominate the poetry of
Hafez – who is regarded by many as the prophet of the Religion
of Love – fresh and most appealing, such as passionate appreci-
ations of the beauty and perfection of the beloved on the one
hand, and the utter abhorrence of hypocrisy and fraudulent
displays of sanctimony on the other. Hafez's poetry is not overt-
ly didactic, and when he chooses to guide, he prefers to point
rather than tell. Like a photographer who captures and stills
the fleeting moments of commotion in nature, Hafez slows down
or stops moments of weal and woe of life, coaxing the reader,
or auditor, to pause and perfect the art of gazing and listening.
In Hafez's world, every encounter with beauty leads to epiphany,
and in his lyrics divinity, love, humankind, and nature are not
treated as separate entities but are presented as a polytheistic

whole. Hafez celebrates recklessness, and his verses affirm that he loved the good life, but his ethics indicate that he preferred the company of honourable rogues and reprobates in dingy taverns to feasting with corrupt judges, disingenuous guardians of morality, or censorious rulers:

I am the talk of the town for revelling in love
The one whose eyes are not begrimed looking at indiscretions

Let us be faithful, embrace reproach, and be happy
By our protocol, taking offence is downright heresy

I asked the elder at the tavern: What is the path to salvation?
He called for a goblet of wine and said: Concealing the flaws

What is the heart's desire gazing at the garden of the world?
If not the keenness of the eye to pluck roses from your cheek?

I trust the mercy of your tresses to surrender, if not
What use is trying if allurement is unrequited

Learn from the fine downiness how to love a winsome face
Tracing the curves of a beauty's cheek is a joy to behold

Kiss only the lips of your paramour O Hafez, and the wine-glass's rim
Kissing the hands of the self-righteous is unseemly and wrong

Almost every Hafez ghazal lends itself to a multitude of inter-pretations. Descriptions of lovers enjoying a feast in a tavern, or courtiers engaged in a dispute with sagely drunks, or an old seafarer and a friend reminiscing, can be taken for exactly what the words relate, but the poem can equally be read as an expression of the search and devotion for the divine or an acceptance of fate preordained, as in this example:

At break of morning the bird of the meadow told the freshly budding rose:
'Prance a little less, there are many buds in the garden like you'

The rose brushed the slight away with a laugh, and said: 'truth does not offend, but no lover speaks so cruelly to the beloved.'

The warp of physical romance and the weft of spiritual love are so tightly interwoven in the fabric and language of the poetry of Hafez that the reader is often presented with a lenticular picture that reveals a different image depending on the way it is tilted and viewed.

The enigma of Hafez's intentions is perhaps one of the main reasons why, some six hundred years after their composition,

readers still delve into his sonorous, caressing ghazals, seeking guidance and oracles, and above all, comfort for the heart and balm for a weary soul.

In many Hafez ghazals, the poetic voice celebrates the power of poetry, and with his customary lack of self-deprecation, he predicts the reach of his own words when he writes, for example, that 'while the central and western parts of the empire were captured by his sweet verse, soon Anatolia and Mesopotamia would also be his' (ghazal 42), or that 'the dark-eyed Kashmiris and the Turks of Samarkand were swaying and dancing in tune with his poems' (ghazal 431). One wonders what Hafez would have made of the enduring popularity of his lyrics in the twenty-first century in lands far from his enchanting city of Shiraz? How would he have responded to Emerson describing him as 'a poet for poets', or Goethe attesting that Hafez 'has no peer'? Hafez would concur with W.H. Auden's tribute to Yeats, that in the darkest days, poets 'persuade us to rejoice'. Hassan, our hero of Flecker's 1923 play, need not be alarmed: 'In the deserts of the heart' poets 'let the healing fountains start.'

Narguess Farzad is Chair of the Centre for Iranian Studies and Senior Fellow in Persian at SOAS University of London.

33
The Spark Is You
Parasol unit in Venice

34
Beneath and Beyond States of Transition in the Works of Morteza Ahmadvand

MAHAN MOALEMI

Morteza Ahmadvand's practice revolves around a confrontation between heterodox approaches to self-expression and dominant metanarratives of representation. In the nine-panel video *Flight*, 2008, [pp.106–107] a bird is filmed trying to break free from its confined environment. Each time it takes off, the contours of the frame block its way. Gradually, what fills in the frame are flimsy traces of its attempt, a ghostly record of impulsive flapping. In its turbulent simplicity, the work delivers a critique of representation and its conventions, one which is informed by a symbolic and allegorical take on the formal parameters of visualisation. It implicitly builds on an acknowledgement of a certain set of expectations from an image sent from within the Iranian context, which has long been tagged as infamous for regimented circumstances of social and political life, mainly due to the specificities of a theocratic setting. However, Ahmadvand's interest does not lie in yet another attempt to bring such circumstances into the light, but in addressing the ways in which an image thereof is often produced.

The criticality of the work can be traced in the particular positioning of the camera towards a subject with the potential for flight, that is, for departing from or rejecting a fixed viewpoint. Emphasised by a gridded structure that defies any illusion of depth and keeps the viewer's eye attached to and loitering around the surface, the positioning of the camera reveals how the onlooker's gaze and the framing of the image supersede and overwrite the initial conditions in which the subject could be found before having been filmed. As the surface value of the image curbs a sense of spatial depth, a parallel is drawn between the visual limitations of representation and the sociopolitical limitations that, in the Iranian context, are expected to be represented and put on display. The bird is captured and held within the image itself, which is made to look synonymous with the boundaries that precede the terms of representation, with the conditions on which the image purportedly reports.

On the other hand, and expanding on such a critical approach towards the reductive conventions of

representation, the work does not succumb to a dichotomy between freedom and constraint. Instead, it accounts for the subtle nuances of a resilient livelihood. The depiction of failed attempts at flight are crossed with the tracing of volatile movements, which evoke the fleeting and often imperceptible circulation of bodies, desires, and sensations under restrained circumstances. In this sense, the accumulation of spectral gestures points towards an elusive history of agitated but vital activities, whether of a social, political, or cultural nature, that passionately thrive below the assumed thresholds of recognisability and, in order to be represented, demand altered frameworks of aesthetic perception.

Societal constraints in Iran are most often associated with the eerie presence of religion across various realms of public and private life, directly or incidentally interfering with the range of individual or collective choice. In parallel to how vital streams of desire and creativity flow beneath ideological coagulation here or there, Ahmadvand investigates the ways in which different religious doctrines coalesce into terrains of possibility that transcend each and every one of them. The video installation *Becoming*, 2015, [pp.37–41] employs the symbolic vocabulary of abstract and geometric formalism to address a transversal mode of consciousness beyond inherited constructs of religious difference. A black fibreglass sphere is surrounded by three screens, on each of which a three-dimensional shape – a cross, a star tetrahedron, a Kaabaesque cube – represents one of the major worldwide religions. The shapes slowly begin to morph and each one eventually transforms into a sphere, identical to the one that is placed before the audience in the exhibition space.

The message can seem fairly straightforward, particularly in the sense of the shared origins of all Abrahamic religions, redirecting factional conflicts towards a singular divinity, and even paying tribute to ancient mysticism, where the purity of abstract shapes and sacred geometries served as a cosmological medium. But the work also points to how ideological differences wither away in the face of a single planet that all humans inhabit together with their non-

human counterparts. The sphere can also suggest an orbuculum in which an unknown future, beyond all the inherited conflicts of the past, can be summoned. This is in fact to put pressure on the here and now, the urgencies of a contemporary moment embodied through the act of exhibition and an exchange with the audience. The contemporary moment stands for the effervescent nature of all things organic and inorganic, abstract and concrete, channelling a state of constant transition and becoming. What is significant about the states of transition, as are portrayed in Ahmadvand's practice, is how they contain oppositional forces, allowing them time and space to debate and mediate, without having to either wrestle or settle.

Mahan Moalemi is a writer and curator from Tehran.

37 *Becoming*, 2015. Video installation: 3 single-channel videos, fibreglass sphere. Dimensions variable

MORTEZA AHMADVAND

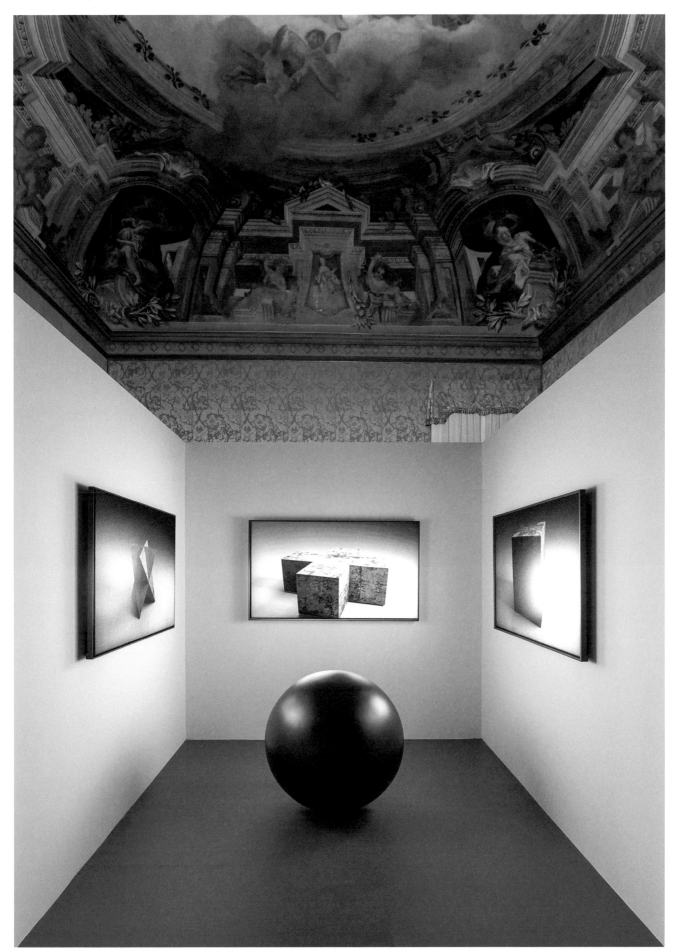

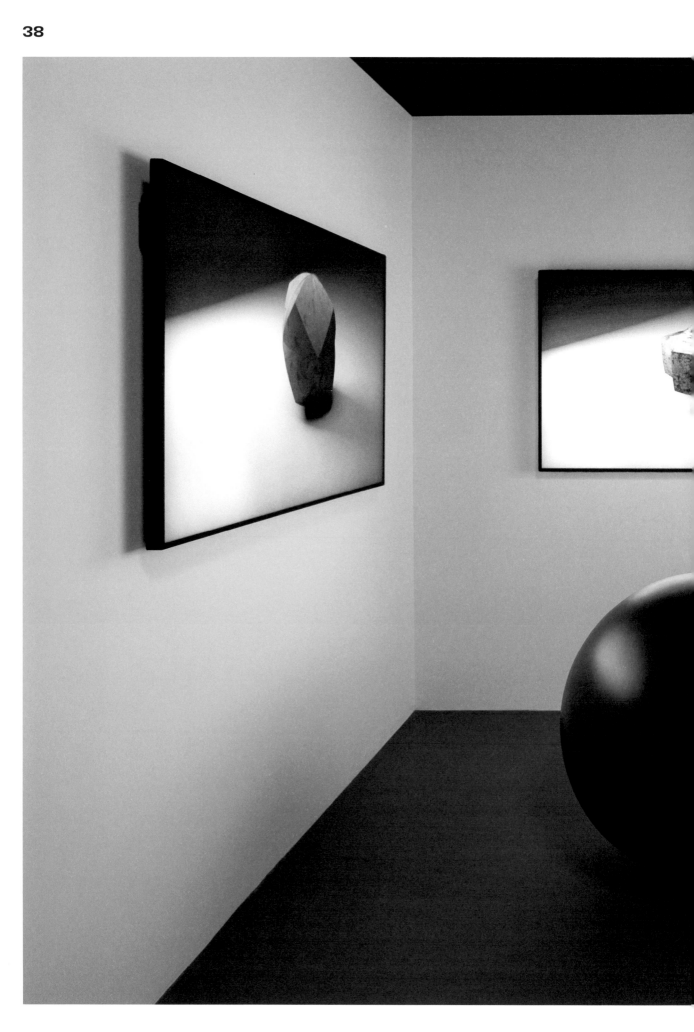

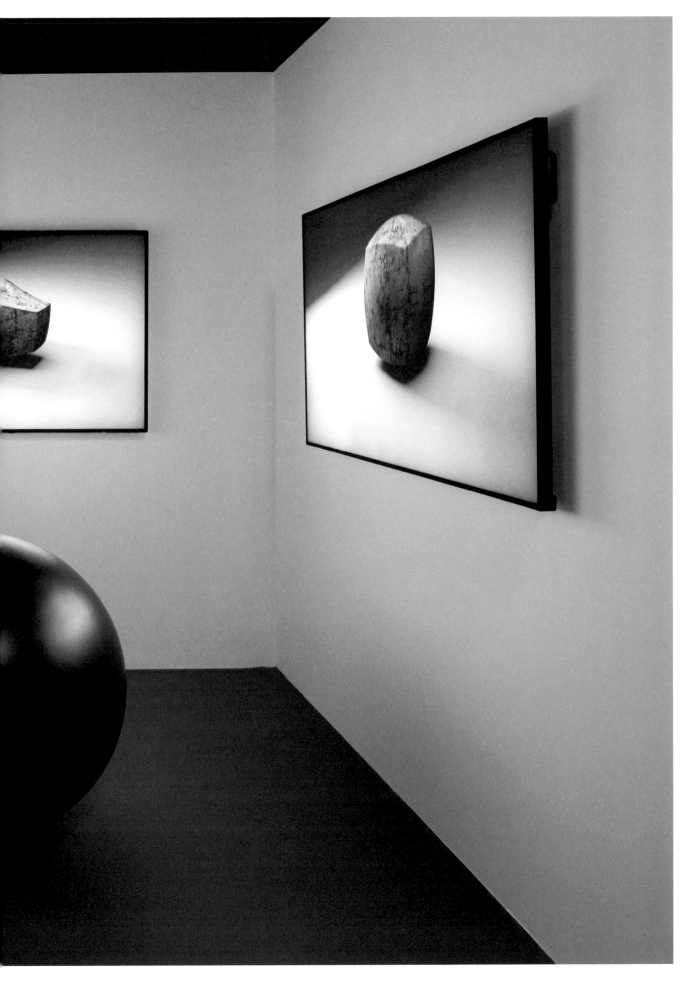

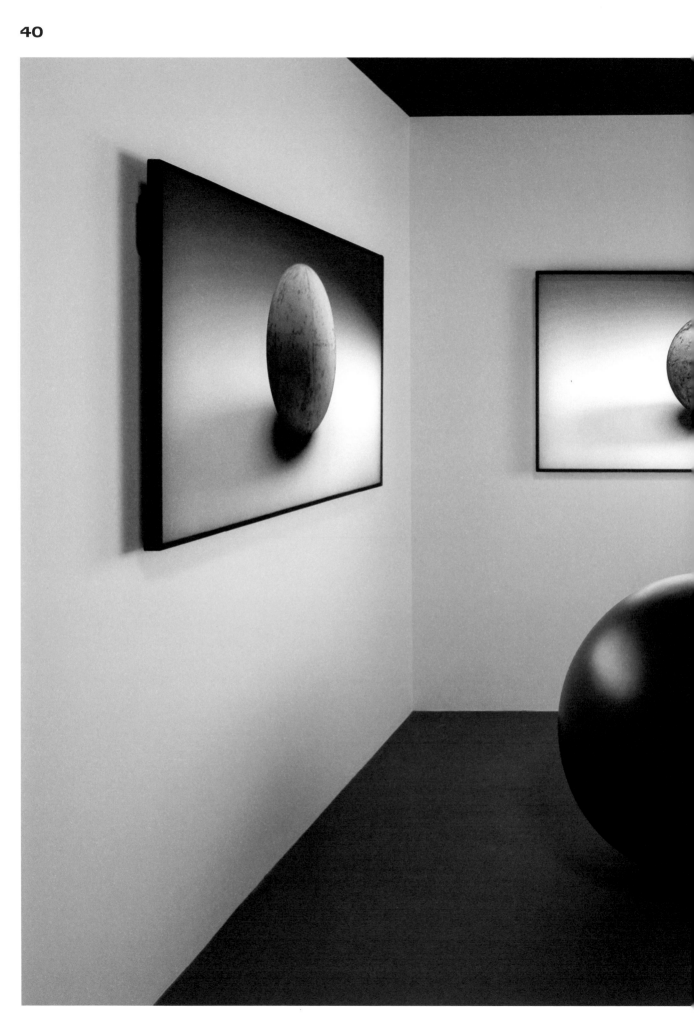

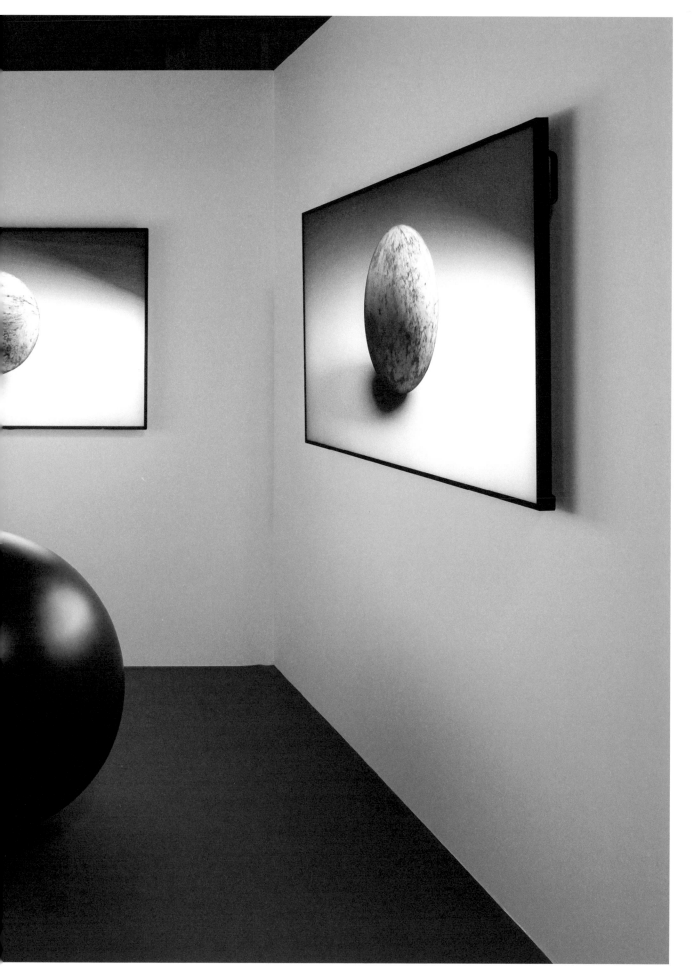

42
Clouds on the Mountain Block the Road

MARYAM MONALISA GHARAVI

Tehran's development frenzy is demolishing the city's existing buildings at an astonishing rate. Nazgol Ansarinia's sculptural and moving-image works capture a city whose feverish adoption of demolition practices leaves it struggling to retain urban memory.

'The worst utopia is the one that remains unnamed.'
Henri Lefebvre, *The Urban Revolution*[1]

In the wider discourse, Iran has been read and over-read through the lens of the Islamic Revolution of 1979. So much, in fact, that even the most casual mention of modern Tehran, in informal conversation or formal analysis, cannot seem to sidestep it. Were he alive to witness the transformation of the city since at least the 1990s, however, Henri Lefebvre, the radical theorist of space, capital, and the right to the city, would characterise this latter revolution as *in toto* urban. The real-estate speculation market and concomitant development frenzy in Tehran is demolishing the city's existing buildings at an astonishing rate, buildings that are useable, intact, and presenting no need of being toppled. While a neoliberal critique of accelerated demolition would pin the problem on privatisation, Lefebvre argues that the 'urban illusion belongs to the state'. The 'unnamed' utopia is a state utopia, one he encapsulates in a startling image: a 'cloud on the mountain that blocks the road'.[2] Tehran-based artist Nazgol Ansarinia's sculptural and moving-image works evoke that same cloud. It is grey and nonporous. It pulverises into debris. Tehran's feverish adoption of demolition practices leaves it struggling to retain its urban memory, which, like a cloud, leaves a dust film over everything it covers.

What is the municipal history of the buildings being demolished? No one seems invested in that question. In a 2016 Tate video, Ansarinia guesses the age of one demolished building: 'You can tell that this is not very old – probably 20 years old. It's been demolished because they probably want to build something like the one that is next to it, like a five-storey high building.' Beyond the speed with which demolitions are happening block by block and neighbourhood by neighbourhood, in other words, the factor of non-necessity is at play; a building with nothing 'wrong' with it is speculated on, resold, quickly knocked down and replaced with a newer one, expanded by just a couple of storeys. The worship of vertical supermodernity in nearby Dubai, for example, is not the main impetus for Tehran's transformation. A different ideological agenda is at hand, one that aligns, Ansarinia notes in an artist statement, with the master plan of Tehran after the American city, modelled in the 1960s by Gruen Associates, a Los Angeles based architectural planning group, in a joint venture with the Iranian firm Abdolaziz Farmanfarmaian and Associates, or AFFA.[3] That plan yielded forked highways and noncontiguous freeways that cut Tehran's neighbourhoods off from one another. Ansarinia notes the 'larger inclination towards privatisation and minimisation of public space,' one, I add, almost entirely empty of public outreach, scrutiny, or contestation. The city's recent experience of hyperdriven real-estate creep (often dubbed 'renewal') has stretched out in a long slog. Instead of one gargantuan whale, it spurted into Tehran like mini-leviathans, constantly in sight but impervious to apprehension.

In three works from her *Pillars* series, titled *Article 44, Article 52*, and *Article 55*, [pp. 45–51] Ansarinia advances a radical thesis. The columns are upright, but they support no arch or entablature. Their exteriors suggest concrete, staid and undecorated; their surface smacks of the generic, bland, and easily repeatable. They could be sourced anywhere, and suggest nowhere. That light materials, such as paper, cardboard and glue, meld together to form a simulacrum of stone pillars is further evidence of the artist's vexation. The sculptural forms suggest austere solidity but are in fact cheap and easily destroyable, like Tyvek, the suburban building material. The interiors, however, invoke otherwise. They too are stylised in the generic: the Persian script peeking out from the perfectly bifurcated columns use a common font (equivalent to Helvetica). Yet the contents are entirely specific: each pillar contains the entire text of an article from the Iranian constitution's 'Economy and Financial Affairs' section. Unlike the nonspecific pillars that encase them, they intimate historical place, geographical positionality, and national vision, one at odds with the turbo-twins of speculative investment and rapid real-estate development sponsoring an erasure of the city on a memory-wiping scale.

Marc Augé, hypothesising that supermodernity produces non-places, gives the following description: 'If a place can be defined as relational, historical and concerned with identity, then a space which cannot be defined as relational, or historical, or concerned with identity will be a non-place.'[4] Ansarinia's *Pillars* series complicate this binary by binding place and non-place irrevocably together. Is Tehran's urban fabric still legible to its denizens, both as locality and visually contiguous surface? The *Article* sculptures are enveloped in their outward-facing surface by non-place: a generic totem (in view of the 'other') in which place is neutered. Their inner surfaces, however, are etched with the complex indices of place, like a finger pointing at a Perso-'self'. Augé expands on this binarised polarity between place and non-place: 'the first is never completely erased, the second never totally completed; they are like palimpsests on which the scrambled game of identity and relations is ceaselessly rewritten.'[5]

In *The Mechanisms of Growth*, 2017, [pp. 110–115] 13 pallets on the floor support piles of handmade 'bricks' (based on a 3-D printed mould) as though the process of either construction or destruction had been stopped in its tracks. The artist has described *Mechanisms* as 'turning rubble into repeatable construction units'. Cast plaster and PVC glue enact the density of actual brick but the homespun colour has been faded out to a grey pigmented pallor. The colour has seeped out of the bricks, and with it, one might suggest, all utility. The enterprise of construction – or even destruction – has frozen midway, leaving behind a vast un-networked clutter of futile detritus.

This confused midpoint of erosion and accretion is important. In *The Urbanization of Capital*, David Harvey, who has thought about capitalist modes of production in the vein just mentioned, reformulates his central theoretical and historical question: 'How does capital become urbanized, and what are the consequences of that urbanization?'[6] *The Mechanisms of Growth* appears to respond in kind, enacting the moment when the process of construction or destruction cannot be neatly ascertained. This vagueness may not be what we immediately associate with capitalist growth, but in isolating and congealing (the 'brick' blocks even look like ice) this non-

directionality, or 'growth for growth's sake', Ansarinia emphasises the capitalism's sad poetics: a mournful loss of situational awareness. If capitalism produces a process of continual erosion and accretion, like water poured into an unplugged bathtub, it never fully empties nor totally accumulates. Development without growth, destruction before expiration. On the cultural level, residents become uninhabited of memory.

In *Membrane*, 2014, [p. 52] made three years prior to *Mechanisms*, the outer layer of a building stands in isolation, like a discarded integument of an animal or plant. The membranes are skin-like, but the white pigment suggests a spectral presence. If ghosts are thought to exist within walls, *Membrane* externalises the ghostly presence of what capitalism has absented. Only discarded layers are left; for the artist, memories left unaccounted for can leave ugly impressions, like the squalorly imprints of brick and plaster. The work was made by hand through a process of laying down and pressing paper paste onto 1:1 moulds based on a 3-D scan of the original wall.

Two video works from Ansarinia's *Demolishing Buildings, Buying Waste* series, *Fragment 1* and *2*, 2017, (both 6:15 minutes) [pp. 116–117] carry over the muddling of creation and destruction to labour, especially the actual labour involved in the demolition of buildings. The series title is based on an advertisement (scrawled on buildings in Tehran) for a business that will demolish a building, often at a profit for the owner. The low-rise buildings scheduled to be demolished are replaced, as earlier mentioned, by buildings that are not much larger. Tehran's *de facto* problem is not a high-rise obsession, but renewal without novelty, and growth without evolution. The videos depict a building reduced from a liveable home to 'piles of rubble' in around two weeks, while the artist documented the demolition. The decision to initially film the labourers in shadowy silhouette, not in their full bodily presence, concocted something even more ghostly about the act of demolition. Later, men in work clothes, helmets and protective head scarves (though, one notes, little other safety gear) appear, breaking down the interior walls of the apartment. They are filmed in slow-motion. The domestic surfaces of kitchen tiles – decorative flowers, sometimes suggesting bucolic landscape art – contrast with the masculine energy of the scene.

What does demolition actually look like? In daily life, we are kept clueless. We hear the noise pollution of demolition from our city apartments or glimpse its wreckage from a distant roof, but we are mostly shielded from how it expresses itself.

After the interior wall has collapsed, *Fragment 2* belabours, in a frenzy of jump-cutting, the labour of the workmen gathering the heaps of broken scraps. When the filing away of the demolition debris ends, the film seems to breathe a sigh of relief in unison with the workers — literally, in the case of one worker who, at the 6:00-minute mark, stretches his torso and shoulders back in relief and breathes a huge gulp of air. The slow-motion shot extends to the audio track, which considerably prolongs this single breath. We would only see a shot like this in film, never in daily life, and rarely in a process justifiably kept out of the sight of citizens. Clairvoyantly, Augé notes of non-places: '[Their] dominant aesthetic is that of the cinematic long shot, which tends to make us forget the effects of this rupture.'[7] By forcing long takes (slowed down, or jump-cutting to scenes of demolition from both sides of the kitchen wall) Ansarinia calls our attention to an interior process that is usually hidden from exterior view. For the artist, medium interior shots and slow-motion editing are necessary in the rare act of witnessing the rupture of a non-place. Red wires jut out of ceilings like bloody entrails. Dust thickens the air like a polarised cloud. We are inside a before-and-after moment, like the multi-leviathan city itself, in which the 'after' is still strewn with shards and fragments.

1 Henri Lefebvre, *The Urban Revolution*, 1970, trans. Robert Bononno, Minneapolis: University of Minnesota Press, 2003, p. 163.
2 Ibid.
3 'Iran-United States Claims Tribunal', *Hague Yearbook of International Law, Vol. 9*, Martinus Nijhoff Publishers, 1996, p. 200.
4 Marc Augé, *Non-Places: An Introduction to Supermodernity*, trans. John Howe, 1995, London: Verso, 2008, p. 63.
5 Ibid., p. 64.
6 David Harvey, *The Urbanization of Capital*, p. 17, digitally accessed: http://www.u.arizona.edu/~compitel/Harvey_Urbanization%20of%20Capital.pdf
7 Augé, op. cit., n.4, p. xiii.

Maryam Monalisa Gharavi is an artist, poet, and theorist living in New York.

Article 55, Pillars, 2016. Paper paste, cardboard and paint
Each part: 80 × 108 × 50 cm (31½ × 42½ × 19¾ in)
Article 44, Pillars, 2016. Paper paste, cardboard and paint
80 × 100 × 100 cm (31½ × 39½ × 39½ in)
Article 52, Pillars, 2017. Paper paste, cardboard and paint
Each part: 65 × 75 × 33 cm (25½ × 29½ × 13 in)

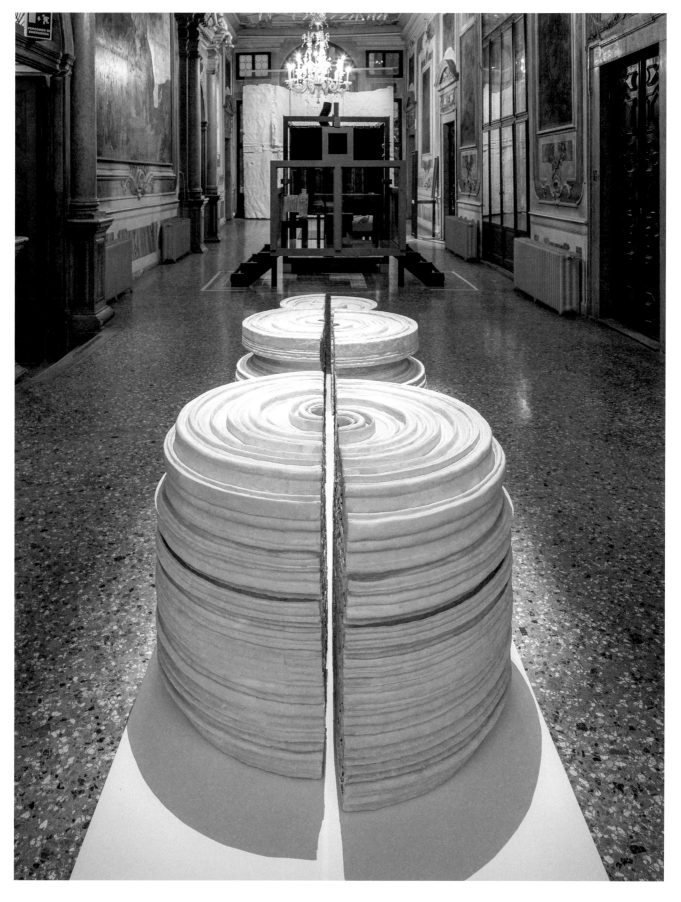

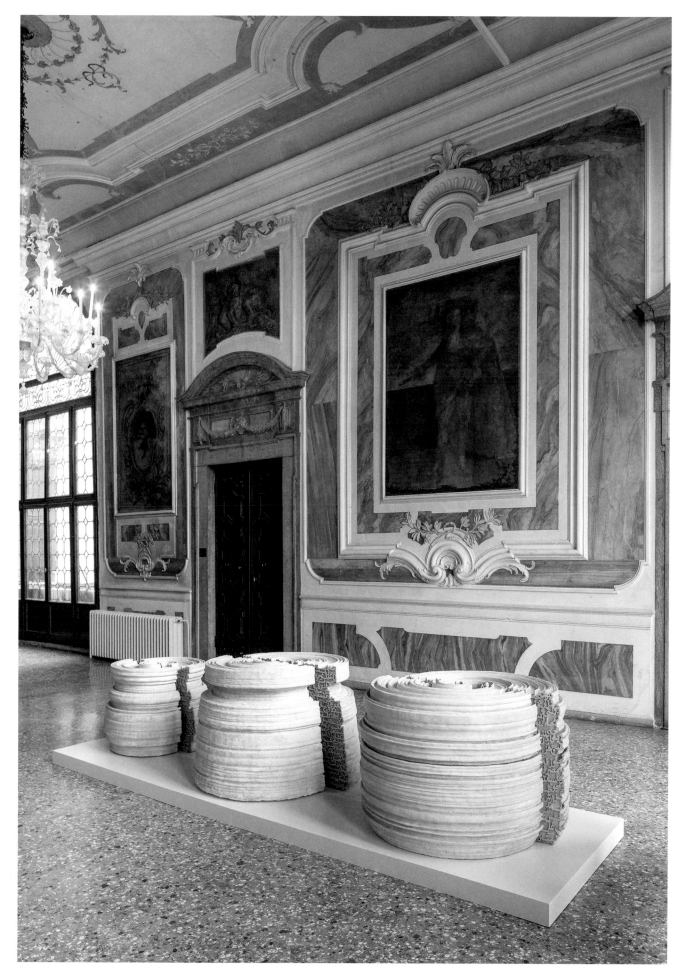

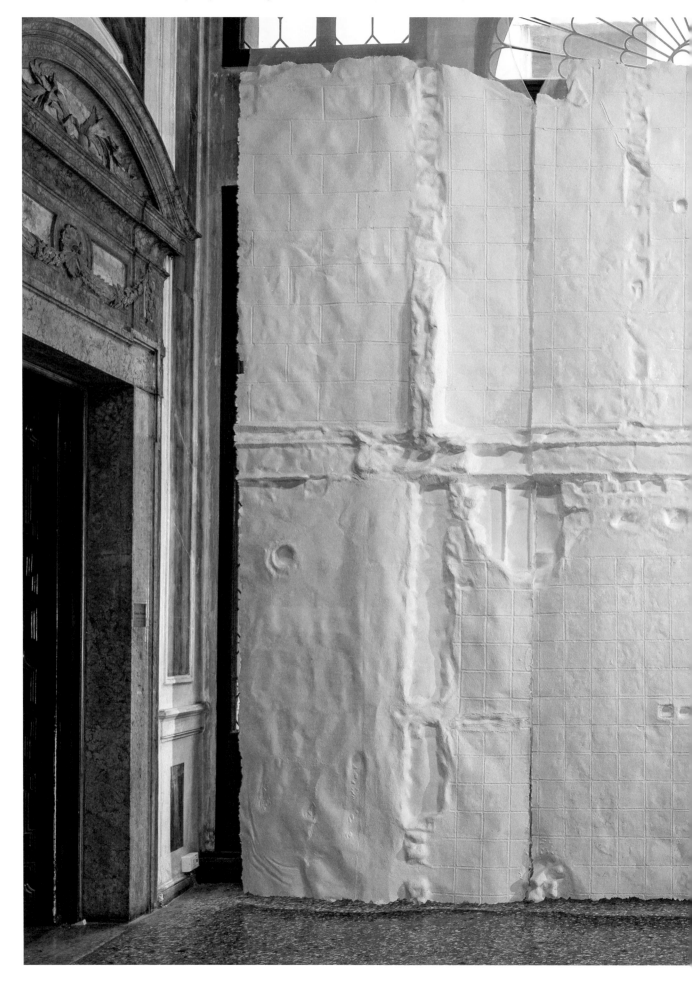

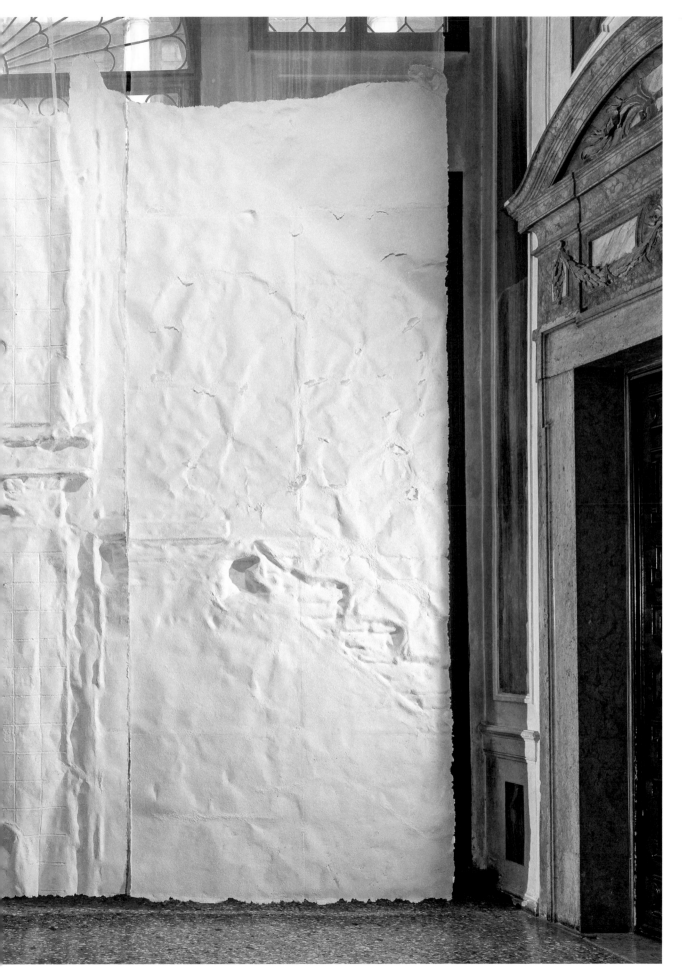

54
Meeting Places

JOHN YAU

Siah Armajani is an artist interested in meeting places and passageways, walking and sitting, movement and reflection. His vocabulary consists of chairs, tables, lecterns, bridges, stairs, lighting, and literary inscriptions. The things he constructs tend to serve multiple purposes, including an actual function and a metaphorical one. The interplay of the literal and figurative is a central feature of Armajani's civic-minded, socially conscious aesthetic.

At 115.5 metres (379 ft) long, his *Irene Hixon Whitney Bridge*, 1988, in Minneapolis, Minnesota, where he has lived for many years, spans 17 lanes of highways and streets, literally connecting the Minneapolis Sculpture Garden with Loring Park. Within this physical joining, Armajani makes other connections, such as bringing together three different architectural structures of bridge: the truss, arch, and suspension. All three types played important roles in the history of Minneapolis-St Paul and the joining together of the major metropolitan area built around the Mississippi, Minnesota and St Croix rivers in east central Minnesota.

Dreaming up as well as making things at vastly different scales, he has made drawings and plans for impossible-to-realise projects. In addition to bridges, plazas and other large public spaces, he has made smaller pieces, ranging from large enough for one or two individuals to occupy to small, discrete models that can be held in one's hands. Drawing inspiration from Russian Constructivism, Bauhaus design, American Shaker furniture and architecture, and vernacular architecture, he has made works that are simultaneously serious and whimsical, direct and allusive.

His *Bridge Over Tree*, built as a temporary structure in 1970, gracefully steps over a lone tree growing in a field. After ascending and descending over the tree and travelling a short distance, Armajani's bridge comes to a complete stop. The absurdity of the project stirs up many possible readings, from gently mocking art that takes itself too seriously to acknowledging mankind's blinkered vision. I think one important way to understand *Bridge Over Tree*, can be gleaned from a statement Martin Heidegger made in his essay, 'Building Dwelling Thinking', 1951.

> Mortals dwell in that they save the earth – taking the word in the old sense still known to [Gotthold Ephraim] Lessing. Saving does not

only snatch something from a danger. To save properly means to set something free into its own essence. To save the earth is more than to exploit it or even wear it out. Saving the earth does not master the earth and does not subjugate it, which is merely one step from boundless spoliation.[1]

Heidegger's essay was one of the inspirations for Armajani's project of architectural models, *Dictionary for Building*. In this large body of work, Armajani ruminates over a problem that Heidegger explores in his essay: what is the relationship between the words, 'building' and 'dwelling'?

In *Bridge Over Tree* and *Irene Hixon Whitney Bridge*, Armajani reveals his willingness to explore Heidegger's sense of 'dwelling' and 'saving' for the good of the earth and of the community. This understanding of 'saving' is one of the motivating impulses in Armajani's civic-minded, socially conscious aesthetic.

Armajani has dedicated a number of works to anarchists, poets, and philosophers, as well as made an anti-war sculpture, *Fallujah*, 2004–2005, [p. 56] in response to the American invasion of Iraq. He also commissioned his friend the poet John Ashbery to write a poem for the *Irene Hixon Whitney Bridge* project. Not surprisingly, Ashbery's untitled prose poem is full of opaque sentences. Seen as raised metal letters, the disconnected lines are found on different architectural elements of the bridge. Depending on where we have stopped, while crossing the bridge, or in which direction we are looking, we might read, 'This far, it is fair to be crossing, to have crossed.', 'Driving us to say what we are thinking.', or 'Not a conduit (confluence?) but a place.' Ashbery's lines invite pedestrians to give his words a context, to connect the separated lines to their own life or to the view before them or to both.

The multiple functions and evocations that we find in Armajani's works stem from his conviction that art must serve a purpose, even if only as ornament. And yet, in contrast to the belief that ornament is extraneous, Armajani believes it is fundamental. This understanding of the relationship between ornament and function has its roots in the artist's childhood and upbringing. Born in Tehran, Iran, in 1939, he has often recounted that he grew up in a house full of books and fell in love with poetry at an early age. In 1960, during pro-democracy protests against the Shah,

and with his father understandably worried about his politically active son, Armajani enrolled in Macalester College in St Paul, Minnesota, where he would go on to study philosophy. Ever since he was a student, Minneapolis has been his home base. And yet, even while living and working in the American Midwest for nearly sixty years, Armajani carries with him an awareness that in Islamic art, which is almost completely non-figurative, the calligraphic inscriptions seen as inlaid tiles in a mosaic, for example, serve a variety of purposes – as ornament and prayer, proverb or instruction.

In *Hall Mirror with Table*, 1983–1984, [p. 61] which is made of bronze, mirror, and painted wood, Armajani layered words into the metal frame that surrounds the table and mirror. The words, based on Ralph Waldo Emerson's writing in 'Art', Essay XII, 1841,[2] read:

> If history were truly told if life were nobly spent it would be no longer easy or possible to distinguish the fine arts from

> The useful arts it is its instinct to find beauty in new and necessary facts in the field and road-side in the shop and mill

Armajani set the two layers of cut-out letters in an open trough-like frame that forms a metaphorical window-doorway. The top, smaller layer of words are green, while the bottom, larger layer is golden-bronze, the same colour as the structure. Along the top of the frame, we read the green letters, 'IF HISTORY...'. Armajani is inviting the viewer to reconsider the nature of history – can it be told 'truly'? Can life be 'nobly spent'? Can life and aesthetic appreciation merge so that the 'fine arts' and the 'useful arts' are one? This strikes me as the creed Armajani chooses to live by. It is what guides his choice of projects, and motivates all his decisions. He is not interested in art-for-art's sake nor in making work the content of which is purely social or political.

Behind the structure as well as framed by it, viewers see a table and mirror. We are not meant to merely examine our appearance in the hallway mirror before stepping out into the world. Rather, Armajani is asking us to think about the way we exist in the world and how we think of the objects around us. Are they there only because of their function? Is it because we think they are beautiful? Beyond their immediate purpose, what role do they have in our lives?

Siah Armajani
Bridge Over Tree, 1970/2019
Wood, steel, evergreen tree

Siah Armajani
Irene Hixon Whitney Bridge, 1988
Steel, paint, wood
115.5-metre (379-ft) steel-truss construction

If the transcendental optimism of Emerson was a source for *Hall Mirror with Table* and other works, Armajani's *Edgar Allan Poe's Study*, 2008, [pp. 57–60] a large elevated room, the entrance to which is locked by a shut gate, might seem the opposite. Denied entrance, we become estranged voyeurs staring into, as well as walking around, a constructed room, which is divided in half by a muslin sheet on which we see three silhouettes of a raven. In one half of this divided room, there is a green painted wooden chair with a coat hanging on the back of it. Poe has left the room, and there is no sense of when or if he might return.

And yet, before we conclude that Edgar Allan Poe's dark tales of claustrophobia and isolation are evoked as the opposite of Emerson's buoyancy, I would remind the viewer of what Poe, the author of 'The Raven' and 'The Fall of the House of Usher', wrote in his essay, 'Philosophy of Composition', 1846.

> When, indeed, men speak of Beauty, they mean, precisely, *not* a quality, as is supposed, but an effect – they refer, in short, just to that intense and pure elevation of soul – not of intellect, or of heart – upon which I have commented, and which is experienced in consequence of con-templating 'the beautiful'.

This is what Armajani seems to me to be after in all of his work. We might also remember that Poe was a writer who – for all of his inventive creepiness and morbidity – was focused on writing accessible tales: he wanted to reach people, even if what he delivered was unsettling.

1 Martin Heidegger, 'Building Dwelling Thinking', *Poetry, Language, Thought*, translated by Alfred Hofstadter, New York: Harper & Row, 1971, pp. 145–61.
2 Ralph Waldo Emerson, *The Complete Works*, 1904, Vol. II. Essays: First Series, XII, 'Art'. Online at Bartleby.com

John Yau, a poet and critic who lives in New York City, was awarded the 2018 Jackson Prize in Poetry.

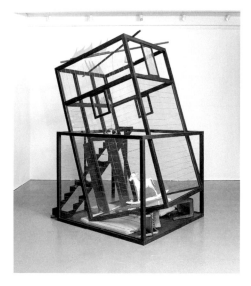

Siah Armajani
Fallujah, 2004–2005
Glass, wood, paint, copper, steel,
rug, chair, table, light fixture, fabric
Overall installed: 505.5 × 331.5 × 381 cm
(199 × 130½ × 150 in)

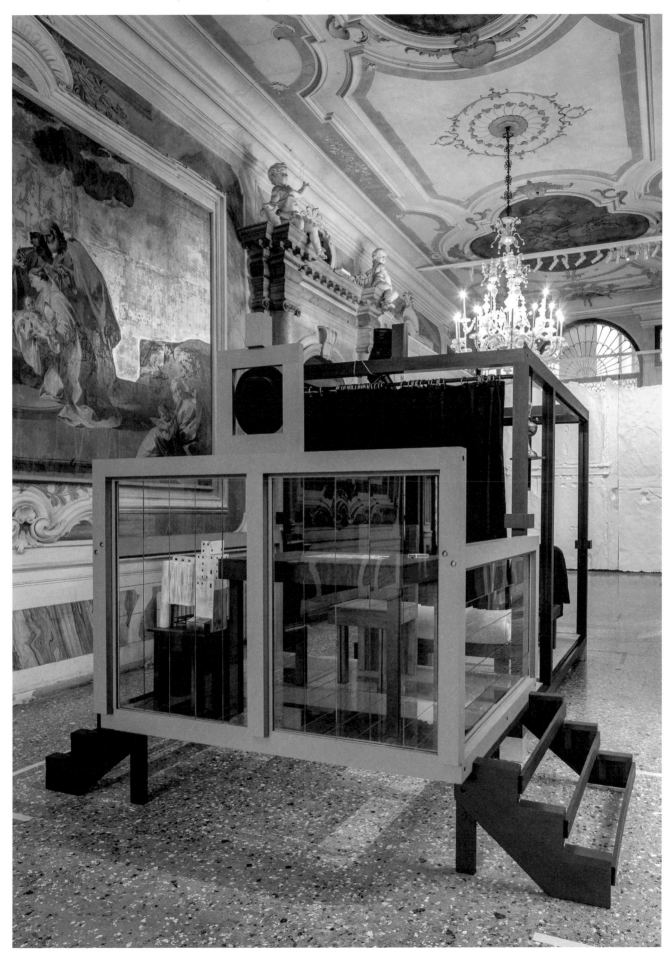

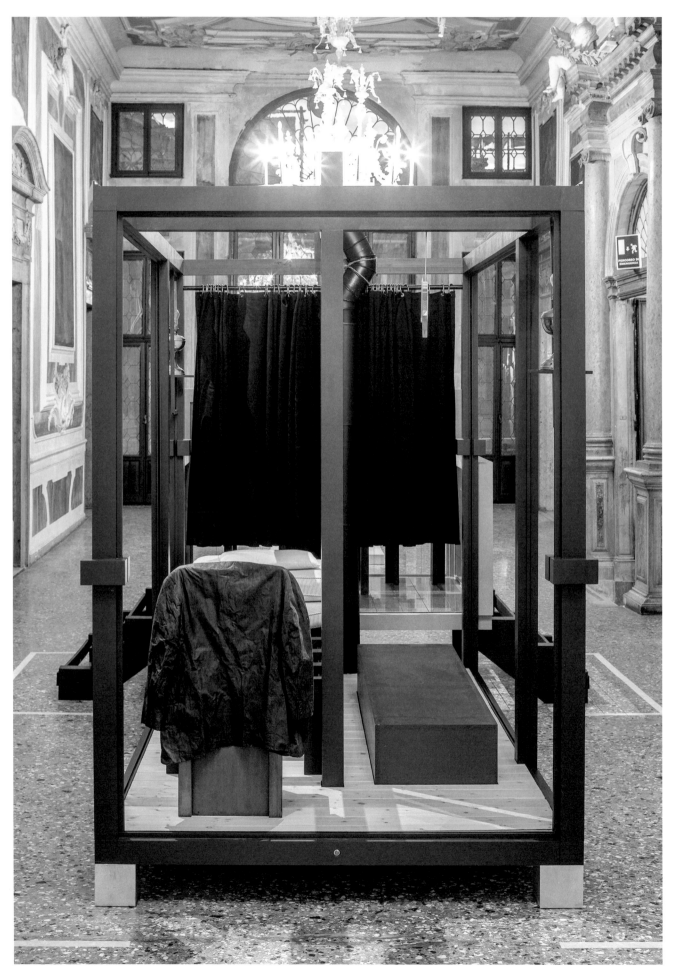

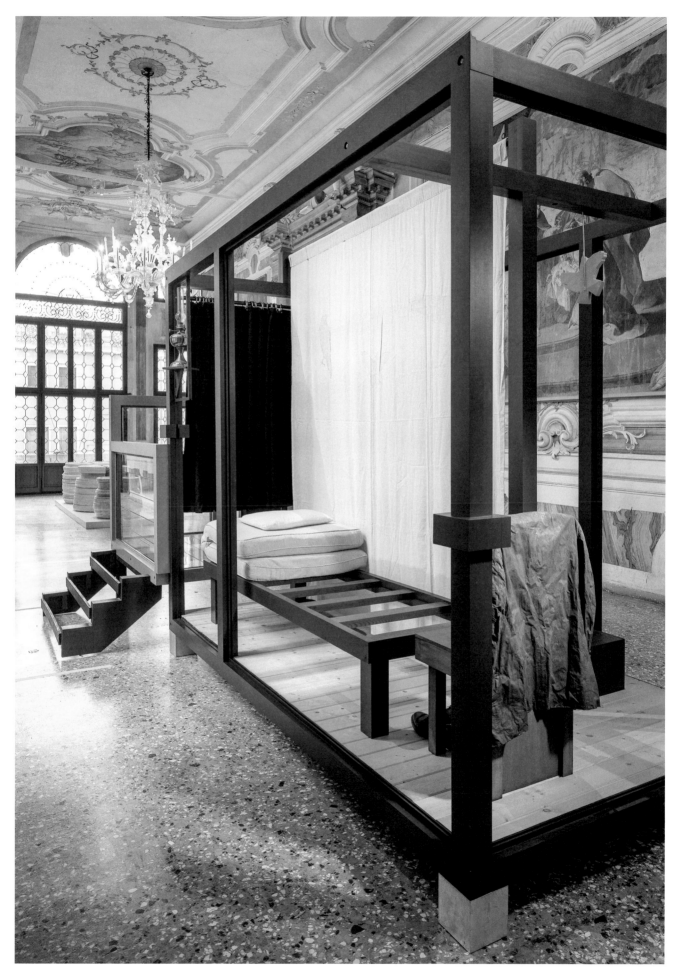

62
In Defence of the Mute Painting

MARYAM MONALISA GHARAVI

In Farahani's film, art viewership, education, and institutional patronage perform an infamous painting which itself remains an unspeaking subject.

In Mitra Farahani's video installation *David & Goliath N°45*, 2014, [pp. 66–67], the viewer watches art spectators during guided tours of the Galleria Borghese, pivotally around the Caravaggio painting *David with the Head of Goliath*, c. 1606. David has killed the Philistine with a slingshot and stone, though they are absent; the killing inscribes itself only in the open wound on Goliath's forehead, and his decapitated remains. Widely thought to be a double self-portrait, the young David-Caravaggio appears emotionally moved as he thrusts forward the slain head of the older Goliath-Caravaggio. Three versions of the painting exist – the one at Galleria Borghese, Rome, is spotlighted in this film. The painting was done in Italy but quickly transported to Spain, where it reverberated extensively on the art there. Though the film does not explicitly discuss the actual handling of the painting – through multiplication, replication, seriality, and shipment – it hones the blade of its analytical power on the way institutions frame art and artists through narrative devices involving difference and repetition. Contrasting storytelling and expert commentaries by the Borghese tour guides versus Farahani's interjections in Persian disrupt the dominant European analyses (and languages) regarding history, fame, and figures of enduring impact. By vexing the relational aesthetics between art institutions, viewers, and the work of art in the public domain, Farahani's film makes a compelling case for the slippery inscrutability of the painting – and of history itself.

Prolonged close-ups on the faces of the group guides and art viewers aggregate the film's unease with the pedantic function of the museum. While one may quickly career past a guided tour – with an éclat of condescension for people who take tours to be instructed about a famous artwork – Farahani's multiple close-up angles on the gallery visitors complicate the triangulated relationship between painting, viewer, and guide. The camera lingers, watching people who watch. What does it reveal? People who care. But even if the spoken contents of the guided tours could be condensed into a couple of Wikipedia paragraphs, the social, embodied nature of the tour 'live' on site turns the painting into a time-based form. Farahani's film

smartly betrays its own intentions, by problematising the work of art in a regulated social space but not making pronouncements or conclusions about it. In one striking shot, a pair of lacquered female hands take iPhone shots of the painting. The yellow facial-detection box of the mobile's auto-identification software first alights on the decapitated head as a face; then moves on to the face of David, recognising him only after-the-fact. The blindness of the algorithm intercedes on art historical concerns over Caravaggio-Goliath and Caravaggio-David, inertly agreeing with art historians about which portrait is the most *real*.

The guides serve not only to direct the patron's eye, but also as interpreters – literally, as they translate the abbreviated Latin transcription on David's sword, H-AS OS or *humilitas occidit superbiam* (humility kills pride) into their respective group's language, and to explicate its significance. One interpretation is that the painting was a gift to Cardinal Borghese, a papal official empowered to pardon Caravaggio's crime of murder, which some guides construe as a plea of guilt and sorrow. The spoken languages of the gallery guides whip in steady succession: French, Japanese, Russian, Italian, and English, a cacophony of voices unwrapping the Latin reference in heterophonic ways. Language, the film seems to suggest, is one filter among many. The mediation and regulation of art historical knowledge in the institution takes place in intermedial forms, primarily audio guides and art catalogues, and other metadata forms of art spectatorship rarely highlighted as explicit templates, and thus largely taken for granted. The film visualises them directly, showing the cords of an audio headset in use in one cut, or patrons browsing a catalogue in the next.

Farahani's own voiceover in Persian plays a distinctly different role. It underwrites not only the fact that the language is not offered as a spoken audio guide, but that the non-diegetically heard Persian language may be acting in collusion with the mute painting itself. All other 'First-World' language sources are diegetically indexed by institutional media. Only the Persian speaks next to, not *for*, the painting.

Farahani's diction moves from an initial command in the tone of the other guides – *'Lisez l'histoire'* – to poetic register, issuing a soft warning to viewers:

'Read history and contemplate the painting. / Which history? / Can you make it out? Who narrates this history? / A story in which small people view big men through the curtains of history.'

Farahani plays with the homophonic *story/history* in French (and English), though those words (*dāstan/ tarīkh*) do not share cognates in Persian. 'A story after whose every performance a curtain falls,' in Farahani's rendition, points to telling and retelling as an accretion, plunging the significance of the painting (and/or painter, here so deeply enmeshed) further into obfuscation. Farahani's voiceover acts in a distinctly different auditory and signifying domain to that of the acoustic guides, whether human or recorded. The Persian language in her hands acts disjunctively, counteracting the narrative seamlessness of the European guides.

What is the consequence of her intervention? For one, the artist circumvents the solidification of meaning. Her interjection in Persian on the thus-far official multilingual (but only European) commentary from the loudspeakers acts like a salve against the hardening of meaning; the diversity of voices within liberal Europe canonise the work of a former *bandito* artist by congealing interpretations of Caravaggio's work. Further, while Farahani's own voiceover is disembodied and non-diegetically inserted into the film, the actual presence of children as art spectators is arguably another preventative measure against solidification, since their senses have not yet been fully institutionalised. Or perhaps not. The sight of children with headphones plugged into audio guides, particularly in French-led tours, indexes the socialisation of artistic viewership. Trained in the lecture style at school, the children listen attentively in the unperturbed aquarium of the pedagogical initiative, whereby the museum justifies its public function through the edification of young minds. (Anecdotally, I am reminded of education practices diametrically opposed to this one, such as in Japan, where children are not told the names of colours before first being encouraged to paint, draw, and experiment with them, prelingually.) In one striking shot, the camera is positioned from the vantage point of a child museum-goer, its low-angle gaze on the docent leading the group. We watch the lecture from the staging of the young girl's eye-ear: *first* the

lecturer, *then* the painting are brought into view. She wears headphones, too; auditory mediation is as multilayered as the visual. Farahani's insistence on the regulation of this eye-ear in art institutions could not be sharper. But the camera is unmoored; the handheld quality softens the edge of Farahani's critique. All artists are inculcated in the system through which their works are viewed and consumed in the public arena. The indexical quality of relational aesthetics points to something which in turn points to something else. That inculcation may extend to this very essay: *about* a video *about* museum aesthetics *about* a painting.

It is not that the institution and its people (after all, the docents are 'stars' in the film as much as the painting, stand-ins for the institution, which is not figurable in any other way) are *wrong* about the framing of the painting, but that their discourses escape reflexivity. They mark their own authoritative positions as regulators of the work's meaning. In Farahani's film, art viewership, education, and institutional patronage perform an infamous painting which itself remains an unspeaking subject. While the relational aesthetics surrounding the painting perform fidelity, the painting itself exists as an ontological betrayal. The hero Goliath whose head has been destroyed is revived with 'seven heads', a hydra risen from the scene of extreme violence – 'like the fragments of history itself', Farahani notes. Her thesis that not only is history a spiral, without a head or tail, but so too is the history of art ('Is this the beginning of our story or the end?'). The film ends on a stylised loop, referencing its beginning. The muteness of the painting is not an attribute of mere formalism, in that the only sense a work carries is contained within itself. Instead, the mute painting in Farahani's estimation bears witness to history made by the victors, not the vanquished. That the film is constructed in the documentary vein but interjects with the author's premonitions about the entanglements of *story/ history* only emphasises her case. 'Painting is remembered gesture that's lost its tongue. And now this tongue has lost its head.' While the museum and its constituent parts create the live theatre of art, the mute painting speaks eternally louder.

Maryam Monalisa Gharavi is an artist, poet, and theorist living in New York.

64 *We are never sufficiently sad to improve the world.*
For E. Canetti. Signed by Jean-Luc Godard, 2019
Golden sheet and oil on canvas. 230 × 155 cm (90½ × 61 in)

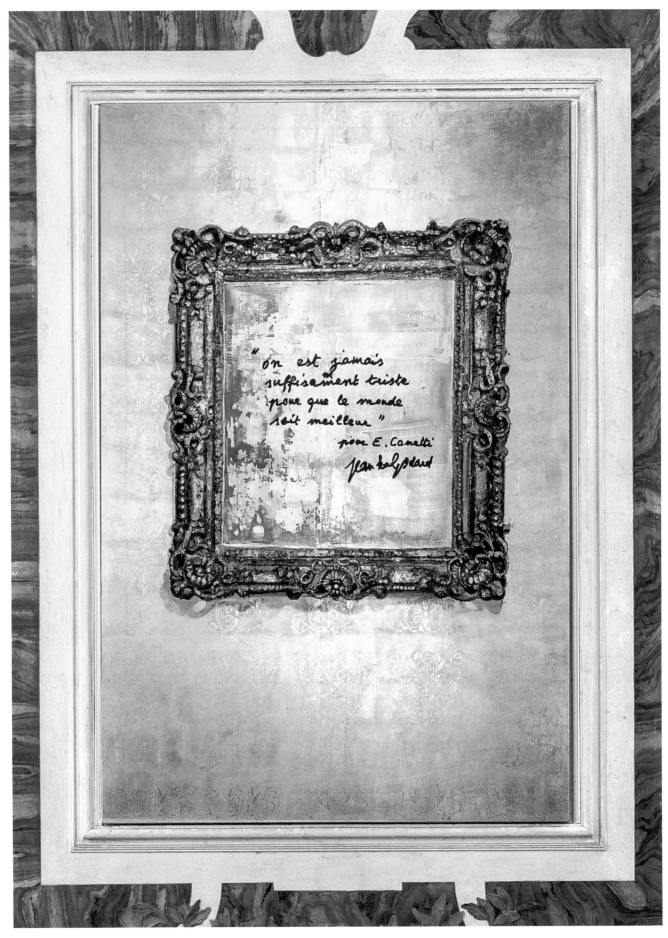

This means humility will defeat pride,

The 'Abandoned Equivalent' Abstract Forms and Concrete Shapes in the Works of Sahand Hesamiyan

MAHAN MOALEMI

Geometry is Sahand Hesamiyan's medium. Trained as a sculptor, his works are characterised by a diverse treatment of Islamic architecture and its underlying sacred geometries, from *muqarnas* to *mandala* and everything in between. Immersive spatial compositions are deconstructed into porous shapes that, nonetheless, remain solid and stable. These calculated shapes both inherit a sustainable state of inner order and actively engage their surroundings in a set of dynamic relationships. Whether hosted by the interiors of an artspace, a sculpture garden, or the urban outdoors, Hesamiyan's works propose the overlapping of different modules and templates within one and the same space. For him, geometry is a tool for navigating the nuanced oscillation between the states of durability and changeability, which is pursued in aesthetic, spiritual, and historical terms.

Revived from centuries of tradition, each shape is then unveiled from within, which Hesamiyan says is to 'peel those architectural layers off, in order to open the inner structure to the viewer'. This points to how Islamic design, drawing and elaborating on ancient Greek geometry, also developed in correspondence to Sufism, especially its understanding of an 'inner core' which is both associated with 'spirit', the 'meaning' of life and the world in the sense of an existentialist metaphysics, and 'a clear form' that draws on the outward exposition and clarity of distinct shapes. In this sense, the capacities of Islamic geometric design allow one to start with basic assumptions and build up a remarkable number of complex formulations of various familiar or unprecedented shapes.[1]

Such an approach to geometric formalism is reminiscent of 'spiritual concerns among many artists in the classical avant-garde working with abstraction'.[2] Both within and beyond the terms of Islamic art and architecture, Hesamiyan's works also engage with the fundamentals of abstraction in art, 'characterised by the co-existence of ideal and matter, transcendentalism and structuralism'.[3] In this sense, a fundamental distinction between abstract forms and concrete shapes comes to the fore – spiritual mindscapes where only abstractions reign, on the one hand, and the material realm of metrics and scales, on the other. The distinction is not an essentialist one, since it keeps reconstructing itself from one work to another and as each work operates as part of a larger process that remains ongoing in principle. 'By making the abstract concrete,' in the words of Liam Gillick, 'art no longer retains any abstract quality, it merely announces a constant striving for a state of abstraction and in turn produces more abstraction to pursue.'[4]

Nahankhane, 2017, [pp. 134–139] displays this process through doubling and rescaling, harnessing and entertaining how abstraction is endured through a 'constant striving'. In this work, the exposed structure of a modular reinterpretation of the dome holds 'its abandoned equivalent' deep inside, to stay with Hesamiyan's own choice of words. The title translates as 'adyton', the small and enclosed space at the farthest, more inaccessible end of a temple, originating in ancient Greece. The space specifically hosted solitary prayers, in the presence of idols or other cult depictions of the deity. Correspondingly, the comprehensive order of *Nahankhane*'s larger shape is both repeated and withdrawn; it amounts to a comparative geometry, navigating deduction and induction on equal terms, wherein one shape is not exactly drawn away from the other but more like absorbed into it.

The etymology of abstraction, of course, originates from the Latin *abstrahere*, literally standing for drawing away or withdrawal. Encountering the geometries of Islamic art and architecture, the abstract mark of withdrawal is often understood in the sense of aniconism, simply put on various forms of portrayal and material representation. However, this is to reduce the capacities of a rich geometric medium to the religious condemnation of idolatry, while overlooking the material shadows or afterglows of that which remains abstract and can find contemporary resonance in the image of various abstractions to

come. 'Abstraction', Gillick writes, 'is not the contrary of representation – rather abstraction in art is the contrary of the abstract in the same way that representation is the contrary of the real.'[5]

The correlation between Islamic-inspired geometric abstraction and material representation is contained in *Forough: Enlightenment*, 2016. Commissioned by the Culture Cities of East Asia project, this site-specific work was exhibited outside the Kōhfukuji Temple in the Japanese city of Nara. The ancient capital of Japan in the Nara period (710–794 CE), the city is located in southern Honshu and through the city of Osaka has been linked to the maritime Silk Roads and therefore developed as a cultural hub where Japanese, Chinese and Korean influences came together, as well as being a religious centre of significance both for Buddhists and Shintoists.

Hesamiyan expands on this chain of filiation, from the far east to the Persian end of the Silk Roads, and develops a certain strategy of inter-regional representation that accounts for the diversity and vibrancy of culture in the territories connected via this ancient network of trade routes. It is in the image of a lotus flower that various cultural references are contained and carried across this particular context. The motif appears in reliefs on the walls and monuments at Persepolis, eave-end tiles used for roofing Japanese temples, as well as on a Sassanid glass bowl with cut facets held among the imperial treasures of the Shōsōin, a log storehouse of Tōdaiji Temple in Nara. Historically, the lotus flower has not only been pictured with varying degrees of abstraction, but has also served as an abstract form itself, a spirit beyond territorial demarcations, symbolising a move away from dross and darkness and towards purity and enlightenment. Hesamiyan's signature employment of geometry absorbs the symbolic abstraction of lotus, while also pointing out its history as a cultural representative.

The dovetailing of geometry and cosmology in Hesamiyan's work amounts to a cosmometric world-view, which entails the study and application of the patterns, structures, processes and principles that are at the core of all manifestation in the universe, both physical and metaphysical.[6] The dialogue between divinity and human models of the world bears particular significance in contemporary times. Augmented realities and immersive virtual environments are supposed to help humans develop narratives that can cope with today's reality of complex abstractions. 'Never before have industry and technology, or even business and advertising, been as loaded with metaphysics as they are today,' writes Mikhail Epstein.[7] Similarly, Hesamiyan's use of parametric design softwares and the industrial texture of his productions contribute to a rethinking of technical and aesthetic traditions, investigating the basis of being-in-the-world in all its abstraction and beyond its phenomenal appearance.

1 See Eric Broug, *Islamic Geometric Design*, London: Thames and Hudson, 2013.
2 Maria Lind, 'Introduction', *Abstraction*, Cambridge, MA: MIT Press, 2013.
3 Ibid.
4 Liam Gillick, 'Abstract', 2011, at http://www.liamgillick.info/home/texts/abstract
5 Ibid.
6 In the same line of analysis, and as a counterpart to cosmometry, the relevance of geology to Hesamiyan's practice seems noteworthy too.
7 Mikhail Epstein, 'The Art of World-Making', *Philosophy Now*, Issue 95, March-April 2013.

Mahan Moalemi is a writer and curator from Tehran.

Forough, 2016. Stainless steel, gold leaf, electrostatic coating
Each of two parts: 290 × 248 × 248 cm (114¼ × 97¾ × 97¾ in)

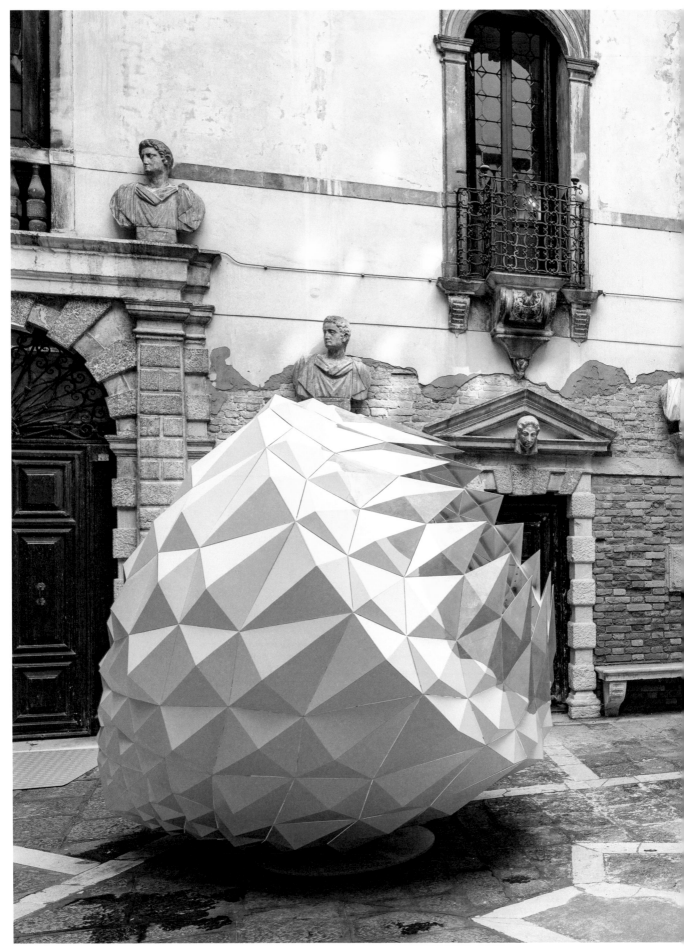

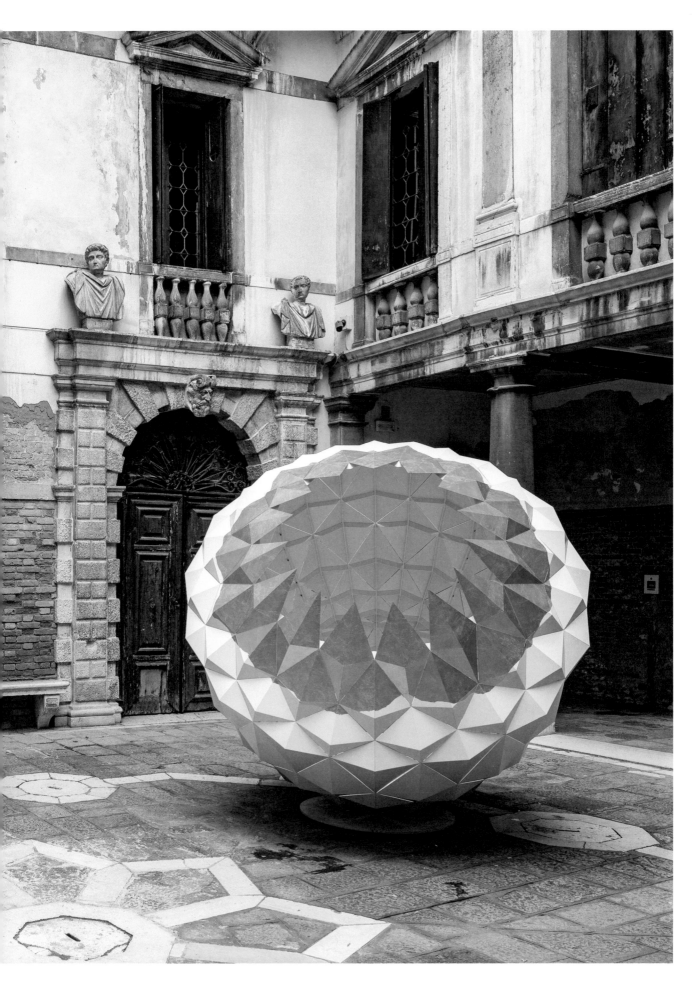

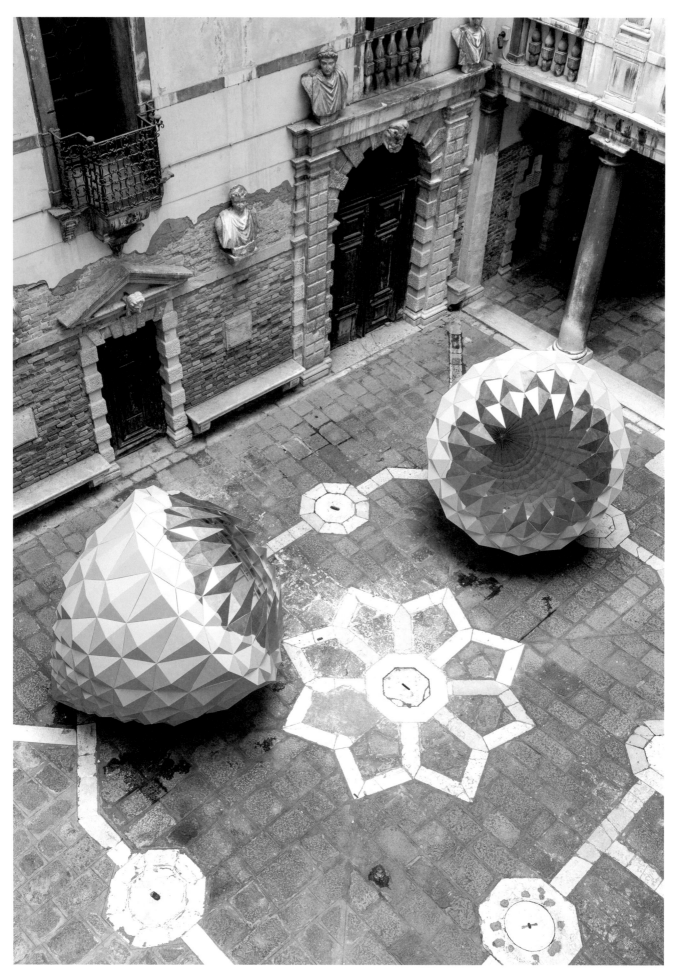

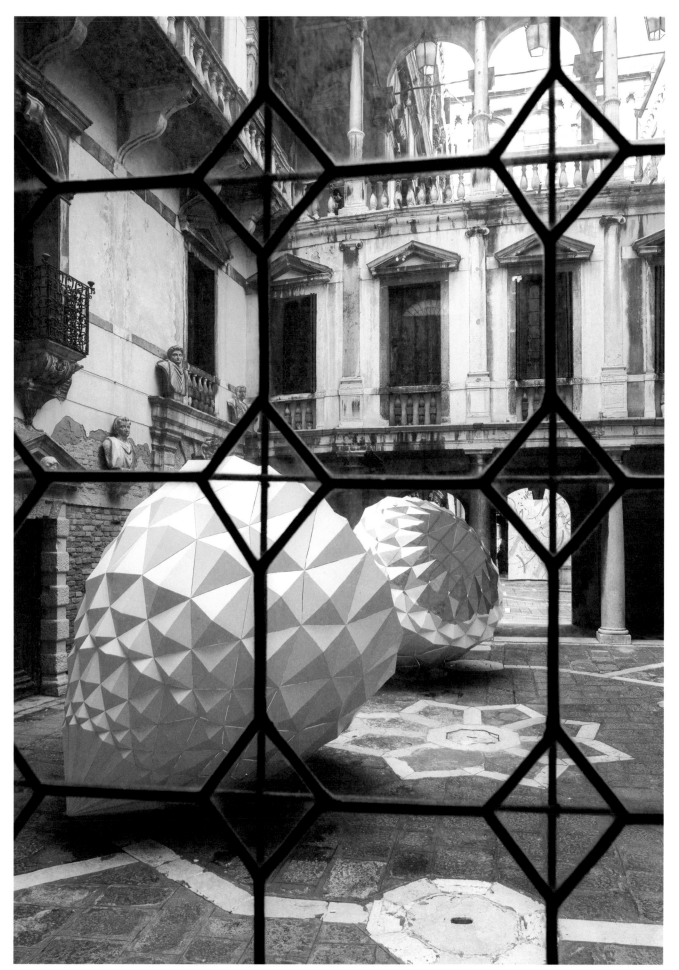

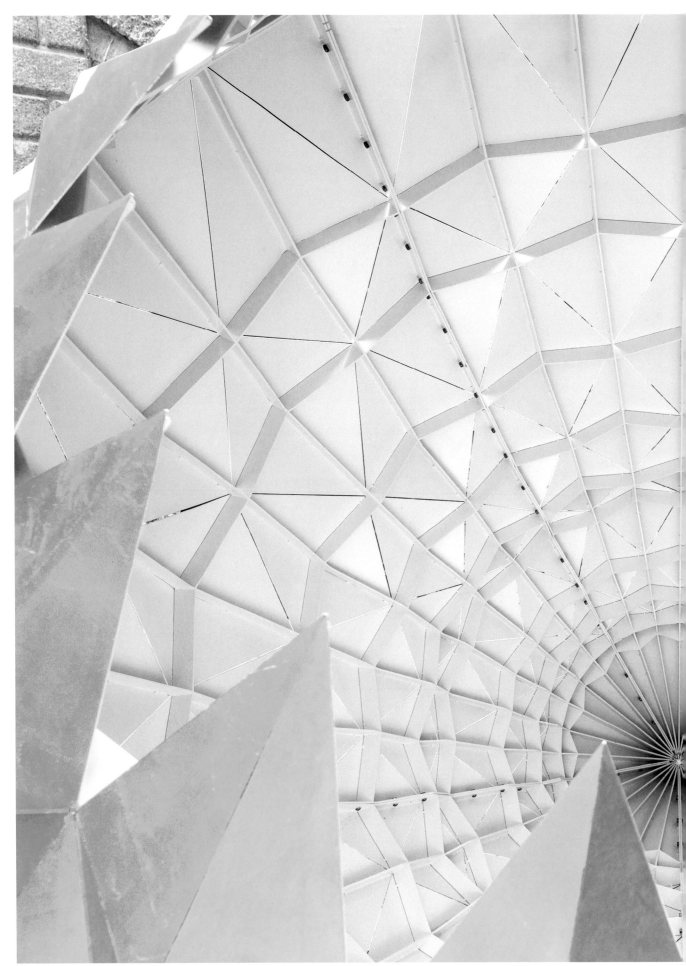

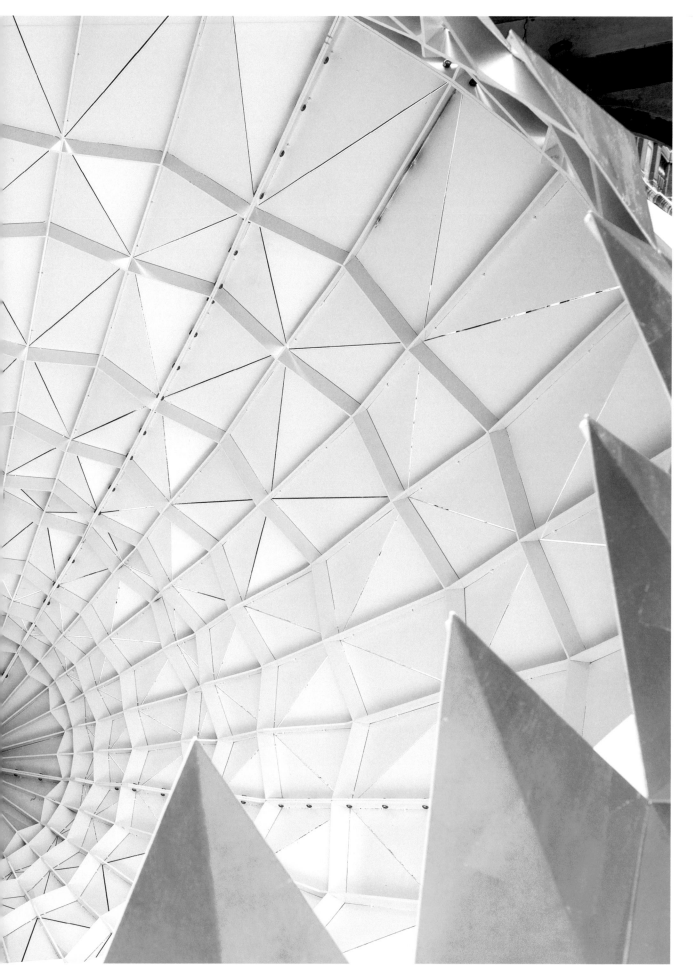

Otherworldliness and Light

JOHN YAU

Y.Z. Kami is an artist whose work can largely be divided into two distinct groups: large-scale portraits and closely hued, multi-faceted abstractions. Derived from snapshots taken by the artist, the portraits confront the viewer with a precisely blurred image of each subject's impassive face. The colours tend to be muted, as if bleached by the light. The abstractions, or what the artist calls the *Dome* paintings, consist of concentric circles of closely hued, tessellated shapes set within a square format.

Placed on adjacent walls in an exhibition, the portraits and the *Domes* inspire different kinds of looking and open up a mental space where viewers can reflect on how they perceive their everyday life. The most obvious difference is that the portraits invite a prolonged scrutiny that is not possible in the real world: we would never be able to examine a stranger so slowly and carefully.

At the same time, the portrait's blurred state establishes an unbridgeable distance between viewer and subject. One could say that in Kami's portraits, the sitter always remains aloof. The figure seems to be suspended in a matte haze that is reminiscent of wax. It is as if the face is both a memory and a close-up view that is impossible to see clearly. Rendered neutrally, it is open to our intense scrutiny yet remains remote, a visual paradox that is likely to stir up a host of associations about time, its ceaseless passing. The use of pale and muted hues against a uniformly off-white background conveys a soft enveloping light that is inseparable from the subject. Is this an inner light, an atmospheric one, or both?

Often, the eyes of Kami's figures are closed or cast downward, underscoring their emotional distance from our inquiring gaze. We can see them, but they have withdrawn from both the world and us. Literally and metaphorically, they are inside themselves, vulnerable inhabitants of a private reverie.

Kami's paintings share something with Fayum portraits, which he discovered in the Louvre while a student in Paris, studying philosophy at the Sorbonne. In an interview, Kami stated: 'I was taken by these pictures probably because of the neutral expression in their faces, with their big eyes and their otherworldliness.'[1]

Many of the Fayum portraits were done in encaustic and the colours have not faded over time. Done while the subject was alive, the portrait was attached to the coffin when the individual died.

Although they begin with a snapshot, the otherworldliness of Kami's portraits is one of the features that distinguish his work from the large-scale monochrome portraits done in the 1960s by Chuck Close in a photorealist style. By using a grid to divide the face's expanse into small, tightly packed, manageable units, Close was hyper-attentive to the tiniest details, including facial hair and blemishes. Kami's attention is equally focused, but the results are very much his own.

The uniformly blurry features are comparable to the way our memory works: its exactness is, paradoxically, an approximation. Most of us are unlikely to possess a picture-perfect memory. We remember certain details with crystalline clarity, perhaps, but not the entirety of a person's face.

The blurred state inhabited by Kami's subjects is unsettling. It is as if we can and cannot see them. Some figures seem more blurred and, in that regard, more distant than others. By making it impossible to observe the face in perfect photographic resolution, Kami evokes the changing relationship between memory and seeing, and suggests that there is something about the individual that always remains inaccessible, no matter how closely we can examine his or her face. This is further underscored when the eyes of his figures are closed or cast downward, as if in a state of inward contemplation. Are his sitters pondering the immaterial world? And, if so, have they in some sense come into contact with it?

This is what I find so enthralling about Kami's portraits: they are simultaneously earthly and otherworldly, ordinary and ghostly. As he has recounted in many interviews, he was born in Tehran, Iran, in 1956. His mother was a painter, who often did portraits. It was from her that he learned to paint. As he has also carefully pointed out: his mother learned to paint from Persian masters who had studied in Europe. He literally grew up in the Western tradition of oil painting and was, in that sense, influenced by globalism and cross-cultural exchange. He studied philosophy but always painted. Eventually, he realised that it was his inescapable calling.

The other thing that Kami has often pointed out was that when he was growing up in Iran he read the

poetry of Rumi and Hafez which became lifelong passions. The thirteenth-century Rumi and the fourteenth-century Hafez were Persian mystical poets who wrote about ecstatic states of divine inspiration, often in the form of a love poem addressed to the Other. Here we might remember that the French poet Arthur Rimbaud famously wrote, '*Je est un autre*' (I is someone else). Are Rumi and Hafez's love poems addressed to a human being or a divine spirit or both? It is the same blending of the earthly and the spiritual that lies at the core of Kami's portraits. Without a trace of irony or scepticism, the portraits suggest that we are all embodiments of a spiritual presence as well as earthbound creatures subject to the ravages of time.

The downward glance of Kami's subjects conveys a state of reflective searching, of aspiring to reach a higher state of consciousness. At the same time, the blurred faces convey a state of simultaneous movement and stillness, a soft inner vibration. This hint of movement reminds us that the actual moment captured by the painting is gone, and that the figure has inevitably become older. We can recall a moment from a person's life, the way he or she looked on a certain day or in a certain light, but we cannot return to that moment. Rather, we carry the person's image inside us.

The blurriness also suggests an in-between state of becoming and dissolving. This simultaneity accurately mirrors our journey towards termination. On a physical level, we are always engaged in both processes.

Kami's interest in the relationship between immateriality and materiality, light and matter, also suffuses his abstract *Dome* paintings, their subdued, optical intensity. These paintings invite a different kind of looking, one that echoes the contemplative poses in his portraits. The longer we look at his repetitive, pulsing abstractions, the more we begin to see ourselves looking at their rhythmic, circular structures. The composition's centre point, reminiscent of a domed ceiling or an oculus – directs our attention towards the light, which transmutes us all.

By devoting his time to painting meticulous portraits and repetitive abstractions, Kami is engaged in something akin to praying. Passion and devotion are present everywhere in his work.

1 Ziba Ardalan, 'An Interview with Y.Z. Kami' in Y.Z. Kami: *Endless Prayers*. London: Parasol unit/ Koenig Books, 2008, p. 39.

John Yau, a poet and critic who lives in New York City, was awarded the 2018 Jackson Prize in Poetry.

Y.Z. Kami
White Dome IV, 2010
Acrylic on linen
177.8 × 195.6 cm (70 × 77 in)

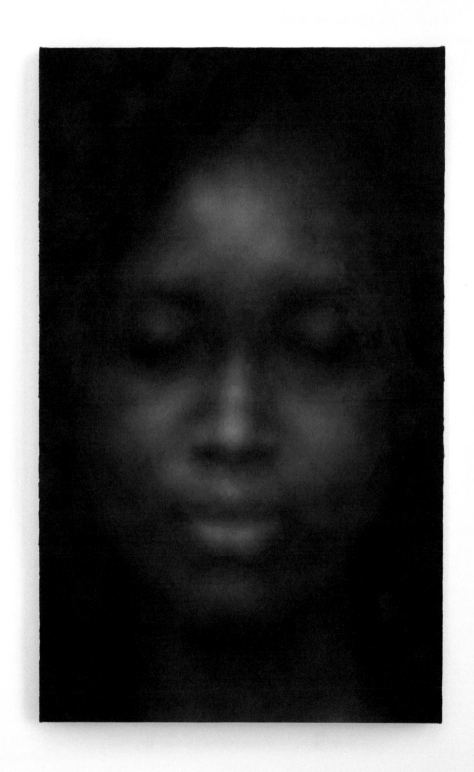

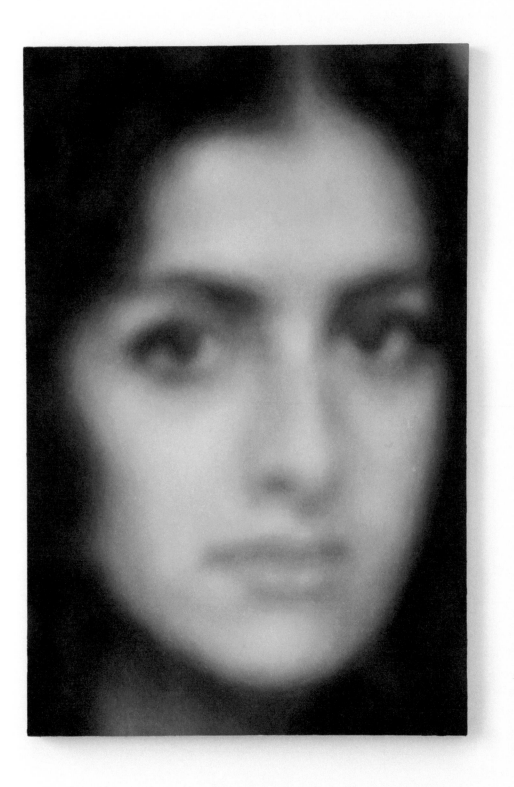

Chronicle of a Death Retold

MARYAM MONALISA GHARAVI

Farideh Lashai's When I Count, There Are Only You… But When I Look, There Is Only a Shadow, *restages Goya's indictment of the dehumanisation of war by orchestrating an animated encounter between the redaction and recovery of historical violence.*

In the golden age of American syndicated animation series for children, when Bugs Bunny and Road Runner outplayed their slow-footed Looney Tunes counter-parts, cascading background cells created landscapes on which the animated figures appeared. The cells staged static, even sublime scenes, while the figures – squirreling into holes in the ground, errantly thwacking off shotguns into the air, exaggerating facial tics and bloodless, impermanent deaths – sprang to action in the foreground. Farideh Lashai's multimedia installation *When I Count, There Are Only You… But When I Look, There Is Only a Shadow*, 2012–2013, [pp. 84–85] initially brings to mind these background landscapes, staid and scrubbed of any evidence of life. (The work also recalls Muybridge's 1878 horse in motion, the first celluloid animation, and one also linked to experiments in photographic manipulation.) But soon the work reverses their laws. Landscape acts as a camouflage for the violence to be rehearsed and reconstructed upon activation. The scenography of violence both proceeds and retreats in the beam of projected light, suggesting the erasure and re-inscrip-tion (and erasure again) of historical memory. What and how and when do we remember? And to whom is that remembrance served? The work is a master suite of lost violence regained, and like the work it reprises, an indictment of the dehumanisation of war through the orchestration of an animated encounter between the redaction and recovery of historical violence. Like actual violence, this particular representation of violence is aware of the myth of closure. Loss, grief and horror may be out of view in one instance, but they threaten to reappear unheeded in the next.

When I Count is an unlikely remake. Lashai recreates 80 of the 82 engravings of Francisco Goya's *Los desastres de la guerra (Disasters of War)* in photo-intaglio prints, with a projection of animated images alighting on them. In intaglio, a design is carved or recessed into the surface of a metal plate. When the plate is wiped clean, the ink remains in the engraving. This erosion-like process harmonises precisely with

the form of this piece, which relies on the accretion and subtraction of animated figures foregrounding violence on static exteriors in stark shadows. In Goya's source work, strewn and deformed human body parts hang in trees. The aftermath of torture, invasion and militarism is neither abstracted nor romanticised in swirls of battle scenes. Instead, human bodies, wrenched into separated hands, heads, flesh and trunks, litter an indifferent landscape.

While the events depicted mark specific melees, includ-ing the 1808 Dos de Mayo uprising in which *madrileños* fought occupying Napoleonic forces, the subsequent art historical impact of the prints lend them an uneasy universality. Goya who started his work in 1810, aged 62 and nearly deaf, went on to create it over the course of a decade. The prints, unpublished during his lifetime, were made public 35 years after his death. Employed by the Spanish crown, his suppression of the prints could be framed as an act of radical self-censorship.

At first, Lashai's restaging makes these landscapes appear without figures or bodies. Then, a moving digital spotlight reinserts animated body parts onto the scenarium. As the spotlight slowly bounces around the field of vision, the figures appear and dissolve within its halo. The dance of occlusion and recovery, obscurity and remembrance plays out in haptic swaths of light ricocheting over the topography. Lashai's restaging is a maverick elaboration and not a straight-forward recreation of the *Disasters of War*. Her treatment of violence made present and absent can be characterised as photojournalistic in the best sense, advancing no stable narrative, overdrawn cause-and-effect framing, or redemption of state violence. Instead, *When I Count* posits redaction itself as a signal of greater danger: historical amnesia, in all its isolated and selective varieties.

What is equally exciting about this work is that it usurps something *fixed* (the landscape, at first emptied of Goyan disfigurations) and animates it with some-thing *live* by the use of digital light projection. The activation of the prints by a light-projected source turns an otherwise 2-D still scene into a complex synecdoche, each moving orbit of light in connective affinity with the whole. This activation, driven by

the interdependent relationship of fixed prints and activated spotlight, re-imagines highlighting (i.e., literal strobing) as a technique whereby unseen violence reactivates from a formerly dormant state, even if in a temporary flash of recollection. In subtracting the human figure and then revivifying it, Lashai's tableau makes the panorama of war not pictorial background but the main subject. The projector's digitised mask lingers, bounces, and speeds up over the images in non-sequential order. If the original Goya suite represented several vestiges of human catastrophe, from Napoleonic occupations to French Imperial repressions, in Lashai's hands – or eyes – they shuffle along the vortex of human history as non-linear historical scenography, the root causes of the trouble indistinct and perhaps interchangeable. Inside the cells of the digitised projections, 'dead' or mordant figures come to life. Figural animation enlivens the cells as palpable and moveable, beyond the immobility of *les arts plastiques*, making them closer to us in time. That chronological sync is on a par with cinematic time, or what I will call the time of live film.

Live film draws on both the fixity of matter and material and the aliveness of performance. Since it is time-based, sequence and seriality matter. Lashai's choice of montage in the treatment of her subject is poignant because the activation of cells (static backgrounds to animated scenes) happens right before our eyes, in real time. Meaning is created in multivalent ways, both between and among the figure-less landscape prints and in the optical mask reinserting figurations of violence. The redaction of violence – through wilful indifference or state suppression, a tragic either/or – in her work leaves open the possibility of re-enfranchisement, or recovery and possible reconciliation with the buried violence. This is at least one major departure from Goya's material, in which horrific and unaccountable human decimation is evidence of more of the same: violence so mass-scale that it is equally repeatable. *When I Count* also brings to mind two other works engaging light or video projection and redaction: Paul Pfeiffer's *Four Horsemen of the Apocalypse*, 2006, and Paul Chan's *The 7 Lights*, 2005–07. In the former, the subtraction of basketball players during an NBA game amplifies the spectacle. In the latter, light projection transforms the solidity and chaos of human apocalypse into a floating weight-

lessness. As in those works, Lashai's *When I Count* (its very title referencing the limits of enumeration) stands in sharp opposition to abstract numericism. Besides Goya's *Disasters of War*, the other work restaged in her opus is T.S. Eliot's *The Waste Land*, 1922:

A heap of broken images, where the sun beats,[1]
And the dead tree gives no shelter, the cricket no relief,
And the dry stone no sound of water. Only
There is shadow under this red rock,
(Come in under the shadow of this red rock)

For Lashai, who died in 2013 at the age of 68 in Tehran (after living with cancer for 20 years), the likelihood of shelter and relief in 'a heap of broken images' is diminished. But in her subtle care, the site of shadow offers the satisfying possibility of insurrection.

What are we to make of the artist's life and work as an expansive trajectory of political commitment? A 2013 *Artforum* obituary[2] by Media Farzin turns to the artist's own discourse in the form of a fictionalised memoir *Shal Bamu* (The Jackal Came), 2003, that traces a 1919 public hanging of a dissident reformer, which Lashai's mother had witnessed as child, to 'her own imprisonment for leftist student activism in the early '70s, and the tumult of the Islamic Revolution of 1979 and the street demonstrations she joined while pregnant with her daughter.' Every time a story is written about an artist's political dispositions, with or without apologia, the work stands to counter it. Farzin's obituary renders Lashai's political commitment with appropriate complexity, as both active witness to half a century of state violence and 'fastidiously removed from ideological realities'. That Lashai chose to engage with explicit scenes of political history (not only in the restaging of the Goya suite, but in nearly all apices of her work in her final years) suggests an artist contending with the specificities of violence and loss against the numbing generalities of the nation-state: *these* trees, *these* streets, *these* bodies.

1 The emphasis is mine.
2 *Artforum*, 'Passages', 19 May 2013.

Maryam Monalisa Gharavi is an artist, poet, and theorist living in New York.

84 *When I Count, There Are Only You ... But When I Look, There Is Only a Shadow*, 2012–2013
Suite of 80 photo-intaglio prints with projection of animated images
3:51 minutes | 191.8 × 309.9 cm (75½ × 122 in)

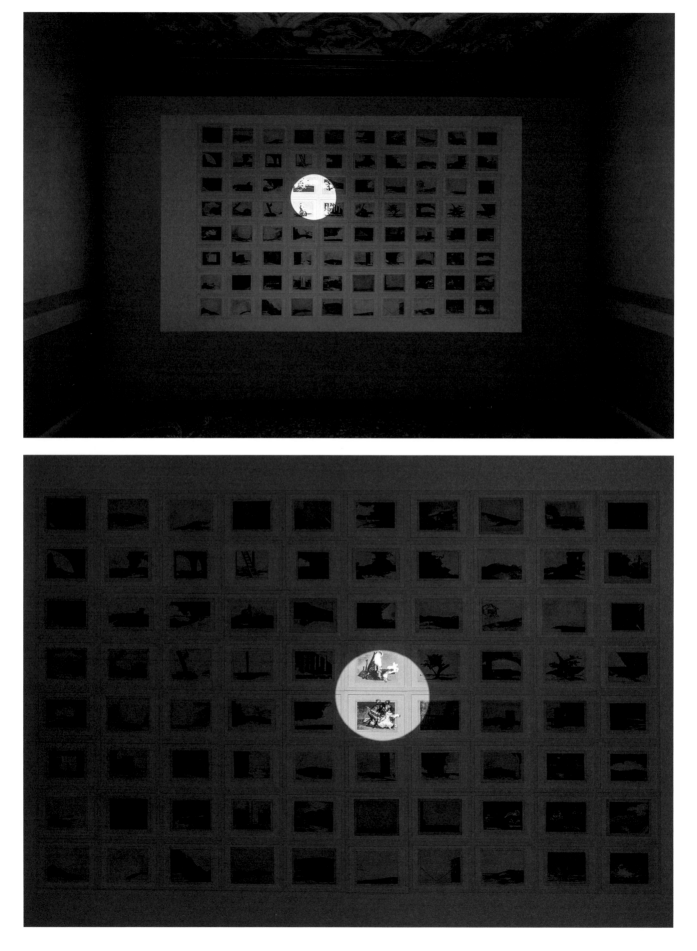

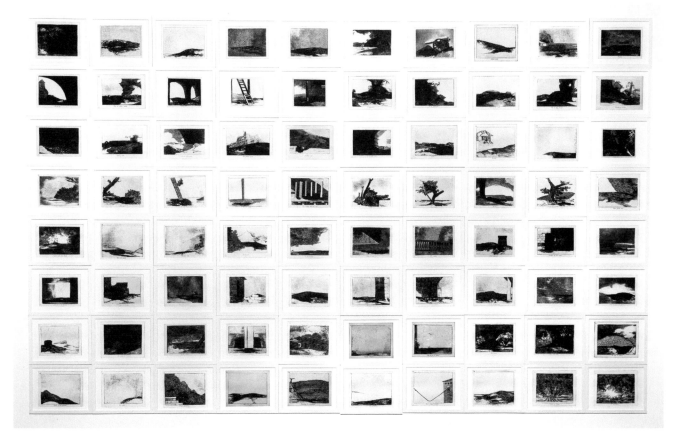

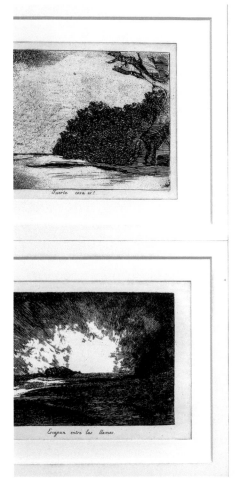

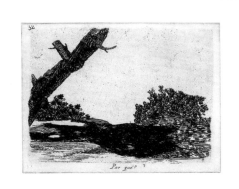

86
On Travelling

OLIVER BASCIANO

My dad, as a salesman for a machine parts company travelled for work extensively. Never to anywhere particularly exciting, but prosaic hotels and grey European cities were a constant setting for much of his professional life. Recently, now retired, he mentioned that he found a particular moment during those trips fascinating. He spoke with slight nostalgia, but mostly relief as he described the few hours at the very end of the last day of a stretch away from home. His meetings were done, what sales could be made had been made. He'd had the hotel breakfast one last time, taken his suitcase down to Reception and asked them to stow it away in the luggage room on checkout. Often with a few hours before his flight, he'd wander about whatever Mitteleuropean city he was in that week. It was these hours that he remembered most, he said, describing a feeling of discombobulation. He used phrases like 'on the trip but the trip was over', 'there but already mentally elsewhere' and 'in limbo'.

That conversation came back to me when thinking about the work of Koushna Navabi. My dad's story is one that comes from a particular place of privilege (I recognise the phenomenon; the art critic covers surprisingly similar ground to the machine parts salesman) being used to make allusion to a body of art that has at its centre a particularly vulnerable subject, the forced migration of the artist. Yet, I make it nonetheless, because Navabi's work is less about the political or even biographical realities of her exile, aged 16, from Iran in 1979 – the year after the country's Black Friday massacre – or her travel first to the US and eventual settlement in the UK, and more of the existential angst that might *forever* keep the migrant in the limbo of a trip that is over but still being felt.

A line from the play *Heauton Timorumenos* (Self-Tormentor) by Terence, *Homo sum: humani nihil a me alienum puto* rings through the work of Koushna Navabi. 'I am human: I consider nothing human is alien to me', also comforted me in making my analogy. For this is not art *about* immigration, or a particular culture, to be only fully understood by the immigrant, or through that culture; there is a universality to it that speaks to human fears the globe over. Yet, of course, there is a complexity to the work that belies the Roman maxim. For all the homeliness in Navabi's use of craft techniques, there is a sense of dreadful alienation that hangs over much of her practice – a constant rub in her work between the familiar and domestic, the violent and the strange.

In *Untitled (Tree Trunk)*, 2017, [pp. 140–145] a female form, complete but for truncated limbs and a gaping hole where the figure's heart might be, has been hewn from a single piece of wood and is suspended with metal wire from the gallery ceiling. It is a macabre image: dismembered and left to hang, a body infused with violence. On the bottom half of the figure the surface of the wood remains rough, the bark missing in parts; yet the woman's upper body and head is covered in Persian kilim, bar an opening for a mouth which appears as if mid-scream. To an extent the presence of the textile softens the image – a reference to Iran certainly, a reminder of 'home' – but with the face obscured it seems less celebratory and more a skin that the body is forced to wear, a reminder perhaps that however comfortable the migrant might be in their newfound country, they are frequently forced to wear the uniform of the outsider. Conversely, the naked lower body suggests vulnerability: the migrant in strange lands, stripped of their moorings. There is a trauma to this othering – and it is an inescapable irony that the western critic writing on the Iranian artist's work will always do it with half an eye to biography and nationality – but in the foregrounding of nature, the work ultimately seeks to escape the prism (prison) of self-reflection to speak instead to a universal essence and earthly commonality. The wire is attached at the navel like an umbilical cord, a reminder of birth (or rebirth) within the death: the comforts of life, always foreshadowing the terror of death.

The artist has often utilised a sense of horror: *Crows*, a large-scale sculpture from 2006, features taxidermic birds given long trailing textile tails that hang down from a bare-branched tree; *Jen (Ogre)*, 2001, spoke to dual identities in its fusion of the taxidermic legs of a llama with two stuffed textile humanoid torsos; a series of early works from the mid-1990s features stuffed textile renderings of human organs. Yet the material sits uncomfortably with the forms, a conjuring of *unheimlich*, of the home, but strange to it.

On the surface, Navabi's subject in *Biskweet-e-Mādar (Mother Biscuit)*, 2019, [pp. 88–93] is a nostalgic one: a popular brand of Iranian biscuits are rendered oversized. The tray a meticulously stitched tapestry stretched over a wooden box frame, with the edible contents reproduced in rough, crumbly-looking, concrete. There should be a Warholian joy to the familiar enlarged, but this work is monstrous in a way. Though the craftwork is beautiful, and the image of

a woman nurturing her baby on the front, sweet, the work unpacks a fraught history. The biscuits predate the Iranian Revolution: before 1979 the woman's head was uncovered. Early television adverts (you can find them on YouTube) show a wholesomely glamorous nuclear family enjoying the snack. Now the woman wears a blue headscarf, a stand-in for the country's isolation as a whole.

Nonetheless, while *Biskweet-e-Mādar* enjoys one explicitly historiographic reading, this work is not about Iran. The biscuits are scattered around on the floor as if spilt, or propped against the walls, like tombstones. Death haunts here too. The work charts a separation from a mother culture – and nods to the artist's own biography – but more than that it speaks of estrangement as being a fundamental force of life, as baby becomes adult, and adult passes on. Navabi's work – complex, packed with dualities, binaries and conflicts – asks questions of settlement and alienation, of the impossibility of stability; the joy, the trauma, of the journey; of being here, but being elsewhere.

Oliver Basciano is a writer based in London. Since 2010, he has worked at *ArtReview* magazine where he is currently International Editor.

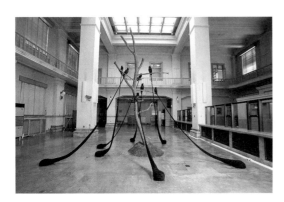

Koushna Navabi
Crows, 2006
Taxidermy crows, textile, sand, bare tree
Dimensions variable
Installation view at *Hiroshima Art Document*, Hiroshima, Japan, 2006

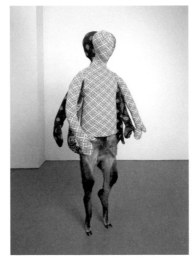

Koushna Navabi
Jen (Ogre), 2001
Taxidermy llama, textile, foam
150 × 90 × 20 cm (59 × 35½ × 8 in)

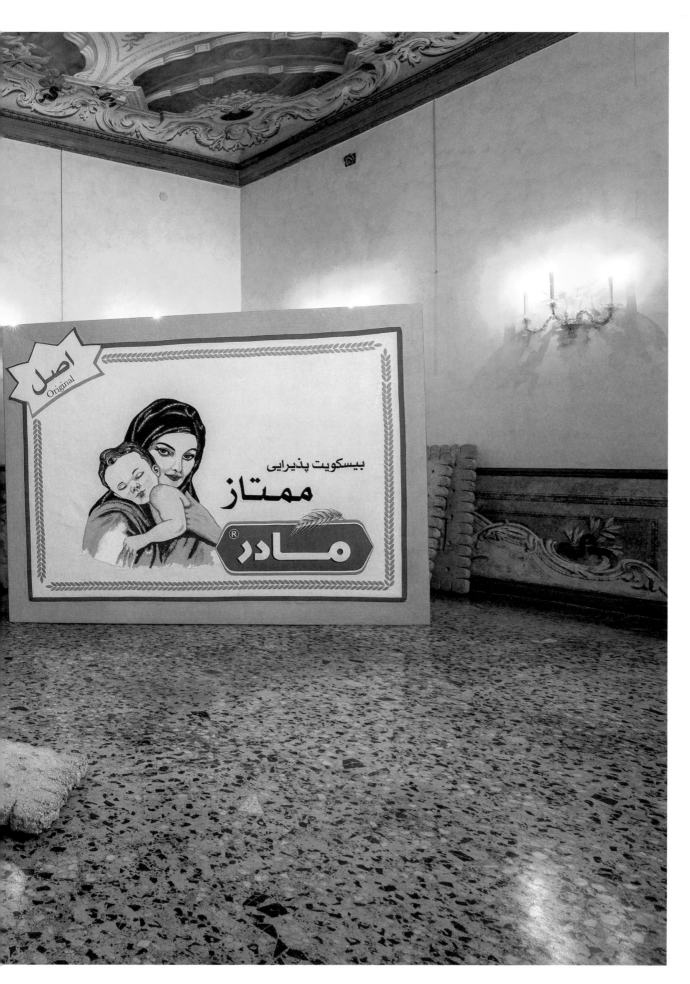

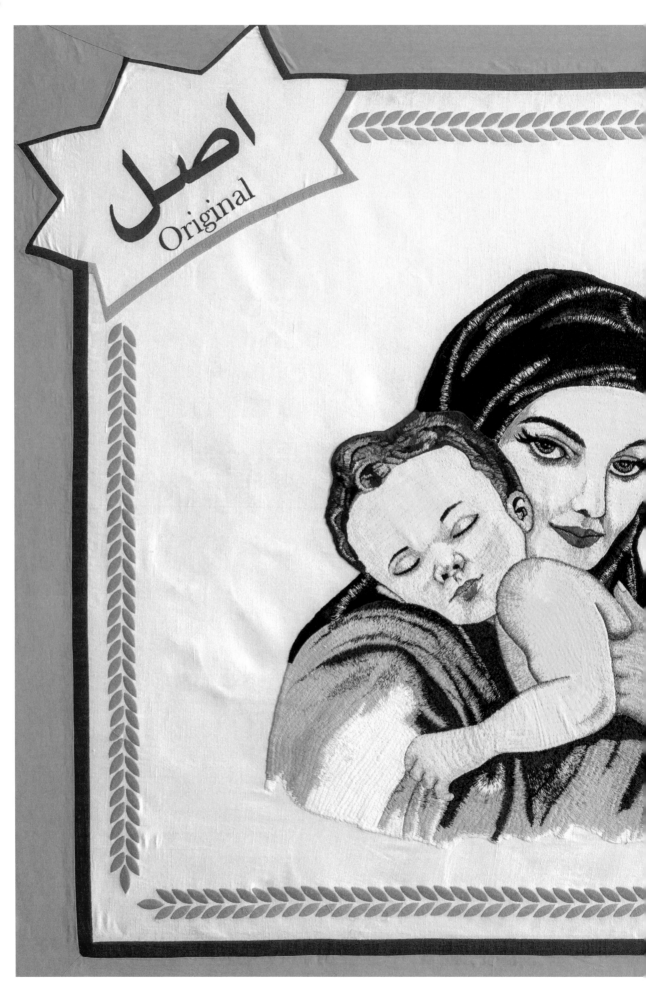

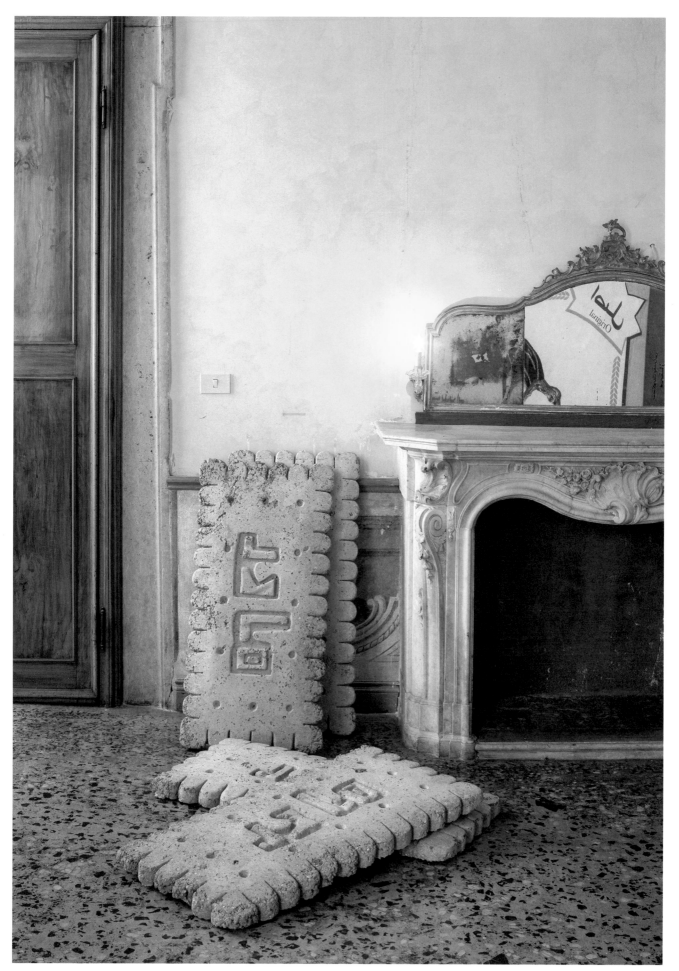

94
A Preservation and a Return

OLIVER BASCIANO

Vision is probably the least reliable of the senses. We see what we want to see; we see what we expect to see; we see with our memory, not our eyes. All images carry baggage, preconceived prejudices or learned expectations. This is not, of course, always or wholly a bad thing: the practice of viewing art for example is often enhanced if one brings to it the relevant history behind its formation. Yet, as Navid Nuur points out, where this knowledge might be useful academically, it blinds us to understanding what is actually in front of us. For his part, the artist refuses to take anything for granted in a work; instead, his art is the result of a restless interrogation of materials, processes and preconceived assumptions. He starts at the beginning each time, each object posing the question: what is this thing? How is it here? What is its make-up?

> The effort needed to see things without distortion takes something very like courage; and this courage is essential to the artist, who has to look at everything as though he saw it for the first time: he has to look at life as he did when he was a child.
> Henri Matisse, *ArtReview*, 1954

In *Broken Blue Square*, 2017, [pp. 148–149] a series of glass tubes are arranged parallel to one another and wall hung, giving it the appearance almost of a Venetian blind. Nuur filled these tubes with crushed glass and argon gas so the whole thing lights up like a neon. There is of course a knowing reference in the title to Malevich and his ground zero of modern art. Malevich's *Black Square*, 1915, pressed the reset button, asked the world to throw out the heavy baggage of art history and start again. Its meaning, for the Russian artist, lay in its absolute lack of meaning. Here, Navid Nuur is flicking that same switch, asking us to think about what we see in front of us. He uses neon not to write words, or to make form; nor, like Dan Flavin, as a marker of the transcendental or spiritual. Nuur's subject is not even light, *per se*, but the materials themselves and the closed system that is in operation, buzzing away in the gallery: gases and interaction; material, function and form, as light vibrates through the glass splinters.

Neon and argon gases are themselves naturally inert, but when a modest electric voltage is run through a sealed container they are activated, causing the elements to light up. To change the colour of this light, one simply coats the inside surface of the glass. What seems therefore to be a static image in *Broken Blue Square* is, in fact, a sculpture in intense chemical motion. Appearances are deceiving.

However, *Broken Blue Square* is also a portrait of the relationship between artist and material, where the latter has been set free from the servitude of the former. Let us consider the artist as the master, and the material as slave: the neon, the paint, the clay, the steel, the camera, does as the artist commands. The studio or gallery is their cell and the given material's own formal qualities are subverted to the intent of its manipulator. To quote Aristotle out of context: 'he is the author of their being', the end artwork is the artist's child. Nuur however does not accept this relationship. For him, the process of making is one of equals in which the material moulds the artist, as much as the artist manipulates the medium. Of course, this is not always a harmonious relationship: the material has qualities that will not bend. Neon follows a particular chemical reaction that Nuur has only a limited amount of power over; equally, Nuur has choices – *Broken Blue Square* is not neon in the raw, it has been shaped and formed, decisions have been made. Back to Aristotle out of context: 'Friendship demands the possible; it does not demand what the giver deserves. In some cases, in fact, it is impossible to make the kind of return which the giver deserves ...'

There is a democracy to Nuur's methodology, one reflected in *The Tuners*, 2005–2019, [pp. 97–102], the work he presents in *The Spark Is You* exhibition in Venice. This triptych consists of what seems a frantic application of squiggly lines applied to an otherwise unpainted canvas. Yet, these are not purely the work of Nuur, but are informed by scraps of test paper collected from the pen counters of stationery shops around the world. There is, the artist states, something primal about the form; a marking that dates to a pre-pictorial, pre-linguistic age. Nuur noticed, for instance, a commonality – unusual given the differing alphabets and cultures of the countries where the sheets of paper were found – to how people checked the quality of line produced by the pens they might buy: no names, no symbols or words, no pictures. Just raw ink.

A wiggly line. The pen, in effect, expressed only itself in this moment, before being purchased and subjugated as a tool of human expression. In *The Tuners* (its title a reference to musical sound in its purest form, as an instrument is readied for human play) these patterns are transferred to paint on large-scale canvases. Without using a brush (again, Nuur, breaks down pre-conceived or learned methodologies of how a task is done), but using an especially-made marker that allows the artist to paint a single line in one continuous flow (to mirror the act of the customer in the stationery shop), Nuur trails the paint across the surface.

The result, as different colours cross and interlace, is a musical composition in which colour and form are key. The work takes us back, strips away the history books, and asks the viewer to forget narrative or symbolism, motive or method. Nuur's works are of course art objects, but before that they are materials and manipulations, interactions between hand and medium as somewhat equals.

Oliver Basciano is a writer based in London. Since 2010, he has worked at *ArtReview* magazine where he is currently International Editor.

97 *The Tuners*, 2005–2019
PVC coated fabric, mixed media
Each of three pieces:
500 × 400 cm | 700 × 400 cm | 500 × 400 cm
(197 × 157½ in | 275½ × 157½ in | 197 × 157½ in)

NAVID NUUR

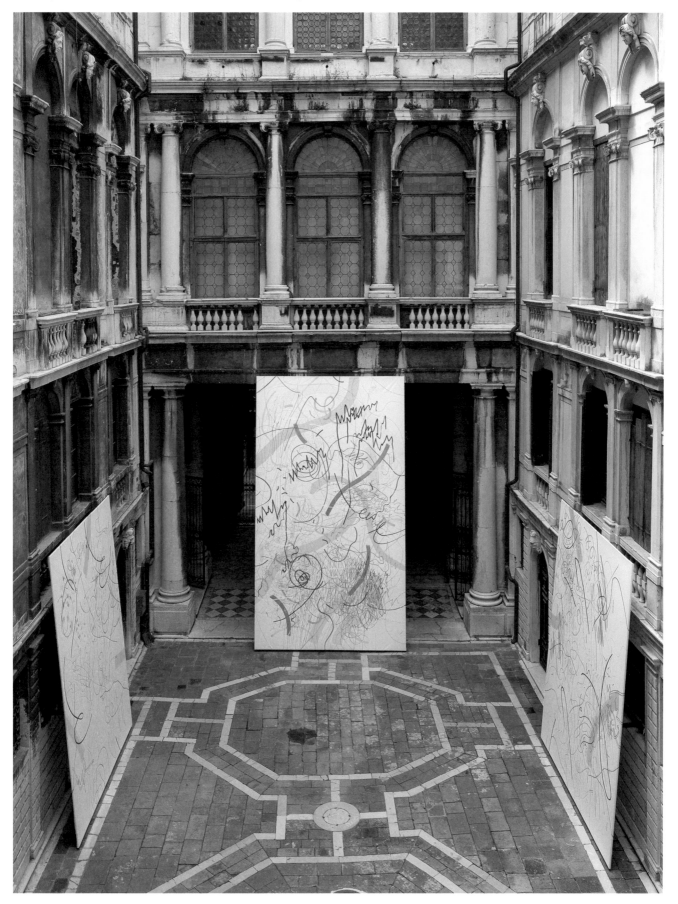

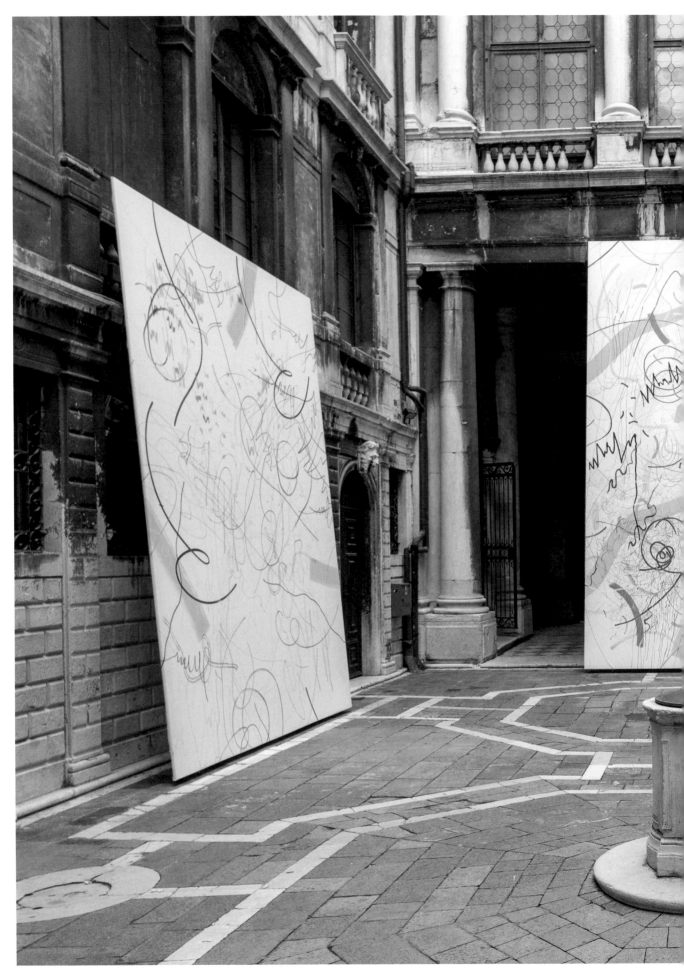

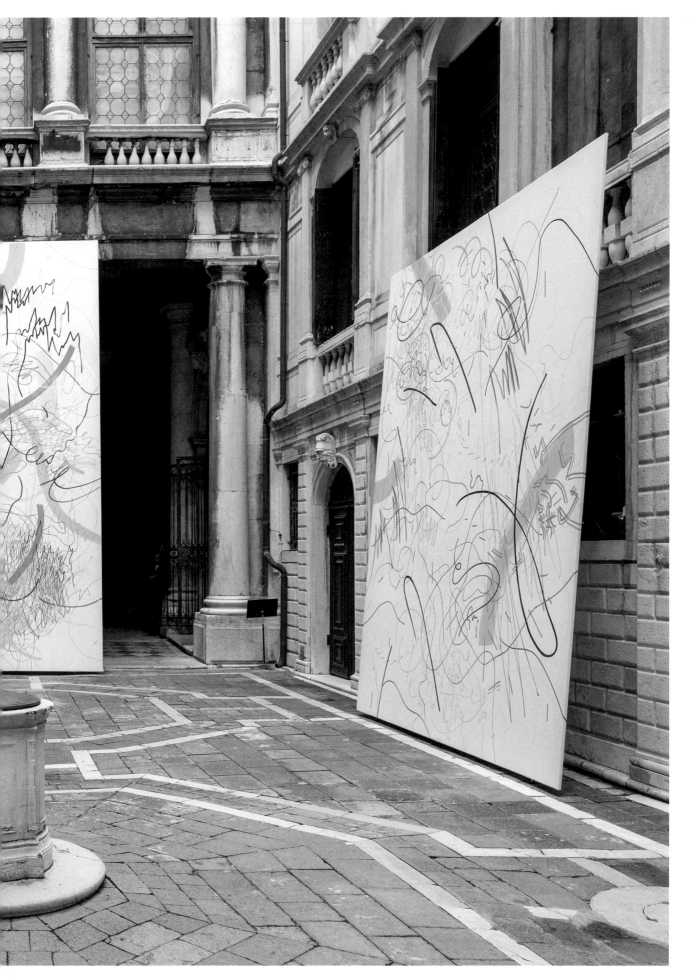

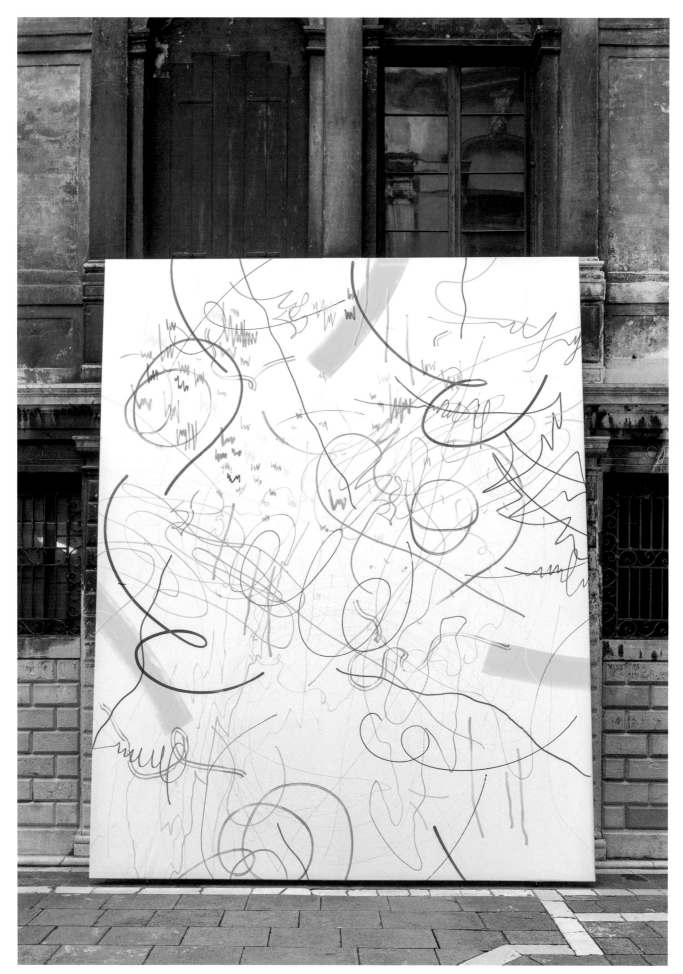

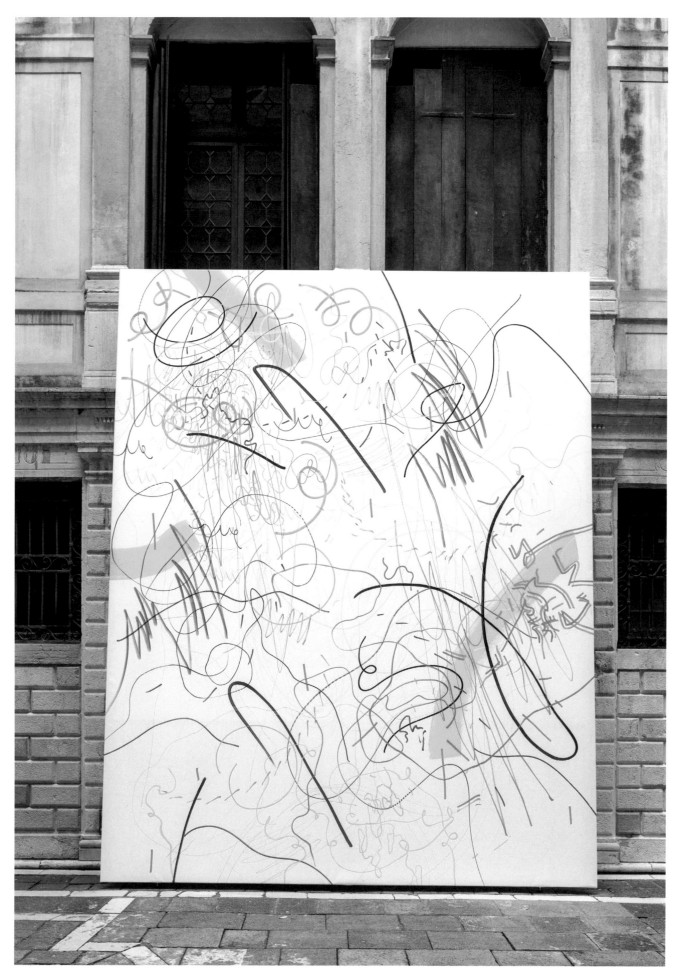

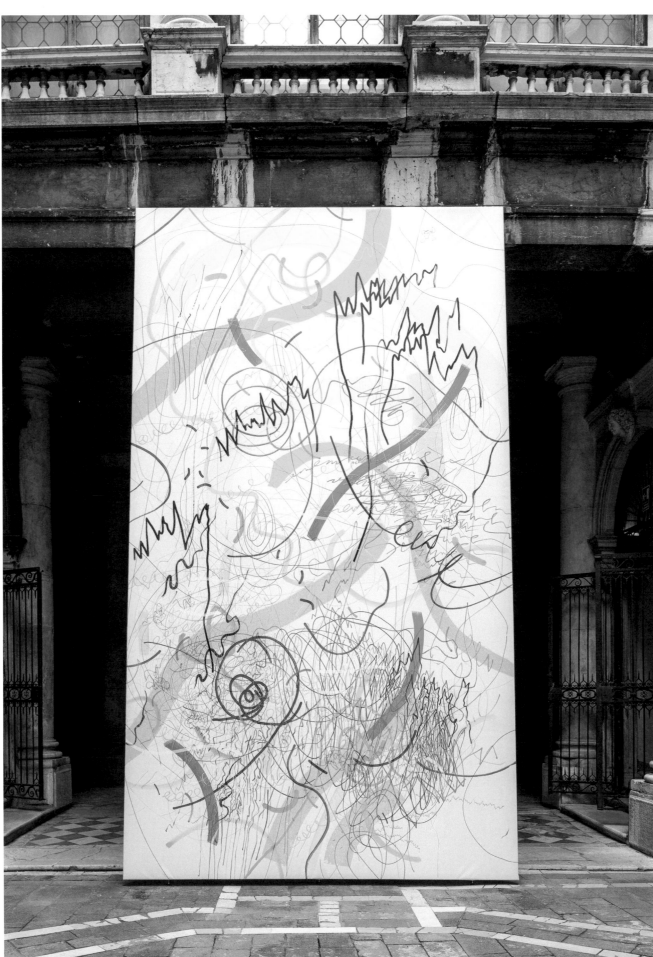

105
Nine Iranian Artists in London
The Spark Is You

Flight, 2008. Video, 2:48 minutes

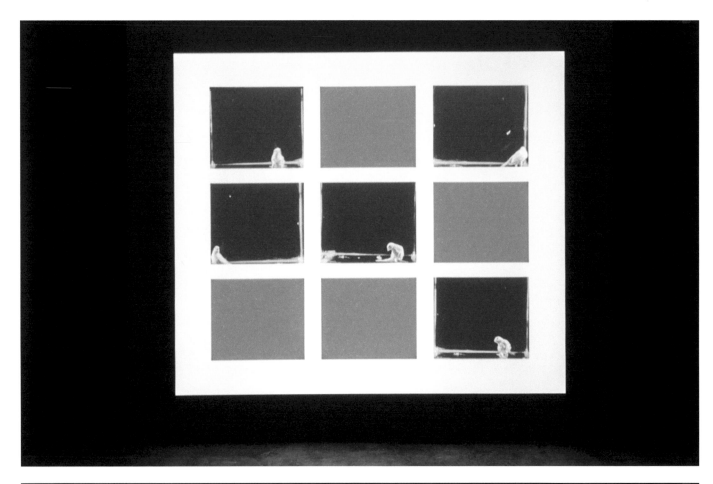

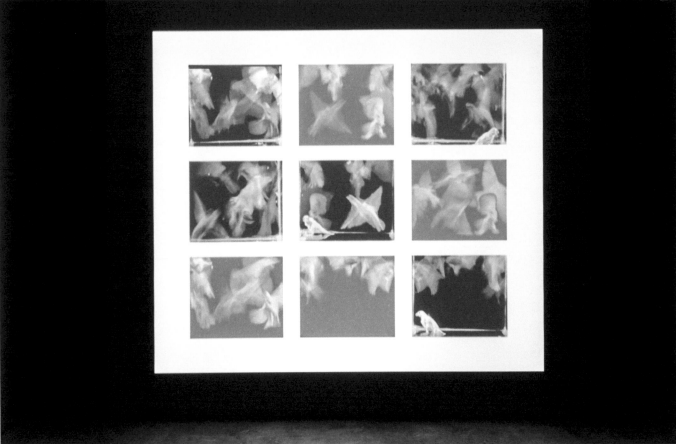

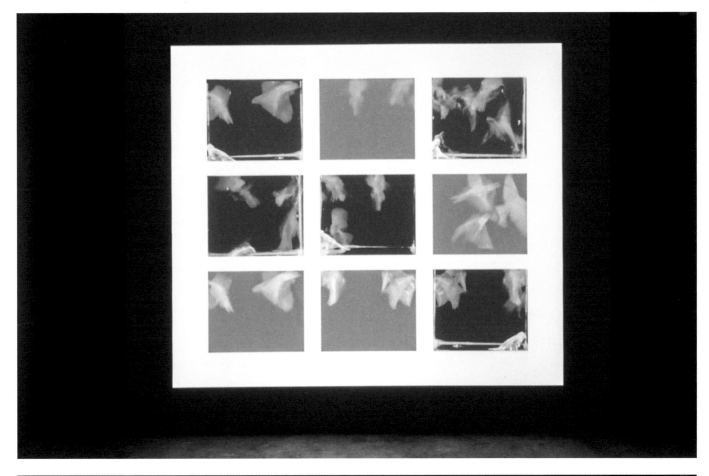

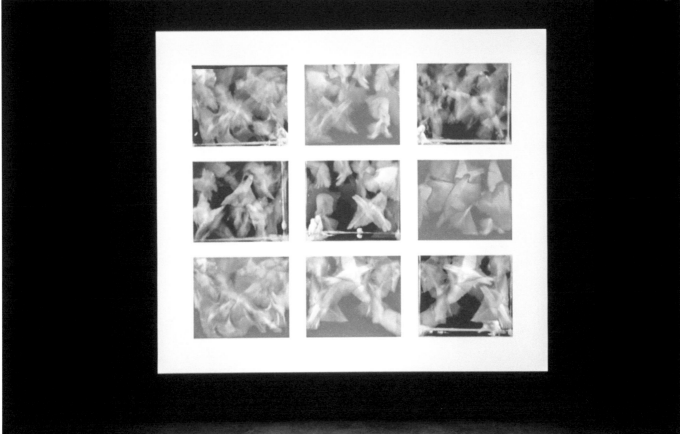

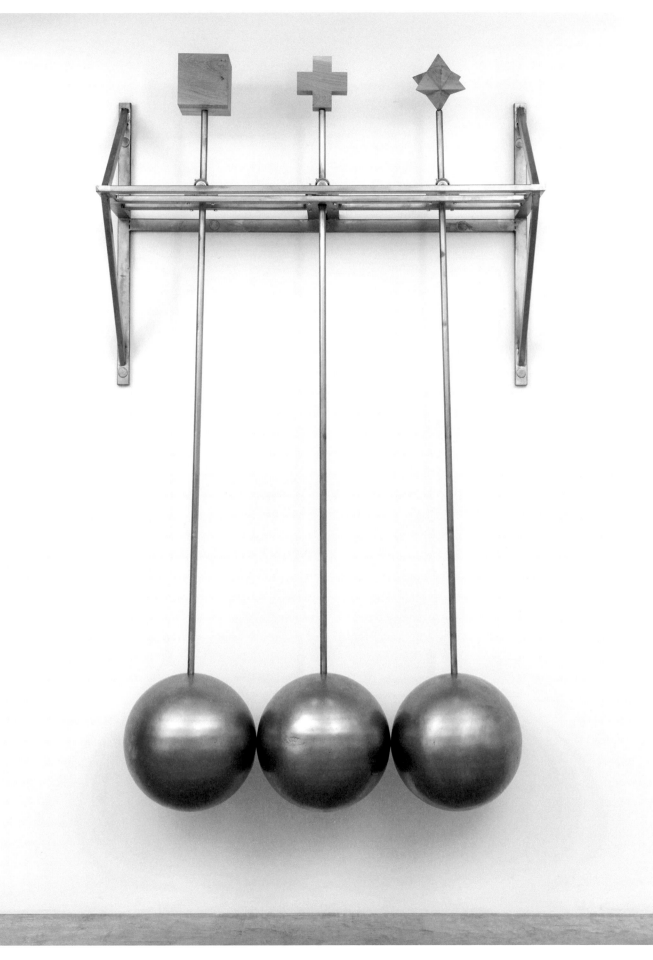

The Mechanisms of Growth, Demolishing Buildings, Buying Waste, 2017
Plaster, PVC glue, pigment. Dimensions variable

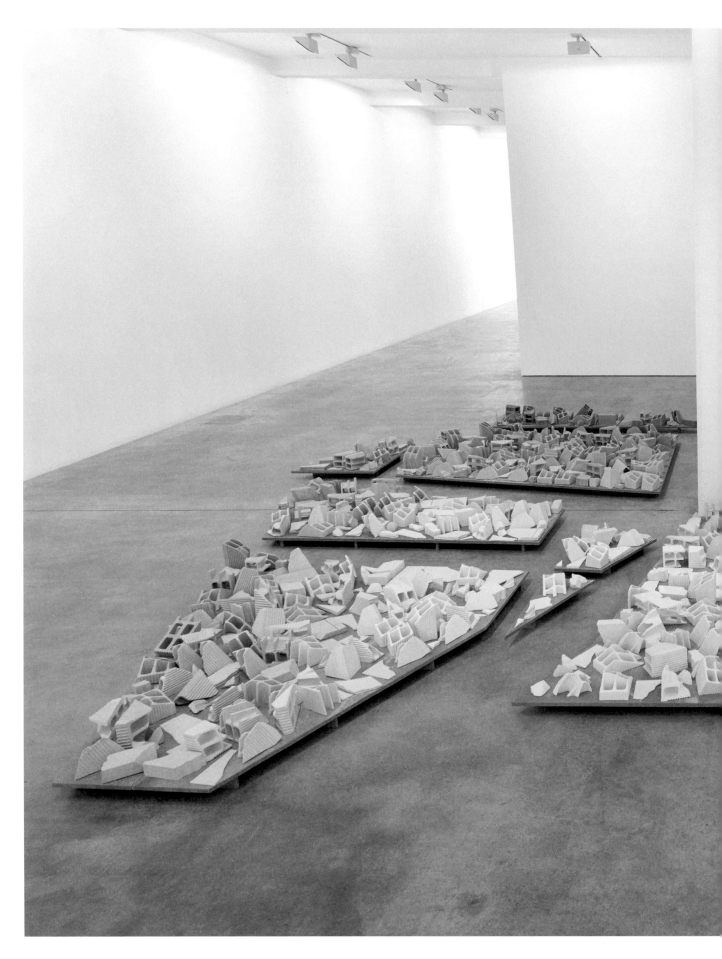

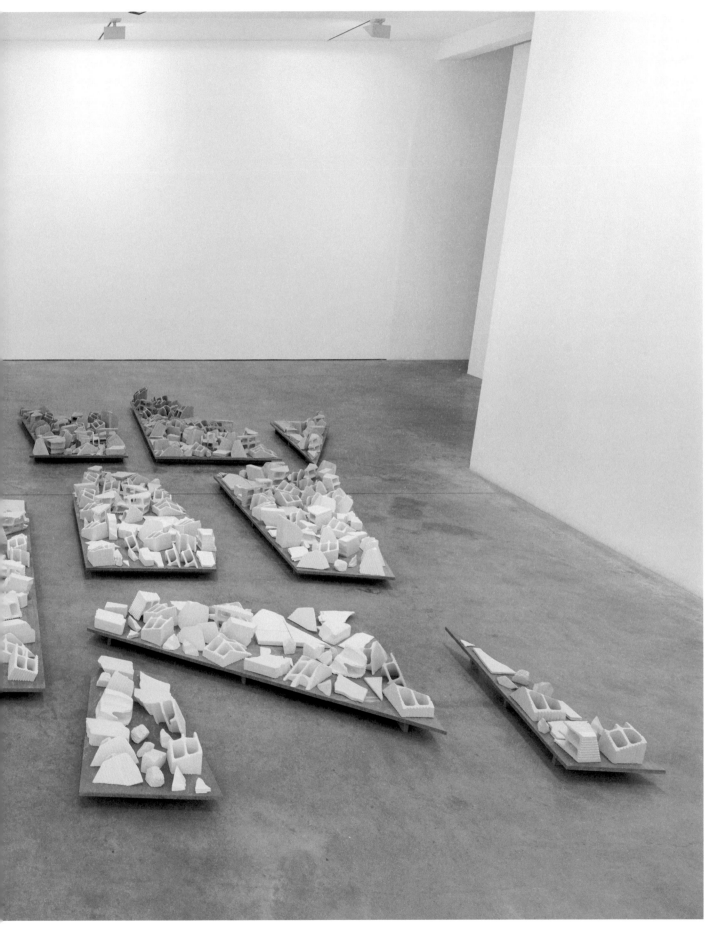

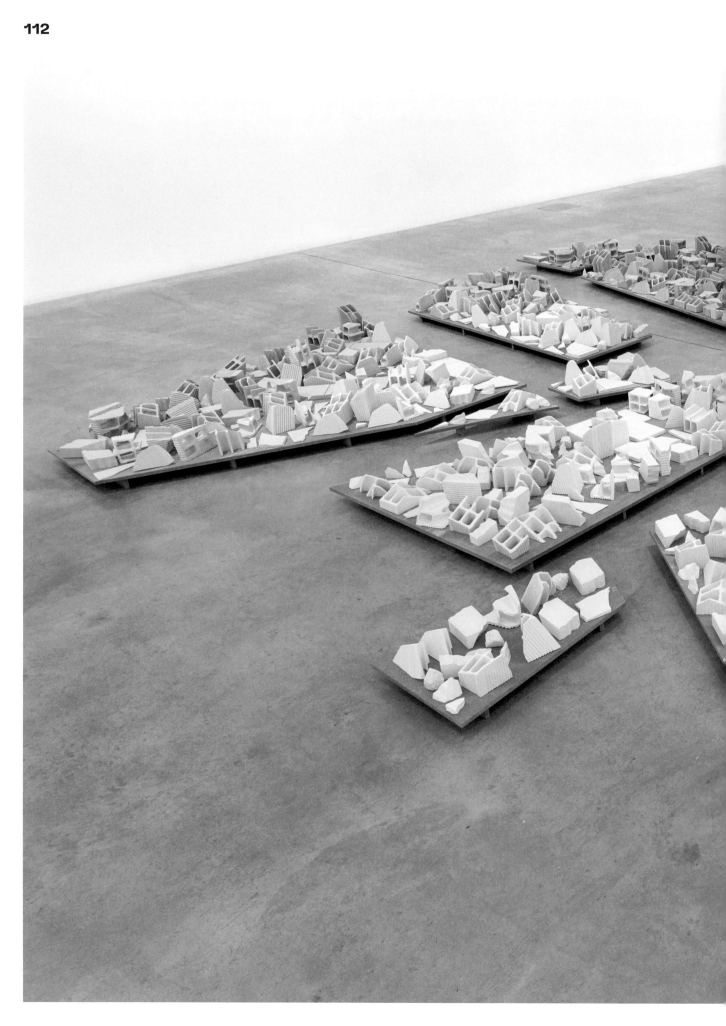

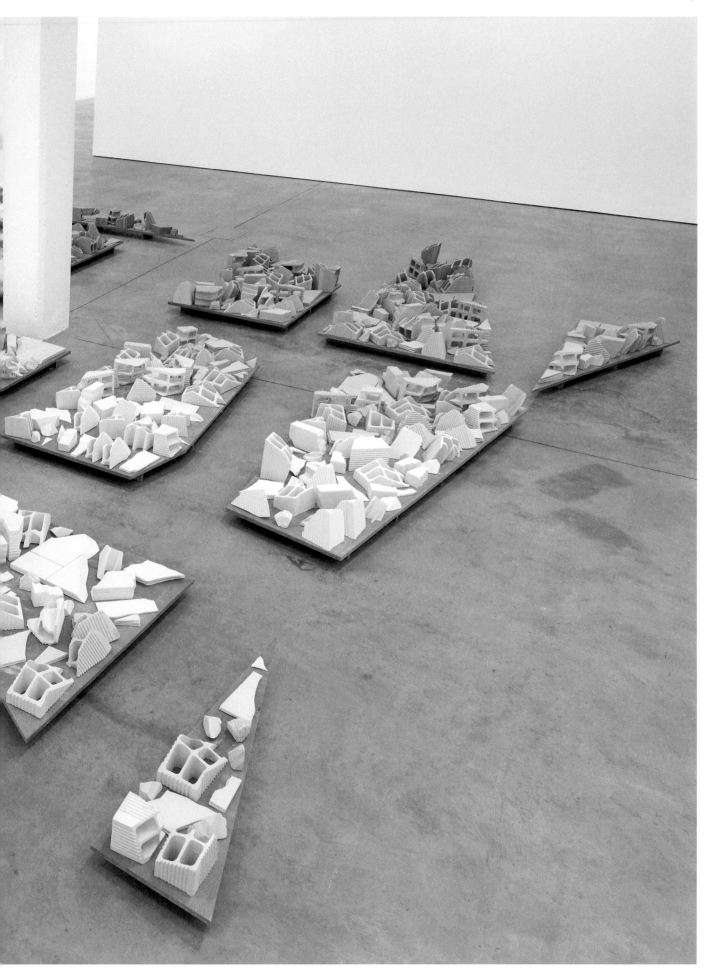

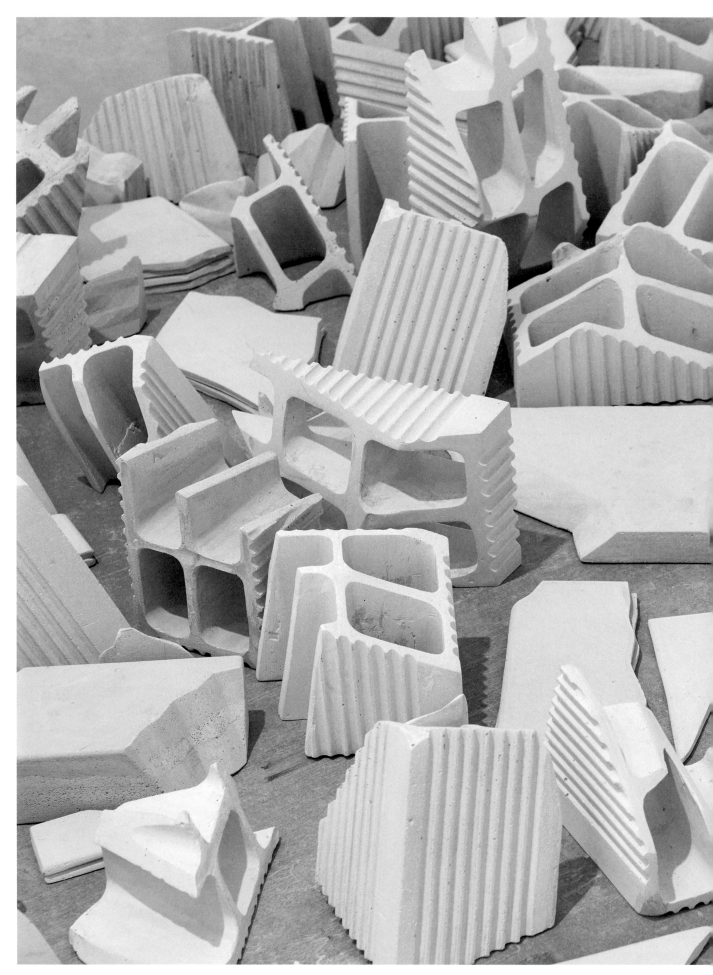

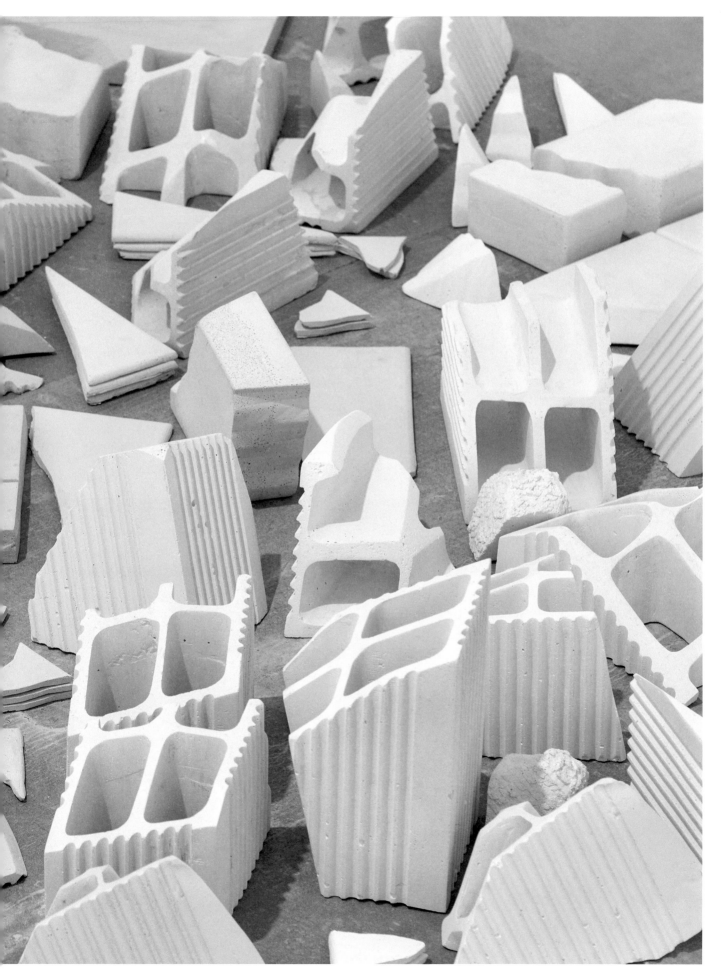

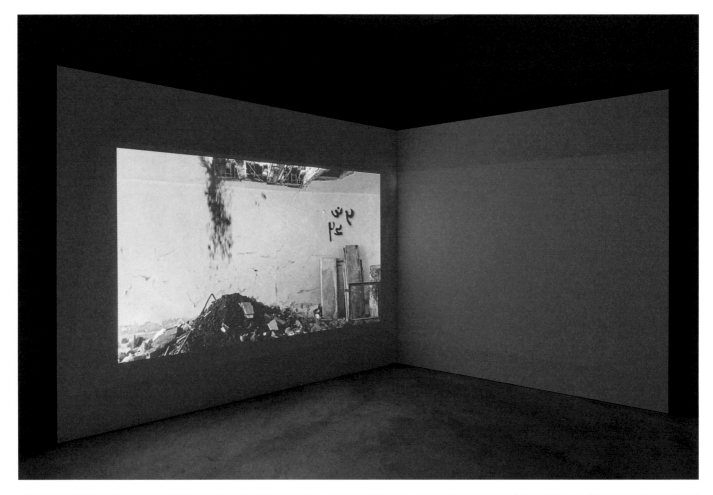

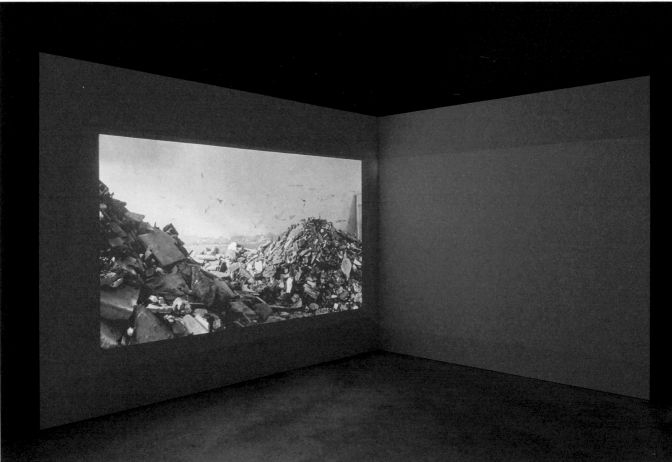

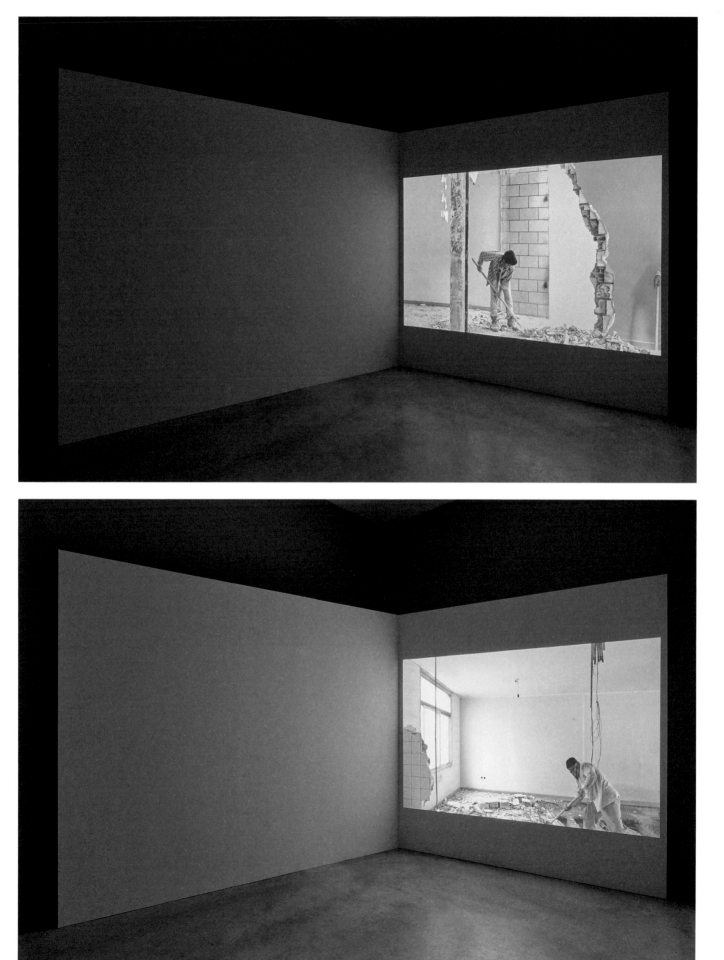

The Grid and the Scratch Tracing the Sensible in the Works of Ghazaleh Hedayat

MAHAN MOALEMI

Ghazaleh Hedayat's practice is characterised by an exploration of the relationship between the two senses of sight and touch, a relationship that is often figured in various sociopolitical settings of sense-making. Trained in photography and fine arts in Iran and the US in the early 2000s, Hedayat's oeuvre displays a diligent and cautious relationship to a certain regime of representation that has come to predominantly define the productions of 'contemporary Iranian female artists'. In contrast to the orthodoxies of this regime, and yet accounting for her own standpoint within it, Hedayat treats the representational element as a found material – from the object of recognition to the object of appropriation. She neither plays into an exotic hide-and-seek nor entirely gives up on her title as a contemporary Iranian female artist. If anything, it is the layered structure or substrate of representation itself that is unveiled. Hedayat identifies the surface element or skin-deep quality of the veil or the cover as not only that which demands to be responded to by unveiling or uncovering but also as the very material for registering or mediating the appearance. The covering surface and the revealing interface, in this sense, overlap to allow for material engagements beyond the recognisability of representational imagery.

In the series *The Strand and the String*, 2008–2018, [pp. 120–126] the canvas frame is treated like a cross between a tapestry loom and an embroidery hoop. Running stitches of white linen thread form a gridded surface on square pieces of white cloth, while human hair — maybe or maybe not the artist's — is woven here and there into the grid lines. This group of works was first displayed in an exhibition titled *The Strand and the Skin*, which also included other series of works that have come to have a lasting impression on the artist's practice to date. It is important to notice that, in Persian, the first part in the title of this formative exhibition reads and sounds the same as the first part of the phrase 'warp and weft', that is, تار [tär], while the second parts also sound similar when pronounced, as in پوست [pōost] for skin and پود [pōod] for weft. In this sense, the title accentuates the texture and materiality of a surface that has historically been reserved as a picture plane. The work incorporates a double treatment of the body of the artist and the texture of the image

(as both are often figured within the bounds of one or another mode of framing) in order to hold together the optic and the somatic. This is to address the tension that lies in the eternal distance and/or intimacy between what one thing is and what it appears to be. However, more than the frame, whether in a figurative or actual sense, it is in fact the structure of the grid that holds these dualities together.

Grids have served different functions in different regimes of representation, from carpet weaving to perspectivity to digital pixelation. 'In the early part of [the twentieth] century', writes Rosalind Krauss of grids in her 1979 eponymous essay, 'there began to appear [...] a structure that has remained emblematic of the modernist ambition within the visual arts ever since.'[1] The modernist function of the grid, Krauss argues, lies in its simultaneously avant-garde and anti-developmental stance, both radically autonomous and bound to repetition and reproduction. More broadly, it is the structural capacity to contain contradictions that characterises the grid. Having broken from the role of the perspective lattice and withdrawn from 'the science of the real', the grid solemnly maps the physical surface of appearance and comes down to some sort of 'naked and determined materialism'.[2] However, modern art also fostered the revival of metaphysics and sacred geometries via the figure of the grid, which survived a desacralising era as a refuge for spiritualist traits and ethereal interests. The grid proved as 'simultaneously transparent and opaque'.[3]

In this sense, the grid serves as an ideal vehicle for the double bind of sight and touch, the canvas and the skin, and the overlaps and grey areas between different regimes of representation. The grid accounts for that which is at once observed from a distance and closely held and measured. Moreover, the strands of hair address the conflicts of the contemporary regime of representation that surrounds the artist herself via the history of the modernist grid, which is defined by its reckoning with the representational and the historical. The hair flickers between referencing the body of the artist herself and getting tangled in generalisations based on bits of information, of a certain representational affordance that might be implied by the hair. As appears in *The Strand and the String*, the grid

indicates a struggle over sense-making. It points to a tension among different ways in which the sensible is channelled and distributed across competing regimes of representation and within their corresponding communities of sense. Hedayat's practice, by and large, alludes to the politics of aesthetics *à la* Jacques Rancière. He defines the 'distribution of the sensible' as the system that both makes something sensible and discloses the a priori delimitations that keep certain things within it from being sensed. 'A distribution of the sensible therefore establishes at one and the same time something common, that is shared and exclusive parts.'[4] Here, politics is practised as a form of sense experience, therefore a matter of aesthetics. The work of art, then, can interrupt the distribution of the sensible or redistribute it in an aesthetico-political act of re-inscription. Therefore, the 'surface' of inscriptions and appearances, Rancière suggests, is crucial to the distribution of the sensible in a way that structures 'the manner in which the arts can be perceived and thought of as forms of art and as forms that inscribe a sense of community [...] A "surface" is not simply a geometric composition of lines. It is a certain distribution of the sensible.'[5]

In Hedayat's series *(un)threading*, 2018, [pp. 128–133] it is the very surface of a C-print image that is scratched to varying degrees and, in one instance, almost entirely removed. The image is a medium close-up of the artist, pictured from behind, showing her hair and the back of her neck and shoulders. Whether the skin, the canvas, or the C-print, it is upon and through the surface that the scratch, in addition to the grid, serves as a tool or technique for redistributing the sensible or, more particularly, the visible.

(un)threading is in dialogue with the artist's earlier works, not only in the use of the scratched C-print but also in conveying a political and aesthetic sense of silence. 'I have been working with different mediums,' Hedayat says, 'but there is one common ground among them all: silence.' She also asks, 'How can I hear the sound of my body?' The way in which her work engages with the redistribution of the sensible is either from within a position of silence or with a 'will to silence', as Krauss wrote of the grid. In fact, the artist's exploration of the relationship between the senses of sight and touch is to focus on those sense experiences that nonetheless remain unspoken and unheard even if the body is pictured or touched, observed or examined.

1 Rosalind Krauss, 'Grids', *October*, Vol. 9, Summer 1979, p. 50.
2 Ibid., p. 52.
3 Ibid., p. 58. As Krauss writes, such double-sided characteristics originate in the two branches of nineteenth-century optics, one concentrated on the physical properties of light and the other on the mechanisms of perception, concerned with light as it is seen and perceived.
4 Jacques Rancière, *The Politics of Aesthetics: The Distribution of the Sensible*, London and New York: Continuum, 2006, p. 12.
5 Ibid., pp. 14–15.

Mahan Moalemi is a writer and curator from Tehran.

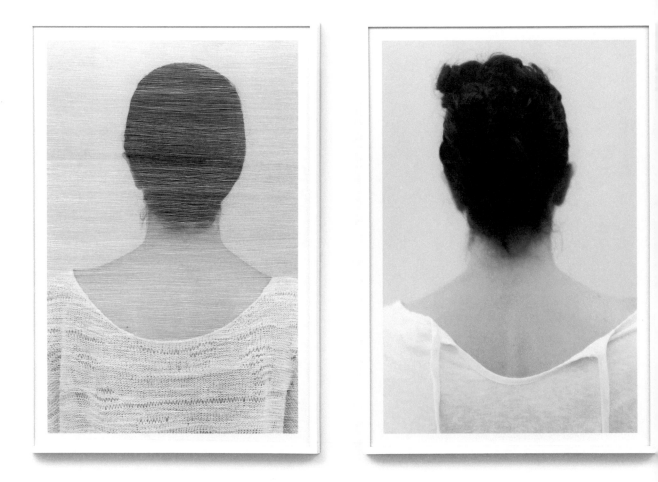

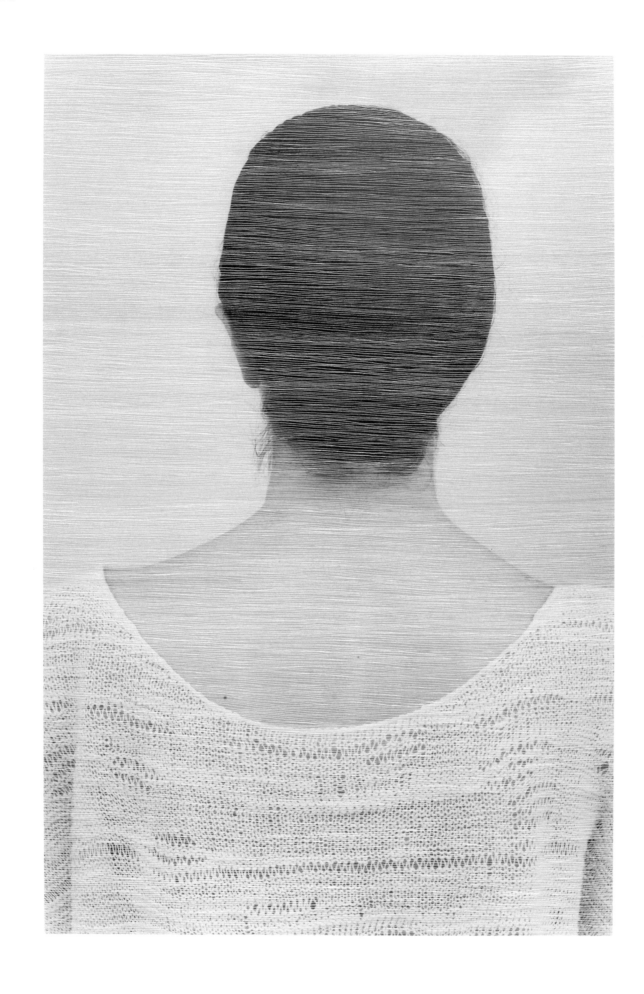

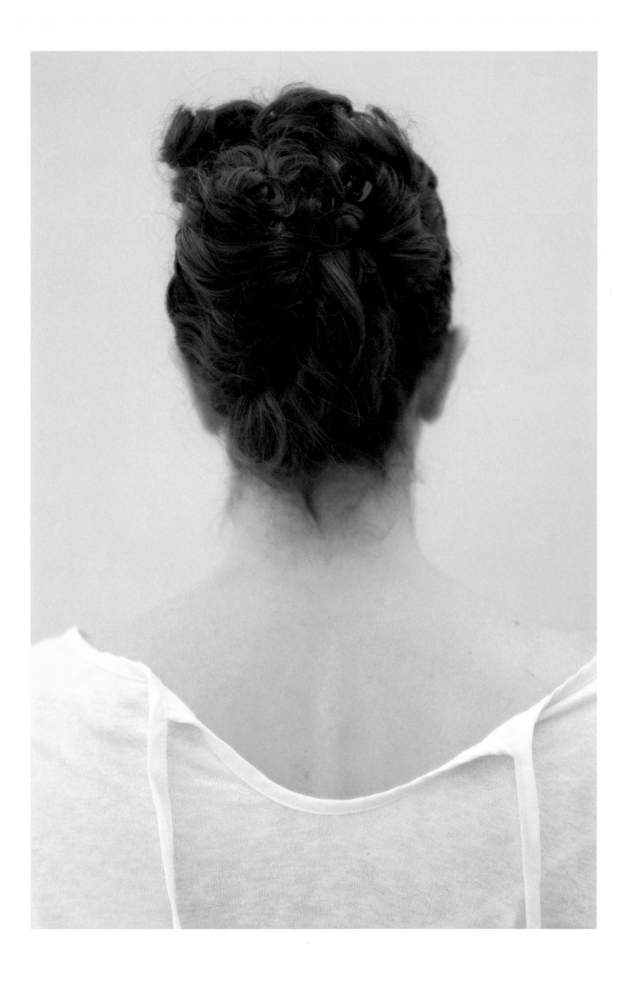

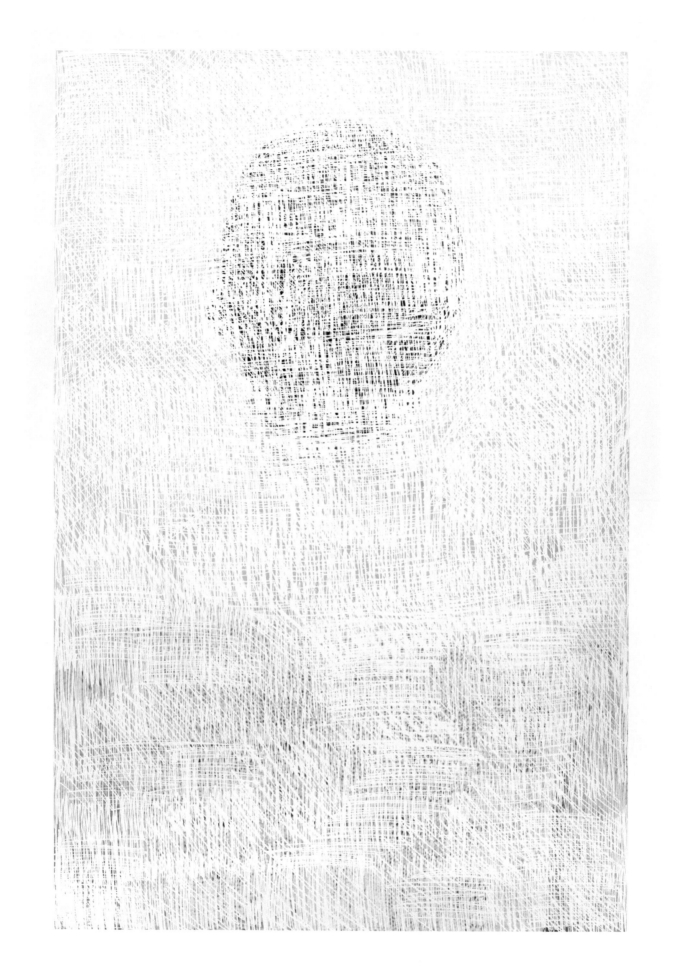

Nahankhane, 2017. Stainless steel, gold leaf, electrostatic coating
212 × 212 × 412 cm (83½ × 83½ × 162¼ in)

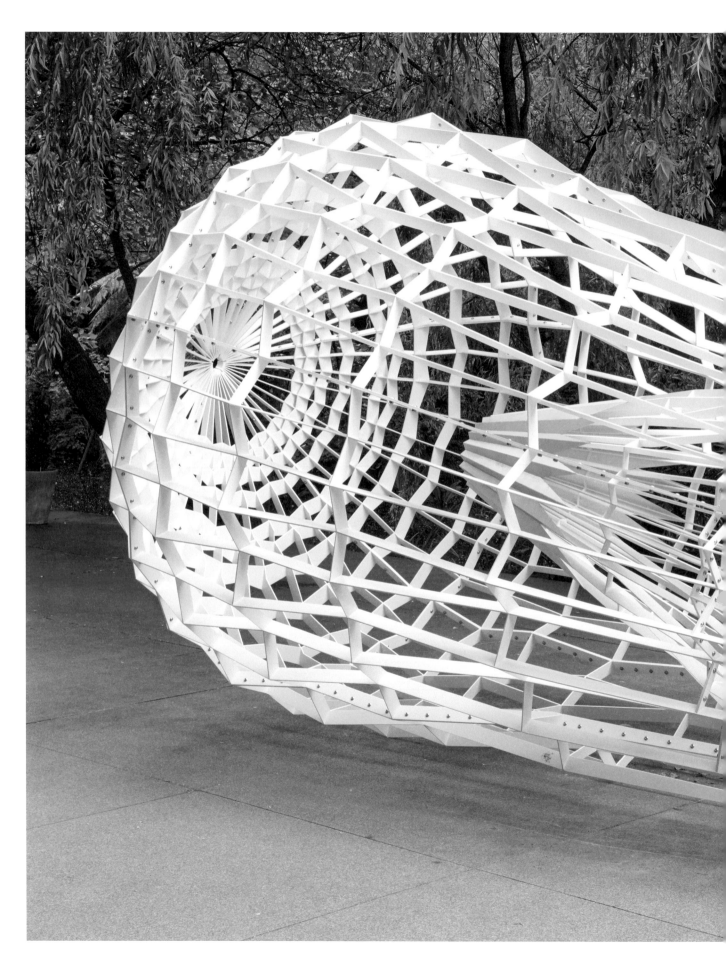

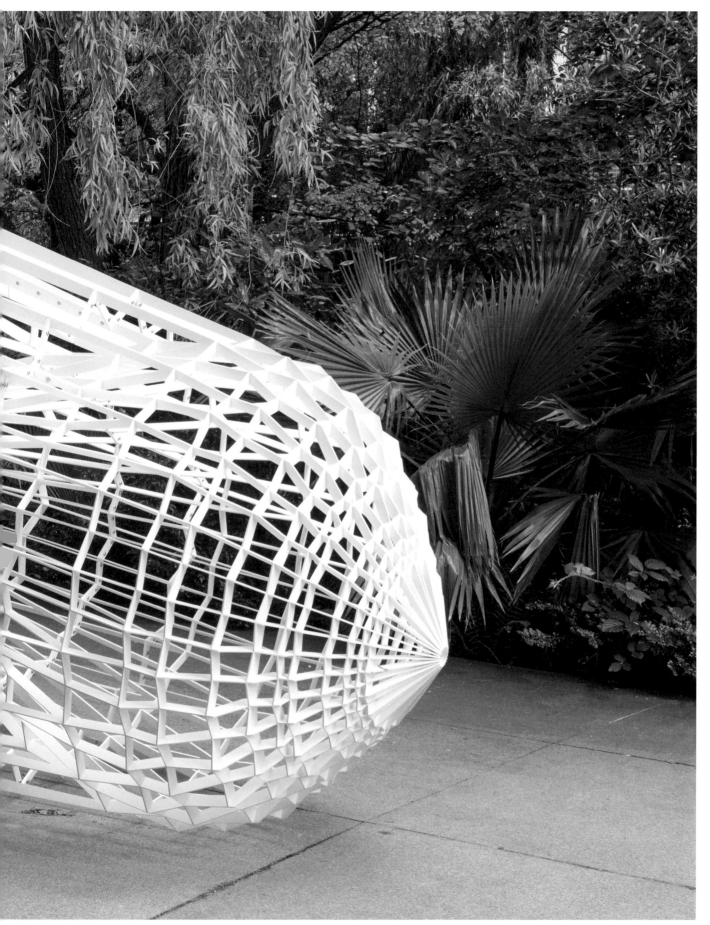

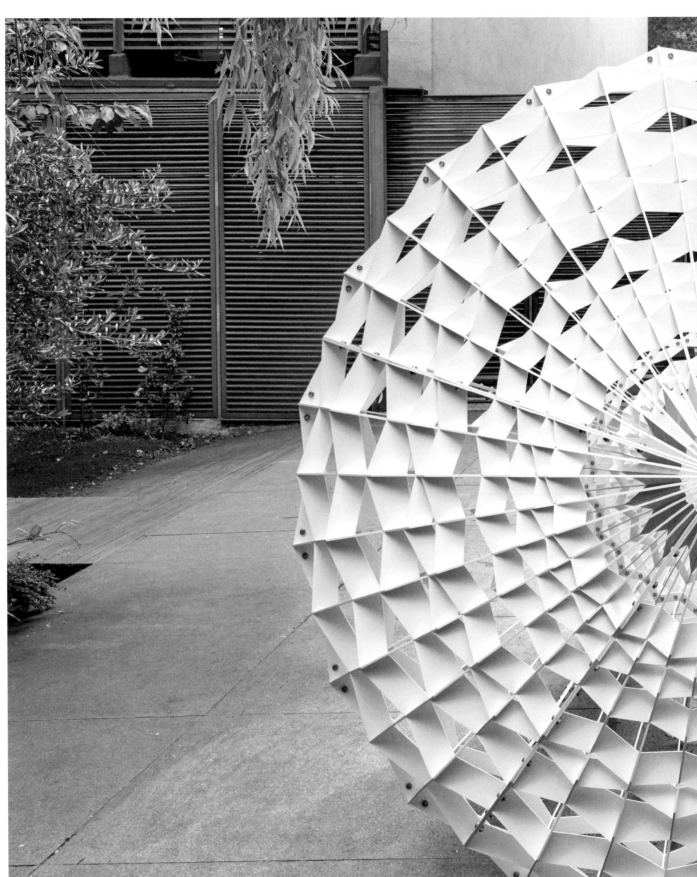

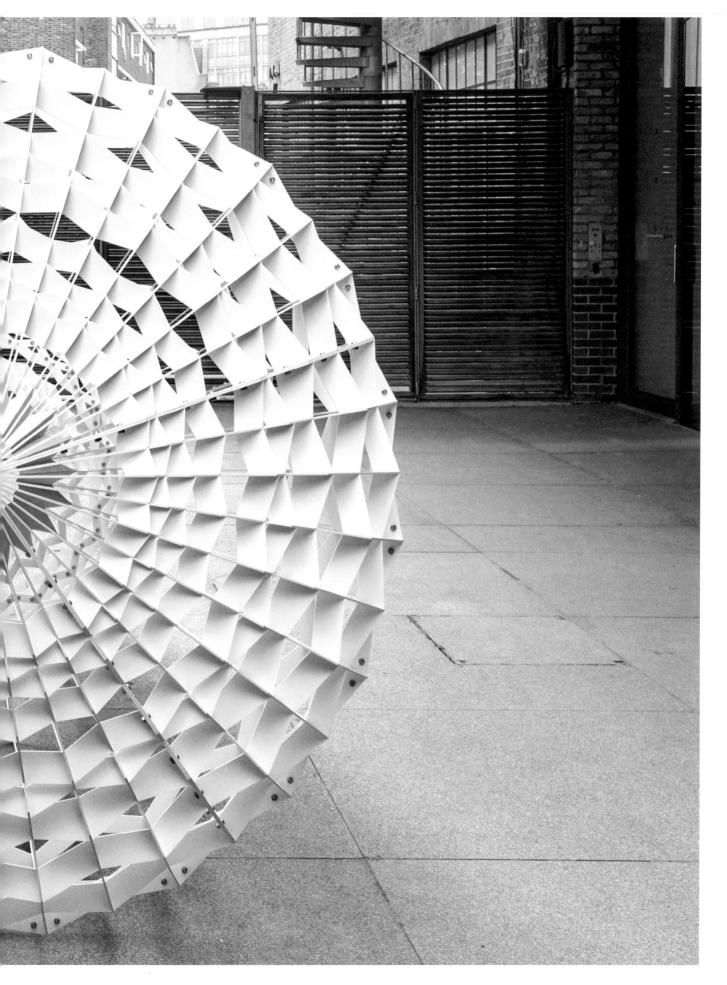

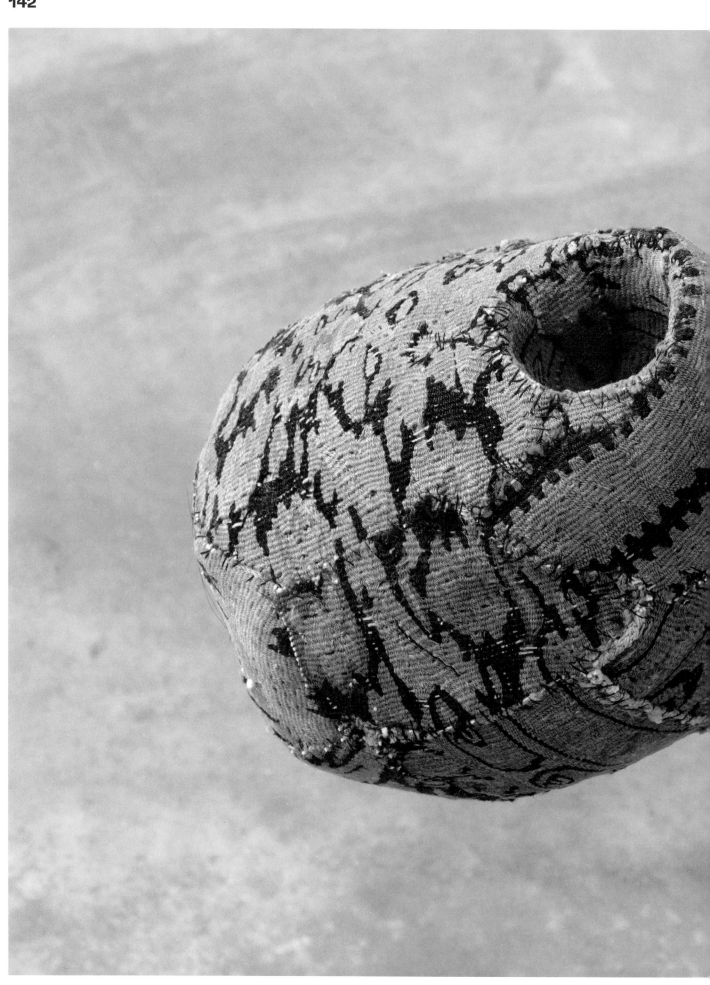

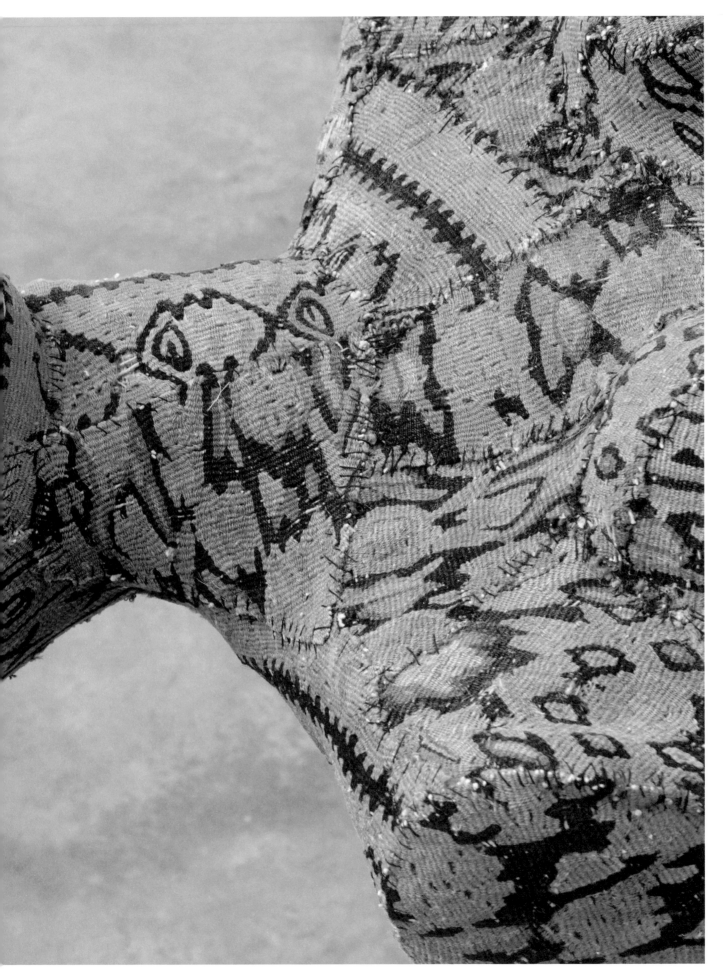

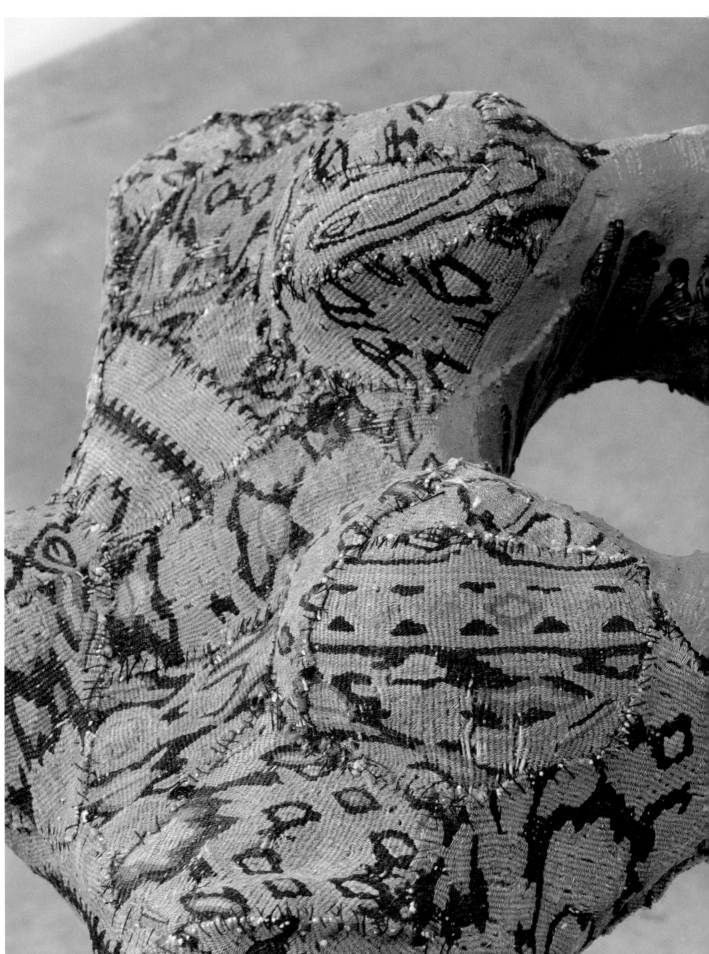

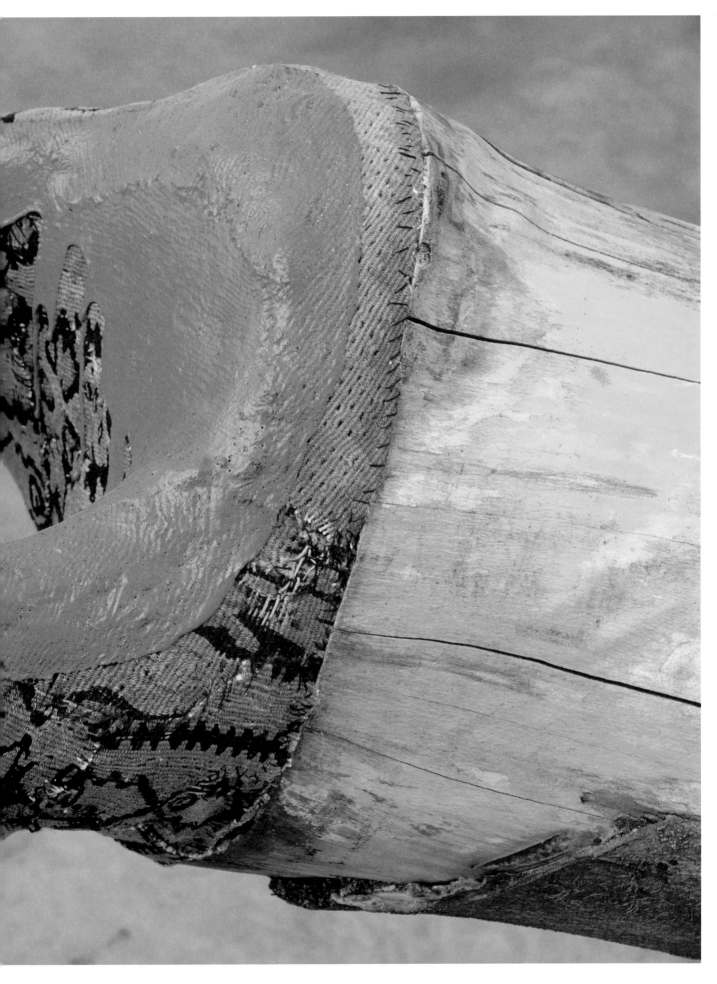

The Tuners, 2005–2018. Unprepared linen, mixed media. 184 × 138 cm (72½ × 54¼ in)
The Tuners, 2005–2017. Prepared linen canvas, solid marker on stretcher. 170 × 130 cm (67 × 51¼ in)

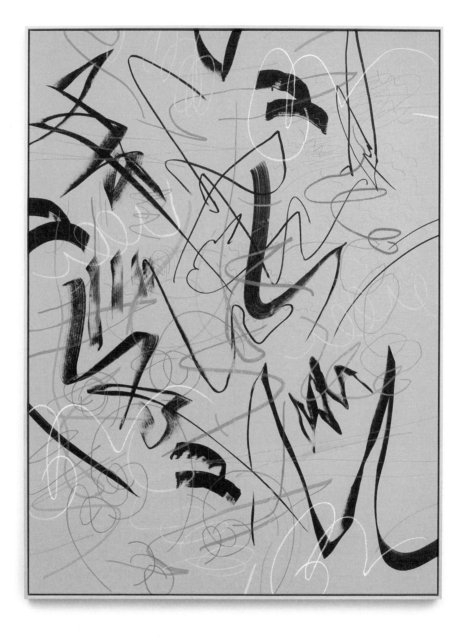

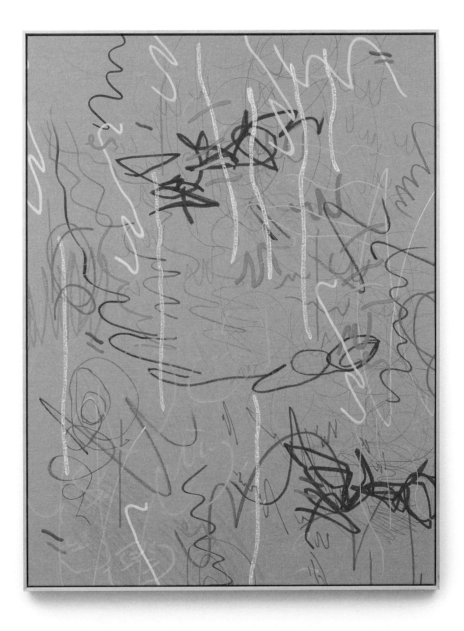

Broken Blue Square, 2017. Glass, crushed glass (put inside the tube from the ends), argon gas. 189 × 151 cm (74½ × 59½ in)

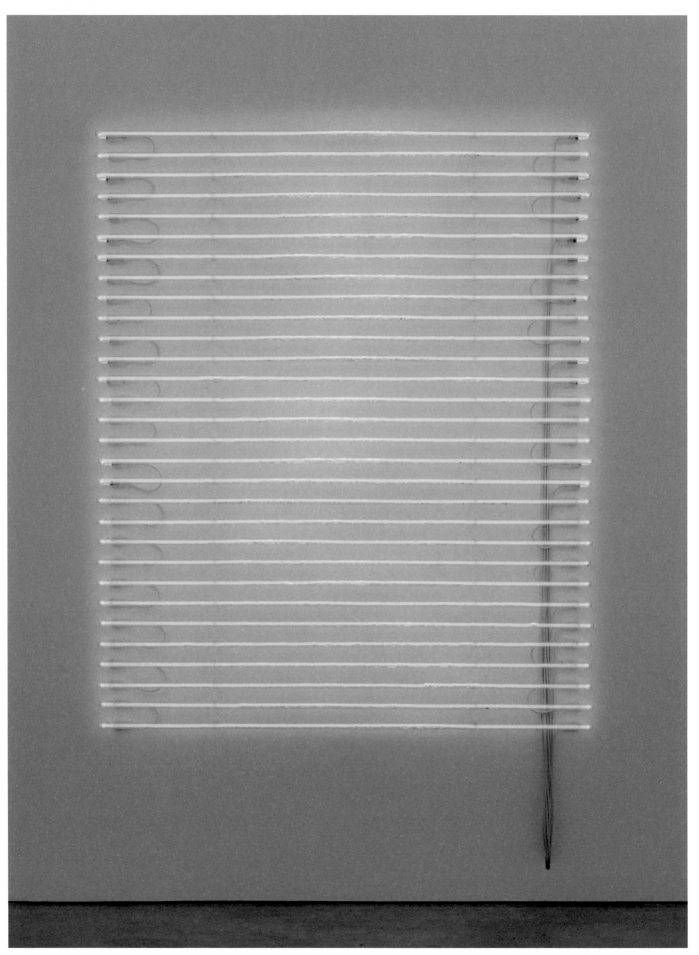

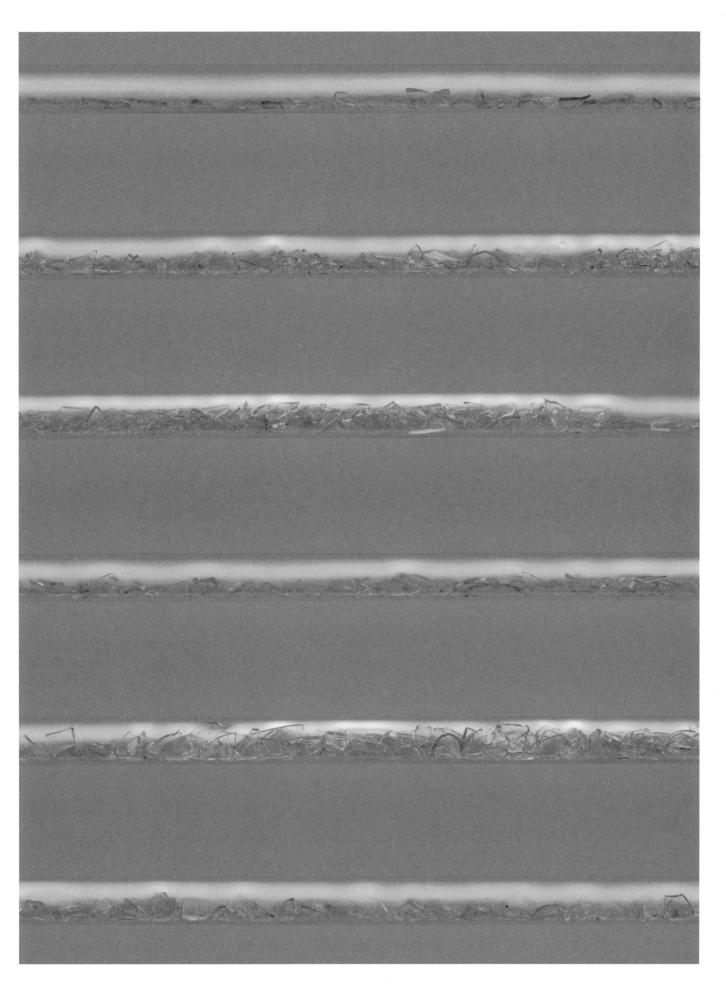

Everything and its Echo

OLIVER BASCIANO

Inside the pink-painted box, which is propped up on black trestle legs and open at one side, is a series of painted cardboard cut-outs propped up as an abstract diorama. It would be a stretch to assign any definitive forms to Sam Samiee's broad thick brushstrokes, yet a few motifs suggest themselves through the neo-expressive composition. A brown scrap of card is left bare but for ten or so silver-grey blobs that could either be a cumulation of clouds or a flock of birds. On another sheet, a series of orange orbs overlay one another, like a diagram visualising a sun 'in motion'. On another, one block of yellow paint rests atop another. Presiding over this is what appears to be the artist's makeshift palette, messy with the colours contained elsewhere in this painting-sculpture hybrid. The work was made by the Iranian-born, Dutch-educated artist for the 10th Berlin Biennale, part of a wider room-sized installation he titled *The Unfinished Copernican Revolution*, 2018. It is enigmatic certainly, but there is a sense of unashamed seduction, a delightful sense of play, that is typical of Samiee's approach.

While the glowing orbs in the work make visual reference to the Renaissance-era paradigm shift suggested within the title, whereby the Earth was recognised as a planet in orbit of the sun (rather than the reverse, as had been thought previously), it is Immanuel Kant and his Copernican revolution in philosophy that is most pertinent within this deceptively simple collection of brightly coloured paintings and painterly sculpture. The eighteenth century philosopher decreed that the human mind does not passively sense the world external to it, but is the originator and motor of perception. Installed nearby, an oddly shaped, ripped piece of un-stretched canvas is pinned to the wall. Daubed in blue, pink and orange paint with thin black brushstrokes messily scribbled atop, it has the look of a landmass, perhaps pictured by satellite from above, a fanciful feeling given credence by both its title, *Untitled: A Map of USA, Seven Designs for a Money Note, Nr. 7*, and the photocopies of a painting made on an iPad of an island, that form a rectangular frame around the textile. Samiee's work avoids dictating its subject matter, but by reaching beyond the flat plane of painting tradition to imbue the medium with spatial qualities, through his use of sculpture and installation, the artist disorientates the viewing experience. Rather, we are left to our own devices, a generous invitation by the artist to delve for narratives of our own making. A possible refutation of empiricism, however, the whole installation instead poses questions of the human subject: are we each a Robinson Crusoe marooned in the isolation of our own personal perception, or is reality a great landmass we share?

A train of thought can be traced from *The Unfinished Copernican Revolution* to the new work Samiee made for *The Spark Is You* exhibition. Samiee composts a lot into his practice – pulling research from Persian literature, psychoanalysis, Western art history and philosophy, and exploring tangents that may present themselves during a voracious reading habit. It is, the artist says, a performance of *adab*.[1] His art-making, though more often abstract in its aesthetic, is the result of an intellectual rigour – and an ethics of making – that belies the joyous flamboyance of the end product. At Parasol unit the artist turns his attention to the character of Shahrzad, wife of the mythological Persian monarch Shahryar, who by enchanting her husband with her prodigious storytelling, staved off his murderous intentions. While an iconic figure of Persian literature, who has provided inspiration to the artist previously, it is the effect of *One Thousand and One Nights* in the West that is particularly important to the artist. 'The centuries go by, and we are still hearing the voice of Scheherazade,' noted Jorge Luis Borges in 1986, using the Arabic name of the heroine. The effect of the mythology behind the enigmatic Shahrzad, and her tale of survival through art and creativity, is so profound to the Atlantic-European canon, Borges claimed, that it has been de-territorised into a global artefact. Unmoored, this Copernican decentring has obvious implications for an artist working between geographies and within a dual art historical and cultural legacy.

Samiee borrows from *One Thousand and One Nights* structurally too. His multi-part installations can likewise be seen as a series of stories, each painting a proposal for a tale – not only with the artist taking on the role of Shahrzad, but also propositioning the viewer to provide their own stories – told independently but within the greater narrative of the wider presentation. At a recent gallery exhibition in Amsterdam, Samiee lured one into imaginative speculation with his titles: *Nomads Depart, Prometheus in Low Lands, Dostoyevsky in China, Prometheus in High Lands, Yo Hamlet*! For his solo exhibition at Gemeente Museum den Haag, Samiee presented his paintings overlapping one another, or installed on the floor or, again, in a box-like diorama. Canvases were rarely square. He also brought in historic works from the collection. This distortion or (albeit controlled) chaos, and his enigmatic use of titles, serve to uproot a sense of a single perspective, as the artist undermines his own authorial control, refusing the viewer's desire for didactic artistic intent. The title of the exhibition, *Love is Displaced, Reason Goes in Search of It*, was taken

from a Manichaean poem which the artist displayed in the space. Manichaeism, a religious movement founded by the Iranian prophet Mani, envisages a cosmology incorporating Buddhist, Christian and Zoroastrian thinking. This multidimensional theology informs much of Samiee's approach to art-making, formally as well as theoretically: Mani, a painter, illustrated his written teaching with imagery. Within the *Picture-Book*, as it became known in later records, there was an incantation of Mani's spiritual teachings into the visible realm, a kind of storytelling in which the meaning is both made material but remains in flux. Likewise, the language that the artist has teased out through his broad research, but is uniquely his, presents proposition after proposition for artworks, suggestions for tales to be told by both artist and viewer, painterly narratives to be found among those exuberant brushstrokes.

1 *Encyclopædia Iranica defines adab as* 'education, culture, good behaviour, politeness, proper demeanour; thus it is closely linked with the concept of ethics... *adab* may be defined in general as ideal refinement of thought, word, and deed. Ways of implementing this ideal in every field are specified by precise rules, whose main common characteristic is regard for proportion (*andāza*) or moderation (*mīāna-ravi*) in conduct.'

Oliver Basciano is a writer based in London. Since 2010, he has worked at *ArtReview* magazine where he is currently International Editor.

Sam Samiee
The Unfinished Copernican Revolution, 2018
Acrylic on wood and paper
135 × 100 × 80 cm (53¼ × 39½ × 31½ in)
Installation view at 10th Berlin Biennale, 2018

Sam Samiee
Untitled: A Map of USA, Seven Designs for a Money Note, Nr. 7, 2018
Acrylic on canvas
275 × 327 cm (108¼ × 128¾ in)

The Fabulous Theology of Koh-i-noor (Theologia Theatrica de Koh-i-noor), 2019
Acrylic on Japanese rice paper, canvas, paper, balsa sticks, ceramic. Dimensions variable

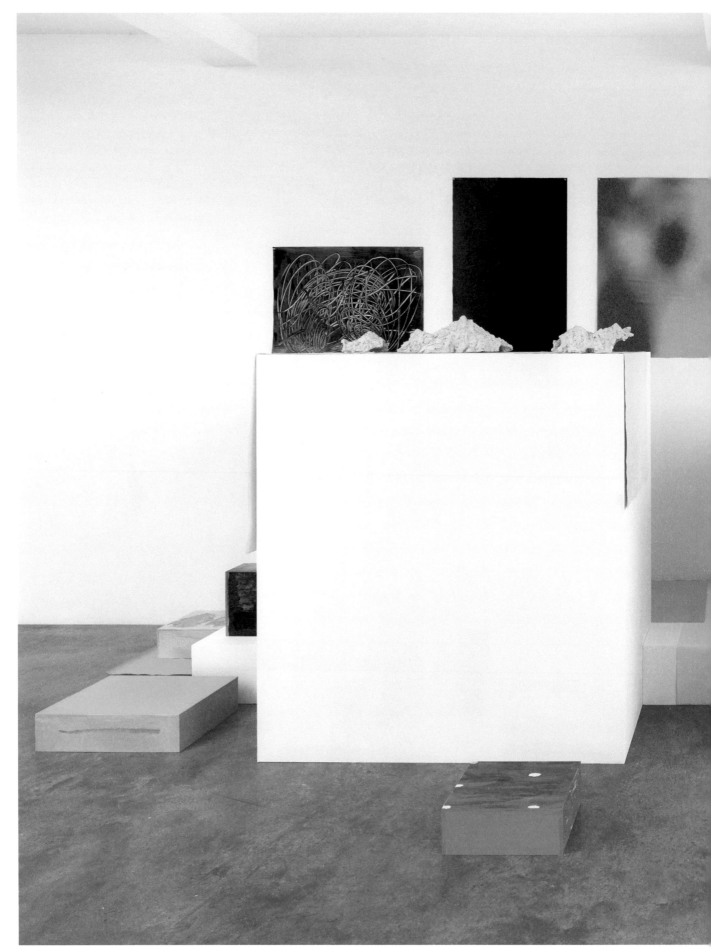

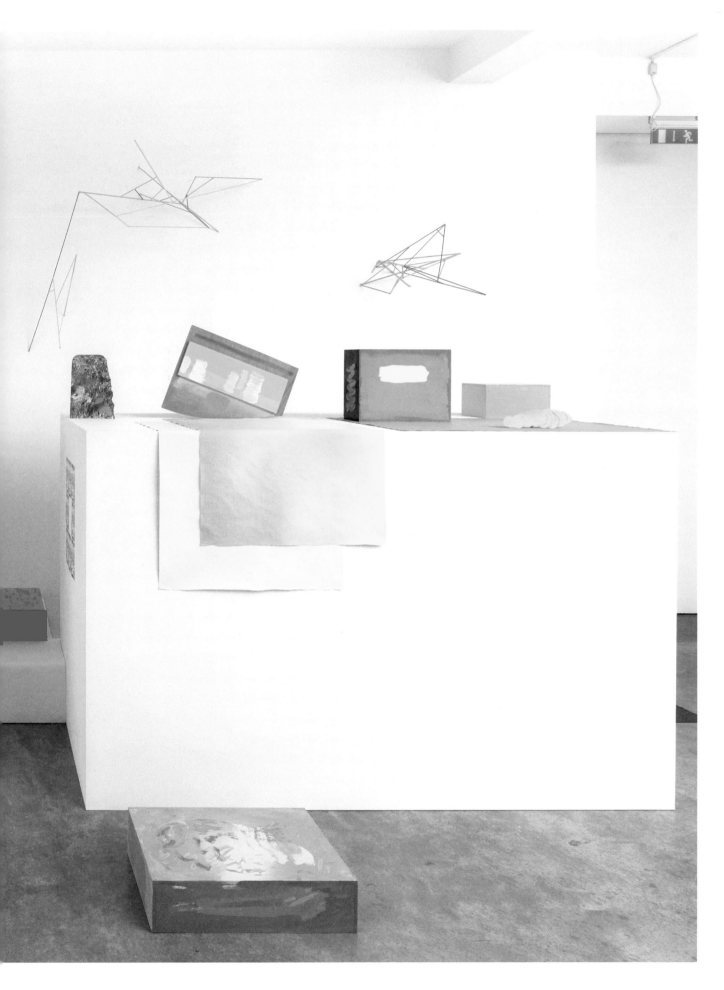

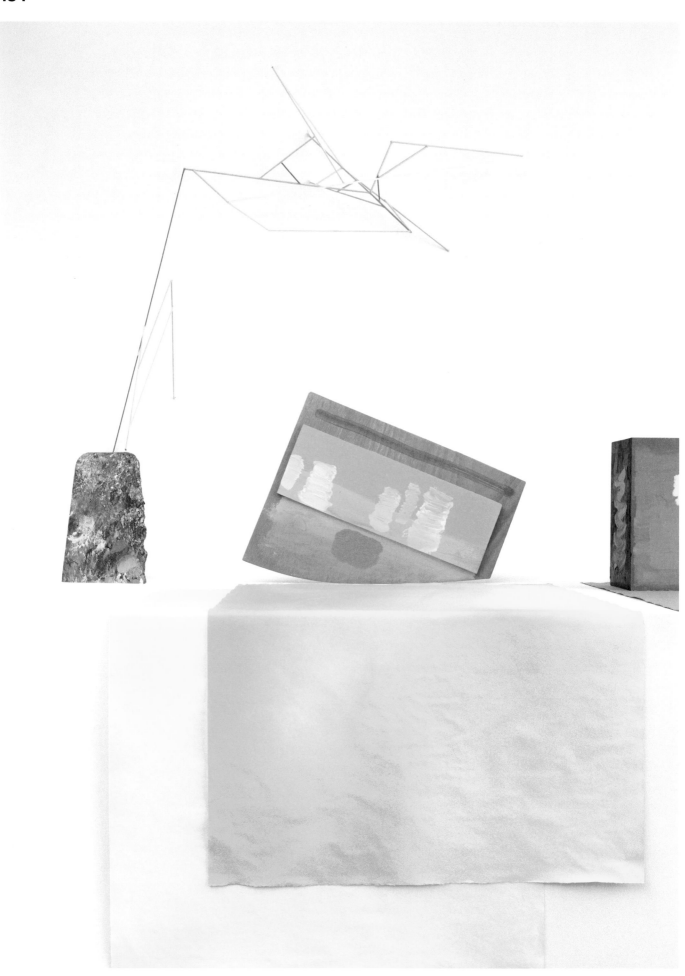

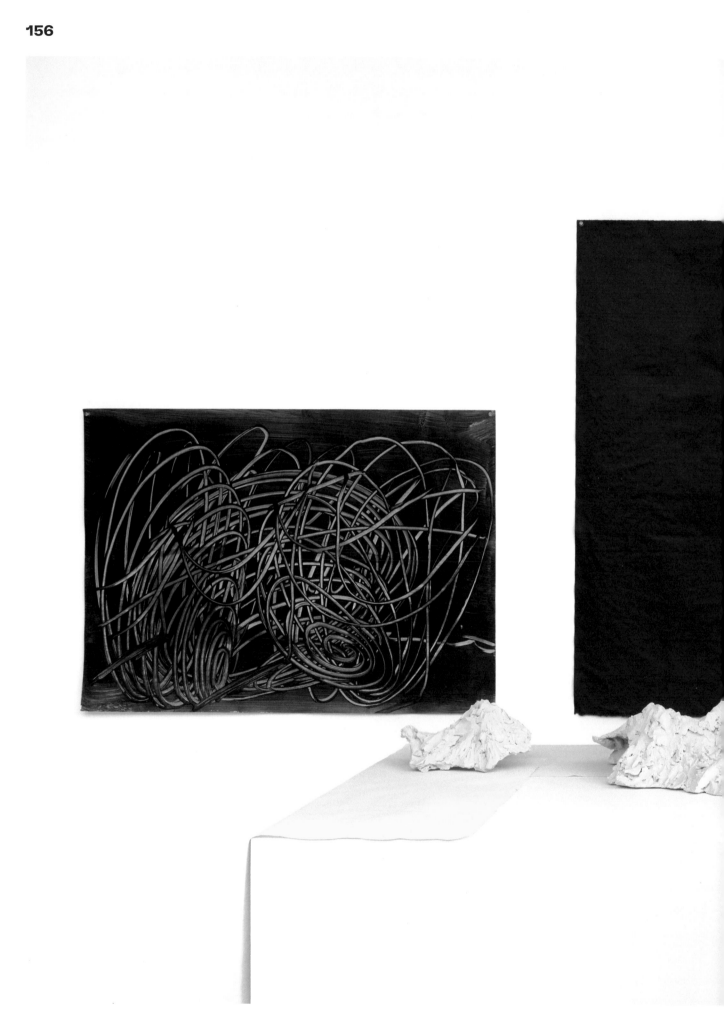

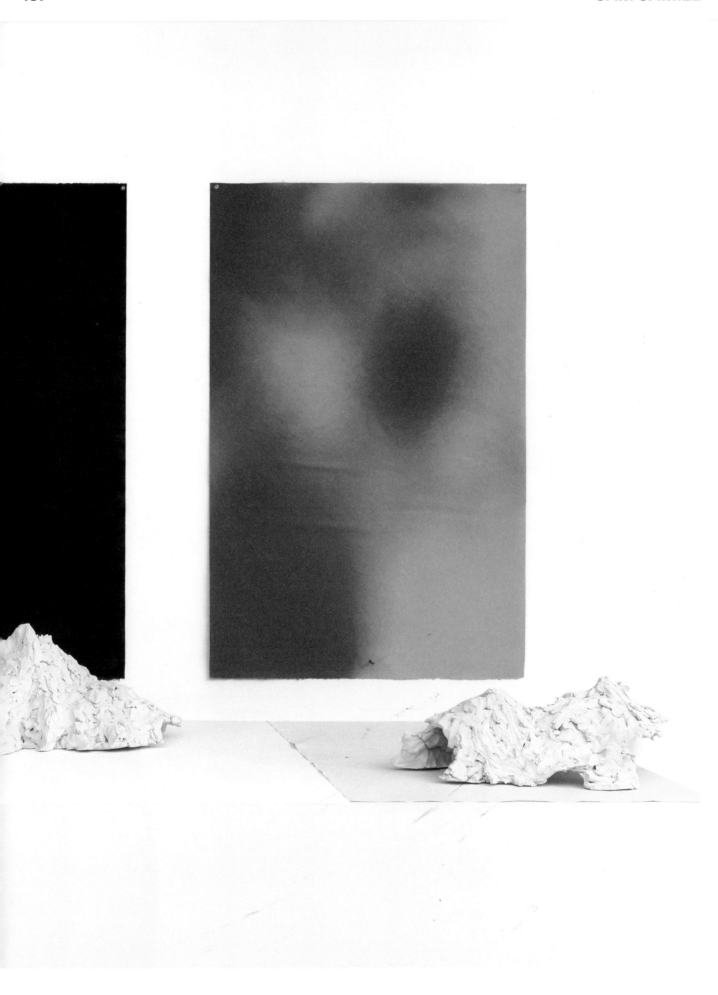

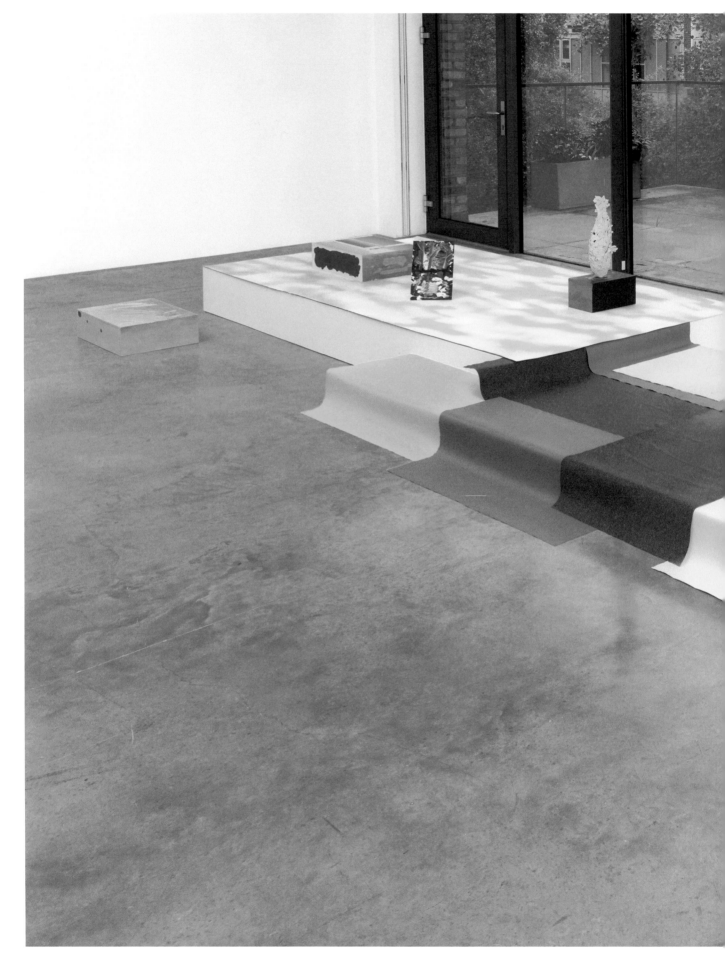

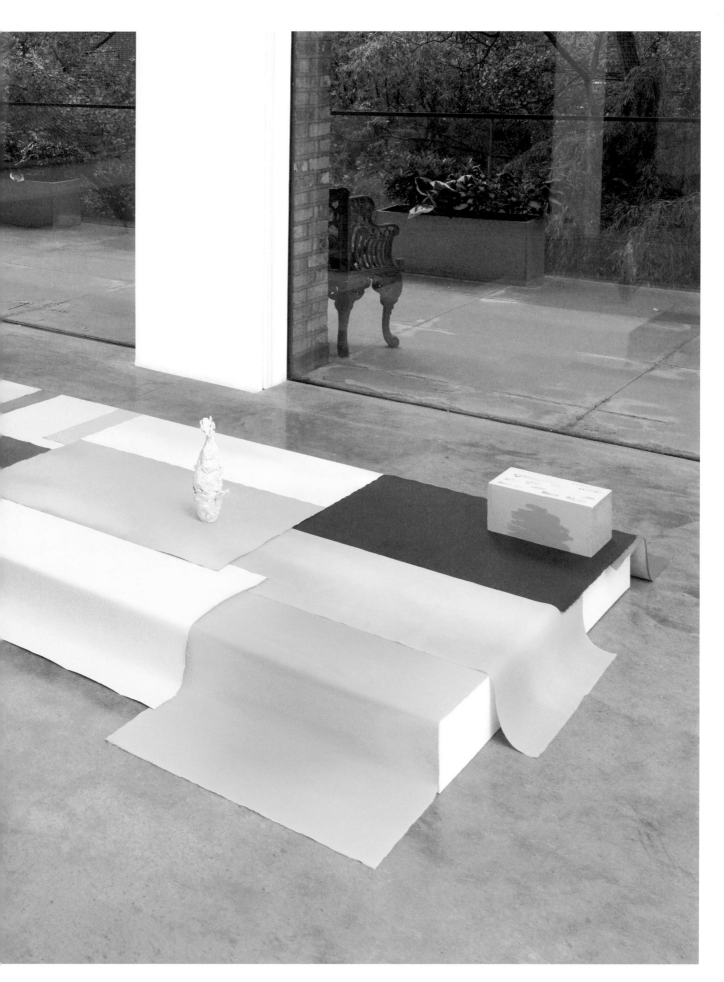

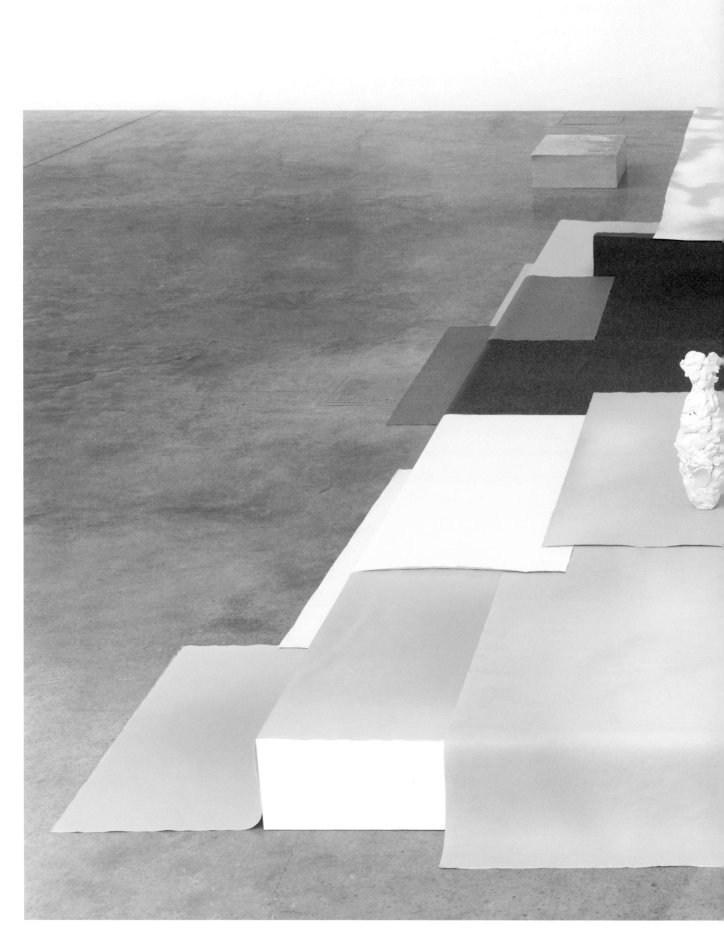

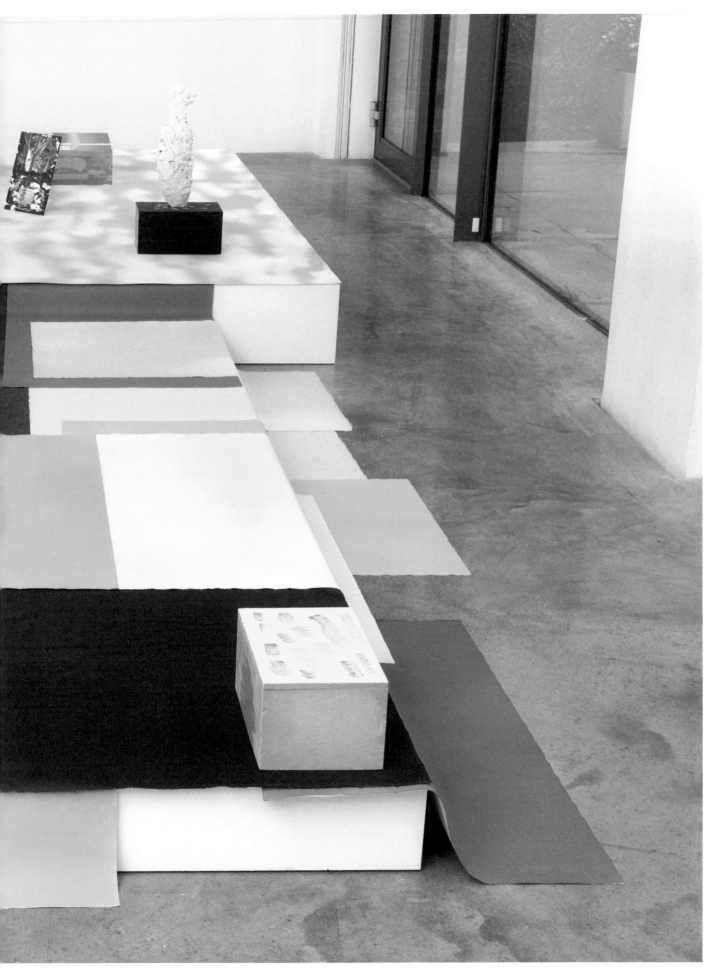

164
Hadi Tabatabai
At the Edge of Perception

MARIA PORGES

I. Limen

The problem with language is that it is made out of words. I can tell you about a person, a place; a smell, a sound, or a quality of light, but my description is just an abstraction of the things I am talking about. Although a word can evoke a feeling (and often does), there is no guarantee that the contents of a powerful phrase: the associations that lie beneath its skin, will be the same for you that they are for me. Unable to enter each other's minds, we can never be sure that our experience of things truly coincides – that the colour of the sky or the taste of rice is the same for us both. All we really know (or think we know) is that what we call rice isn't what we call blue.[1]

Working within a strictly limited set of variables, Hadi Tabatabai has spent the past two decades exploring a visual realm that can only be imperfectly described in words or revealed in reproductions. Rigorously investigating the transitional spaces between mark and matrix: working in the delicate, almost invisible margin between planes of thread and the materials to which he affixes them, Tabatabai draws his viewer's eyes to the limen, or edge, of perception. To him, this is the place where the real experience of his work exists.

For the most part, Tabatabai's work defies categorisation, in that it frequently combines sculpture, drawing and painting. For the purposes of this essay, however, his pieces can be said to fall into one of four groups: objects that are essentially in the traditional painting format and hang on the wall; works that are made or installed directly into the wall's surface; works consisting of multiple modular elements that attach to that surface, incorporating it as part of the work; and installation pieces. *Transitional Spaces* [pp. 166–169], Tabatabai's contribution to this exhibition, represents the last of these. In it, the artist's evocation of liminal space becomes fully three-dimensional, creating an experience that, even more than his wall-bound work, requires the viewer to experience its ethereal planes of painted thread from multiple viewpoints, to visually enter its world.

The planes of thread in *Transitional Spaces* recall the warp of a loom before weaving begins. The work is a freestanding installation consisting of a low plinth which holds a central panel, measuring 213 × 122 × 2 cm

(84 × 48 × 6 in), that has been painted black on its front and back. It faces three additional panels of the same dimensions on either side of it, each separated by a distance of 45 cm. These panels consist of a layer of individual strands of white thread, stretched vertically over an open frame at 1.6 mm intervals. A rectangular section of the thread on each panel has been painted black, creating a visual 'portal' when viewed from either side, as if the distance between the membranes of thread and the central black panel disappears.

Transitional Spaces functions as a painting that has come off the wall and become an immersive experience. Each of the piece's six thread panels includes nearly 800 strands stretched vertically, adding up to a total of 11 km of thread. The rectangle of black painted on each panel leads the viewer's eyes towards and seemingly through the piece's dark centre.

Although virtually every process that the artist has devised to make his work is almost inconceivably labour intensive, his practice is not an exaltation of such labour. Instead, it suggests a willingness to do whatever it takes to make objects that are as perfectly evocative of liminality as possible. In recent drawings, luminescent floating fields of blue are created by delicately applying seven or eight layers of coloured pencil with a layer of acrylic varnish between each successive application. In another group of pieces, the artist cuts a series of shallow grooves with a laser. Having filled them in with paint, he then sands the surface. Ten successive layers of paint, each meticulously sanded, are required to fill the whole cavity.

The laser cutter is the most recent addition to Tabatabai's otherwise traditional arsenal of tools and methods. To Tabatabai, however, the ultramodern laser is merely a means to an end, no different from a straight edge. He describes his current use of it as accidental, in that what he wanted to do was to laser-cut a bevel, which turned out to be impossible. Experimenting, he discovered that an 'incomplete' cut – a groove – offered new possibilities. In another series, the shadows cast by these tiny incisions into the matrix of Plexiglas constitute the lines that the viewer sees – a grid formed by absence, rather than presence.

Much of the artist's practice is devoted to this kind of legerdemain – gestures and practices that suggest

simplicity and effortlessness, when the opposite is true. Tabatabai asserts that this is a by-product of his motivation to make the work. He sees it as part of a life-long learning process, describing it as an attempt to understand consciousness and create an ineffable, indescribable experience.

II. *Sodachi*

In the Japanese language, the word *sodachi* is used to describe the place where someone was born and raised, as well as the process and experience of childhood itself. Behind that identification lies the implicit belief that every location has a distinct and unique effect. Being from somewhere – even if one has left that place, and can never return – shapes one irrevocably, like the shake of the genetic dice that randomly hands down certain physical traits.

Born in Mashhad, Iran, Tabatabai spent only the first 13 years of his life there before emigrating to the United States. His experiences and memories of Iran are, as he puts it, essentially frozen in time; for him it will always be the place he left in 1977, before the revolution transformed the country. Settling in the Bay Area of San Francisco, he became a first generation immigrant, attending local schools and obtaining degrees, first in construction engineering, then in painting. Although he has lived in California for more than forty years, he will always be an Iranian-American.

Taken as a whole, Tabatabai's work suggests that 'what's past is prologue',[2] meaning, everything in his life has created the conditions in which he functions as an artist, as well as the reasons for him making art. In conversa-tion, he recounted a story that he read as a child. 'An old man is planting a walnut tree in his yard. When a passer-by asks why he plants a tree when he will never see the fruit from it, the old man says, "Others planted so that I would have fruit, so I am planting so that others will eat."' The purpose of our lives, the story suggests – and, for Tabatabai, of art – is to be of both mundane and spiritual service, both now and in the future when only the art remains.

Stripped down to a minimal number of variables, almost ascetic in its purity and truth to materials, Tabatabai's project can be seen as the culmination of a progression of similarly visionary modernist forebears. These include both Ad Reinhardt's austere black paintings and Agnes Martin's grids of pencil lines. However, there are also other, non-Western influences framing Tabatabai's elegant explorations. Many of the methods and materials incor-porated into his practice resonate both with Iran's rich textile traditions and the widespread presence of non-representational pattern in tile-work and mosaics. Seen in this context, Tabatabai's use of thread as line and grid is at once innovative, original and part of an age-old lineage. Whether *Transitional Spaces* is a journey into the unknown or the familiar, the past or the future, Tabatabai means it to lead us to a meditative space wherein resides the sublime.

1 M.F. Porges, 'Blue Rice', *Shortest Stories*, 2017.
2 William Shakespeare, *The Tempest*, Act 2, Scene 1.

Maria Porges, an artist and writer based in San Francisco, is Professor at California College of the Arts.

Transitional Spaces, 2017. Thread, acrylic paint, aluminium frame, wooden platform
213 × 122 × 305 cm (84 × 48 × 120 in)

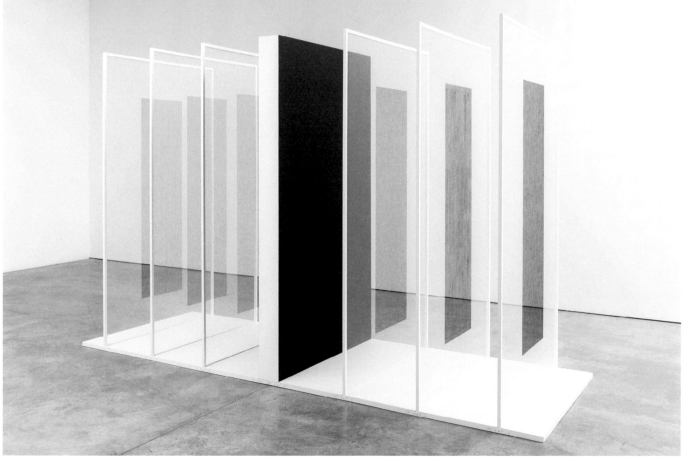

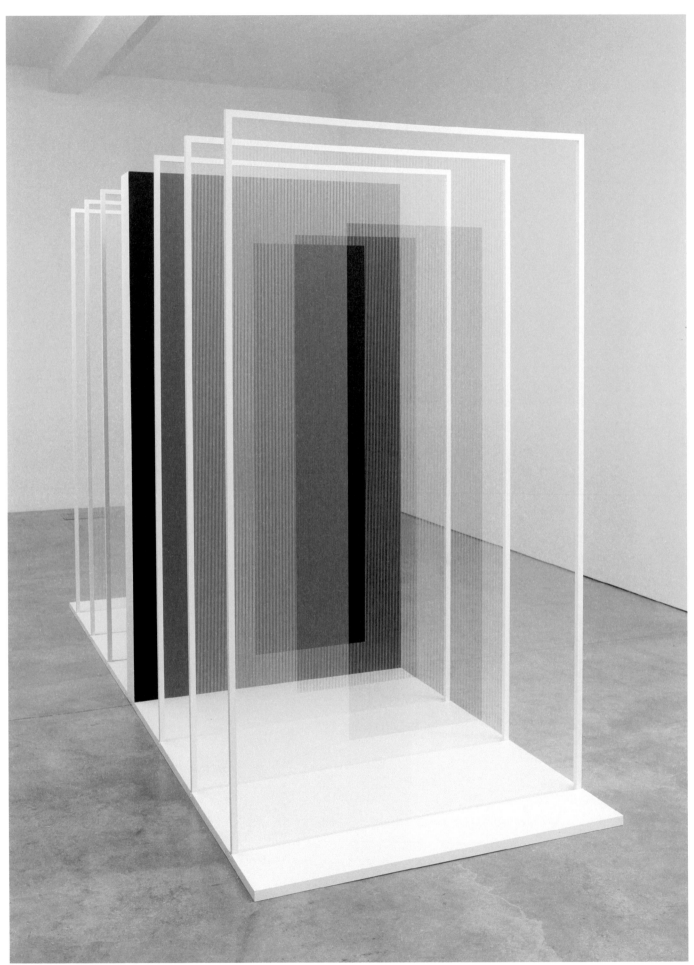

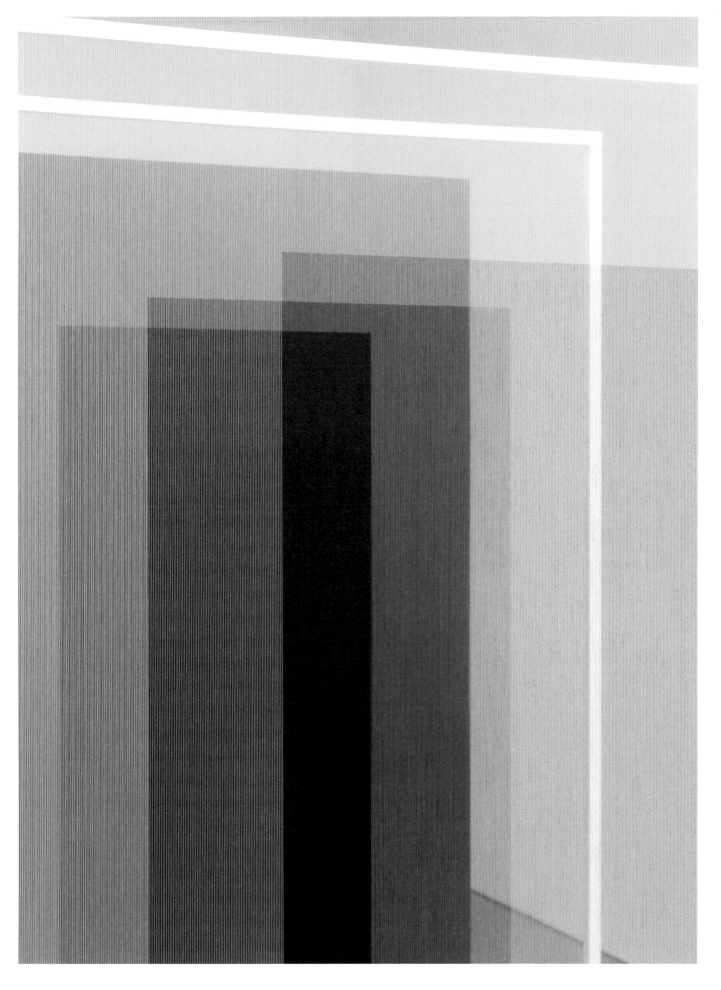

SARAH THOMAS

Hossein Valamanesh's *Lotus Vault #2*, 2013, [p.172–175] was inspired by a visit in 2010 to the Masjed-e Jāmé (Friday mosque) in Isfahan, a remarkable building whose origins lie in the ninth century and which became a prototype for mosque design throughout Central Asia. Geometric patterning in art and architecture is widely considered to have reached its apotheosis in the Islamic world, drawing in late antiquity from Greek, Roman and Sassanian traditions: Islamic artists elaborated on them, designing a new form of decoration which emphasised the significance of order and unity.[1] Valamanesh lovingly evokes here the patterned vault of the Jāmé Mosque, brick by brick, using lotus leaves purchased from Chinatown in his home city of Adelaide, South Australia.

Valamanesh emigrated from Iran to Australia in 1973, leaving behind the intense period of modernisation and westernisation under the rule of the country's last Shah. His work is an evolving meditation on the patterns, practices, and metaphysical poetry of his homeland: love, transcendence, free will, transculturation and personal identity are all concerns that have endured in his practice over almost five decades, inspired in part by the Sufi poetry that he grew up listening to at home, much of it committed to memory. In an earlier work crafted from lotus leaves, *Untitled*, 1995, the artist evokes a human shadow emerging from the veined foliage of a neatly folded shirt. The shadow is embodied in Persian script, a poem by the Sufi poet Rumi: 'I tear my shirt with every breath', it reads, 'for the extent of joy and ecstasy of being in love; now he has become all my being and I am only a shirt.'[2]

Yet while Valamanesh continues to identify closely with Persia and its rich cultural and intellectual history, it is in Australia that his artistic career has crystallised. Valamanesh's cosmopolitanism complicates Goethe's 'East-West' binary, reminding us that in today's evolving geo-political landscape we can no longer ignore the longitudinal dialogue between the 'North' and a newly emergent 'Global South'. Walter Mignolo argues that today the world order is being 're-mapped' in ways that cut through the 'North-South' and 'East-West' divides. Such remapping, he says, leads us to borders: 'physical, epistemic, ethic, religious, psychological, and aesthetic. Dwelling in the borders creates the conditions for border thinking, doing and being. That is, for border epistemology, praxis and ontology.'[3]

Valamanesh's practice dwells in such borderlands, encouraging us to think anew about geo-cultural circuits of influence and hybrid forms. A year after first arriving in Australia he was invited with several other artists and musicians to visit some of the remote Aboriginal communities in Australia's central desert. Here he witnessed the painting of traditional Dreamtime narratives, as well as sacred ceremonies. Profoundly moved by what he saw and keen to explore his own personal stories, he later reflected: 'What was overwhelming about this experience was witnessing our connection to nature and the universe. It did not seem to matter where we had come from and I felt I was part of the ceremony. The effects on my practice were both physical, through the use of natural materials, and metaphysical by recognition of such a connection.'[4]

In *Longing Belonging*, 1997, a fire burns brightly in the middle of a *Qashqa'i* rug which lies strangely within an Australian mallee landscape on the edge of the desert.[5] Here Valamanesh has drawn on memories from early childhood in the remote town of Khash (in the province of Sistan-e Baluchestan near the border of Pakistan) where he would play on such rugs, with their arabesque patterns and saturated colours evoking in his young mind a vision of mountainous pathways, rivers, expanses of desert and ocean.[6] The fire here is alluring, a source of warmth and fuel for cooking, a place for the family to gather: yet it also threatens unbridled destruction if left unchecked. In his practice Valamanesh likes to play with fire, meditating on its transformative power and its elemental ability to connect cultures beyond borders.

Just as the designs on the *Qashqa'i* rug encouraged the imaginative reveries of a young child, so the tessellated patterns in Lotus *Vault #2* allow the mind to wander. Like fire, the work both repels with its shimmering optical effects while also drawing us closer to admire the finely wrought detail of its delicate materiality. Created with the painstaking precision of an architect (or indeed a bricklayer), the work pays homage to the dazzling complexity of Islamic geometry whilst resonating too with the cosmopolitan concerns of a global artist. Valamanesh delights in identifying common threads of humanity: natural materials, elemental forces, mystical poetry, ritual, emotion, order and unity.

1 Department of Islamic Art, 'Geometric Patterns in Islamic Art', *Heilbrunn Timeline of Art History*. New York: The Metropolitan Museum of Art, 2000–. http://www.metmuseum.org/toah/hd/geom/hd_geom.htm (October 2001).
2 Translated by the artist.

3 Walter D. Mignolo, 'The North of the South and the West of the East: A Provocation to the Question', IBRAAZ, *Contemporary Visual Culture in North Africa and the Middle East*, 6 November 2014, VI–VII, https://www.ibraaz.org/essays/108#top

4 Hossein Valamanesh in conversation with Ian North, 'Profiling Hossein: A Conversation with the Artist', *Hossein Valamanesh: Out of Nothingness*, Mary Knights and Ian North (eds), Adelaide: Wakefield Press, 2011, p. 3.

5 The Australian mallee is the habitat of a certain low-growing species of eucalyptus in semi-arid areas of the country.

6 Mary Knights, 'Longing Belonging', in *Hossein Valamanesh: Out of Nothingness*, op. cit., n. 4, p. 79.

Dr Sarah Thomas is Lecturer in History of Art and Museum Studies at Birkbeck, University of London. She was formerly Curator of Australian Art at the Art Gallery of South Australia.

Hossein Valamanesh
Untitled, 1995
Lotus leaves on gauze, synthetic
polymer paint
60 × 145 × 3.5 cm (23½ × 57 × 1½ in)

Kwementyaye (Kathleen) Petyarre
*Mountain Devil Lizard Dreaming
(with Winter Sandstorm)*, 1996
Synthetic polymer paint on canvas
184 × 184.5 cm (72½ × 72¾ in)

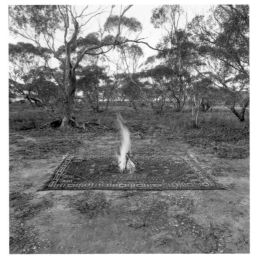

Hossein Valamanesh
Longing Belonging (detail), 1997
Direct colour positive photograph
99 × 99 cm (39 × 39 in)

Lotus Vault #2, 2013. Lotus leaves on paper on plywood. 210 × 525 cm (82¾ × 206¾ in)

MORTEZA AHMADVAND
Born 1981, Khoram Abad, Iran
Lives and works in Tehran, Iran

Education

2009 MA, Painting, University of Tehran, Iran
2006 BA, Painting, University of Yazd, Iran

Selected Solo and Duo Exhibitions

2018 *Becoming*, Etemad Gallery, Tehran, Iran
2014 *To Become*, Etemad Gallery, Tehran, Iran
2013 *Regards Persans, Kiarostami & Ahmadvand*, Musée de la Chasse et de la Nature, Paris, France
2011 *Video Art*, Etemad Gallery, Tehran, Iran
2009 The Visual Art Gallery of the University of Tehran, Tehran, Iran

Selected Group Exhibitions

2019 *The Spark Is You: Parasol unit in Venice*, Collateral Event of the 58th International Art Exhibition – La Biennale di Venezia, Conservatorio di Musica Benedetto Marcello di Venezia, Venice, Italy
Nine Iranian Artists in London: The Spark Is You, Parasol unit foundation for contemporary art, London, UK
2018 Spring Group Exhibition, Etemad Gallery, Tehran, Iran
2017 *Rebel, Jester, Mystic, Poet: Contemporary Persians*, Museum of Fine Arts Houston, TX, USA; Aga Khan Museum, Toronto, Canada
2013 Etemad Gallery, Dubai, UAE
2012 *Rewind, Pause, Fast Forward Mirrors on Iran*, Pi Artworks, Istanbul, Turkey
L'Iran pulse, São Paulo, Brazil
Lowave Rising Images, Centre Pompidou, Paris, France
2011 *1st International Video Art Festival*, Katara Art Center, Doha, Qatar
L'Iran pulse, São Paulo, Brazil
MOP CAP 2011 Shortlist Exhibition, Magic of Persia Contemporary Art Prize, Traffic Gallery, Dubai, UAE
2009 *Iran without Border*, Galerie Almine Rech, Paris, France
Fajr Afarinan, Saba Gallery, Tehran, Iran
2007 *New Art Exhibition*, Saba Gallery, Tehran, Iran
2006 *The Fourth International Painting Biennial of Islamic World*, Saba Gallery, Tehran, Iran

Picha Pouch, Tehran Gallery, University of Tehran, Iran
Young Artists Exhibition, University of Yazd, Yazd, Iran
2005 *Exhibition of Art Schools*, Bahman Gallery, Tehran, Iran
First Annual Drawing Exhibition, Karaj, Iran
Young Artists Exhibition, University of Yazd, Yazd, Iran
2004 *Exhibition of Art Universities*, Bahman Gallery, Tehran, Iran
Young Artists Exhibition, Kamal-el-Din Behzad Gallery, Tehran, Iran

Public Collections

Centre Pompidou, Paris, France
Musée de la chasse et de la nature, Paris, France
Boghossian Foundation, Brussels, Belgium

NAZGOL ANSARINIA
Born 1979, Tehran, Iran
Lives and works in Tehran, Iran

Education

2003 MFA, Design, California College of the Arts (CCA), San Francisco, USA
2001 BA (Honours) Graphic & Media Design, London College of Communication, University of the Arts, London, UK
1998 Foundation diploma, Art & Design, Chelsea College of Art & Design, University of the Arts, London, UK

Selected Solo Exhibitions

2018 *Demolishing buildings, buying waste*, Green Art Gallery, Dubai, UAE
2017 *Fragments, Particles and the Mechanisms of Growth*, KIOSK, Ghent, Belgium
2016 *Paper Trail*, Raffaella Cortese, Milan, Italy
2015 *Surfaces & Solids*, Green Art Gallery, Dubai, UAE
2014 *Change of Skin*, Aun Gallery, Tehran, Iran
2012 *Refractions/Subtractions*, Aun Gallery, Tehran, Iran
Reflections/Refractions, Daniela da Prato Gallery, Paris, France
2011 *Just Words*, The Free Word Centre, London, UK
Interior Renovations, Green Cardamom Gallery, London, UK

2010 *Patterns*, Aun Gallery, Tehran, Iran
2008 *Patterns*, Skånes Konstförening, Malmö, Sweden
2006 *Untitled (do not give your opinion)*, Ave Gallery, Tehran, Iran

Selected Group Exhibitions

2019 *The Spark Is You: Parasol unit in Venice*, Collateral Event of the 58th International Art Exhibition – La Biennale di Venezia, Conservatorio di Musica Benedetto Marcello di Venezia, Venice, Italy
Nine Iranian Artists in London: The Spark Is You, Parasol unit foundation for contemporary art, London, UK
UnDoing, curated by Tom Emery, Castlefield Gallery, Manchester, UK
2018 *Structures of Meaning | Architectures of Perception*, Manarat Al Saadiyat, Abu Dhabi, UAE
Punk Orientalism, curated by Sara Raza, Mackenzie Art Gallery, Saskatchewan, Regina, Canada
Remnants, curated by Sara Alonso Gómez, Green Art Gallery, Dubai, UAE
Slice and Dice, curated by Gregory Lang, Iréne Laub Gallery, Brussels, Belgium
Starting from the Desert. Ecologies on the Edge, Yinchuan Biennale, Yinchuan, China
Only the morning bird, REDCAT, Los Angeles, CA, USA
Long, Winding Journeys: Contemporary Art and the Islamic Tradition, Katonah Museum of Art, New York, USA
Women House, National Museum of Women in the Arts, Washington, DC, USA
2017 *Women House*, Monnaie de Paris, Paris, France
Rebel, Jester, Mystic, Poet: Contemporary Persians, Aga Khan Museum, Toronto, Canada
Variable Dimensions, Museum of Art, Architecture and Technology, Lisbon, Portugal
What We Know that We Don't Know, KADIST, San Francisco, CA, USA
Plant 9, Kunsthalle Darmstadt, Germany
2016 *Dimensoes Variaveis*, MATT, Museum of Art, Architecture and Technology, Lisbon, Portugal
The Eighth Climate (What Does Art Do?), Gwangju Bienniale, Gwangju, Korea
Schnitt Schnitt (Cut Cut), Kunsthalle Darmstadt, Germany
2015 *56th Venice Biennale*, Iranian Pavilion, Venice, Italy
Metatextile: Ruptured Narratives, Exchanged Values, Edel Assanti, London, UK

DUST, Centre for Contemporary Art, Ujazdowski Castle, Warsaw, Poland
Investment Opportunities, OFFICE Gallery, Cyprus
Adventure of the Black Square: Abstract Art and Society 1915–2015, Whitechapel Gallery, London, UK
2014 *Recalling The Future: post revolutionary Iranian art*, The Brunei Gallery, SOAS, London, UK
2013 *The Fascination of Persia*, Rietberg Museum, Zurich, Switzerland
Safar/Voyage, MOA – Museum of Anthropology, Vancouver, Canada
When Attitudes Became Form Become Attitudes, Museum of Contemporary Art, Detroit, MI, USA
The Statute of Limitations, Green Art Gallery, Dubai, UAE
2012 *A Permanent Record For Future Investigation*, Green Art Gallery, Dubai, UAE
Systems & Patterns, International Centre of Graphic Arts, Ljubljana, Slovenia
When Attitudes Became Form Become Attitudes, CCA Wattis Institute, San Francisco, CA, USA
Elephant in the Dark, Devi Art Foundation, Delhi, India
2011 *12th Istanbul Biennial*, Istanbul, Turkey
Interior Renovations, Tehran, 2010, Green Cardamom, London, UK
Drawn from Life, Abbot Hall Gallery, Kendal, UK
2010 *Tarjama/Translation*, Herbert F. Johnson Museum of Art, Ithaca, NY, USA
2009 *Abraaj Capital Art Prize*, Museum of Arts and Design, New York, USA
Iran Inside Out, Chelsea Art Museum, New York, USA
Made in Iran, Asia House, London, UK
Tarjama/Translation, Queens Museum of Art, New York, USA
2008 *Drawn from Life: process*, Green Cardamom Gallery, London, UK
Drawn from Life: space, Green Cardamom Gallery, London, UK
2007 *Nightcomers*, 10th Istanbul Biennial, Turkey
Retracing Territories, fri-art Centre d'Art Contemporain, Fribourg, Switzerland

Public Collections

Queensland Art Gallery | Gallery of Modern Art (QAGOMA), Brisbane, Australia
Los Angeles County Museum of Art (LACMA), Los Angeles, CA, USA

Tate Collection, London, UK
British Museum, London, UK
Devi Art Foundation, Delhi, India
SPM (Salsali Private Museum), Dubai, UAE
Kadist Art Foundation, Paris, France;
San Francisco, CA, USA

SIAH ARMAJANI
Born 1939, Tehran, Iran
Lives and works in Minneapolis, MN, USA

Education

1963 BA, Macalester College, Saint Paul, MN, USA

Selected Solo Exhibitions

2019 *Siah Armajani: Follow This Line*, a sixty-year
retrospective, The Met Breuer, New York, NY, USA
Siah Armajani: Bridge Over Tree, Brooklyn Bridge
Park, Brooklyn, NY, USA
2018 *Siah Armajani: Follow This Line*, a sixty-year
retrospective, Walker Art Center, Minneapolis,
MN, USA
2017 *Siah Armajani*, Rossi & Rossi Hong Kong, Hong Kong
2016 *Siah Armajani: Bridge Builder*, Kemper Museum
of Contemporary Art, Kansas City, MO, USA
Siah Armajani, Alexander Gray Associates, New
York, NY, USA
2014 *Siah Armajani: The Tomb Series*, Alexander Gray
Associates, New York, NY, USA
2013 *Siah Armajani: An Ingenious World*, Parasol unit
foundation for contemporary art, London, UK
Siah Armajani: Bridges for Paris Transit System,
MAMCO, Geneva, Switzerland
2011 *Siah Armajani: 1957–1964*, Meulensteen Gallery,
New York, NY, USA
2009 *Siah Armajani: Murder in Tehran*, Max Protetch
Gallery, New York, NY, USA
Siah Armajani: 3 Sculptures 3 Drawings, Max
Protetch Gallery, New York, NY, USA
2008 *Siah Armajani: Dialogue with Democracy*,
The Nelson-Atkins Museum of Art, Kansas City,
MO, USA
2007 *Siah Armajani: Fallujah*, Artium, Vitoria-Gasteiz,
Spain; Centro de Arte y Naturaleza/Fundación;
Fundación Beulas, Huesca, Spain; Fundación
Cesar Manrique, Lanzarote, Canary Islands;
Santa Fe Art Institute, NM, USA
*Siah Armajani: L'art n'est pas le salon de beauté
de la civilisation*, MAMCO Musée d'art moderne
et contemporain, Geneva, Switzerland
2005 *Siah Armajani*, Weinstein Gallery, Minneapolis,
MN, USA

2002 *Siah Armajani: Glass Room for an Exile and
Related Works*, Senior & Shopmaker Gallery,
New York, NY, USA
Siah Armajani, Jiri Svestka Gallery, Prague,
Czech Republic
2001 *Siah Armajani*, Senior & Shopmaker Gallery, New
York, NY, USA
2000 *Siah Armajani: Glass Room*, Senior & Shopmaker
Gallery, New York, NY, USA
Siah Armajani, University of Iowa, Iowa City,
IA, USA
Siah Armajani, Diputación de Huesca, Spain;
Fundación César Manrique, Lanzarote,
Canary Islands
1999 *Siah Armajani*, Museo Nacional Centro de Arte
Reina Sofia, Madrid, Spain
1998 *Park Furniture: Sculpture and City Center
Drawings*, Max Protetch Gallery, New York,
NY, USA
Dictionary for Building, The Matthew
Architecture Gallery, University of Edinburgh,
Scotland, UK
1997 *Siah Armajani: The Poetry of Public Art*,
Beloit College, Beloit, WI, USA
*Musterwohnen: Siah Armajani, Room Furniture
No. 1 A Chair for Gropius*, Berlin, Germany
1996 *Anarchistic Contributions 1962–1994*, Neue
Galerie am Landesmuseum Johanneum, Graz,
Austria
Siah Armajani: Reading Spaces, Museu d'Art
Contemporani de Barcelona, Spain
Siah Armajani: Streets and Street Corners,
Gallery Joe, Philadelphia, PA, USA
*Siah Armajani: The Staten Island Ferry Pedestrian
Bridge and Other Works*, Newhouse Center
for Contemporary Art, Snug Harbor Cultural
Center, Staten Island, NY, USA
Siah Armajani, The Customs House, Newcastle, UK
1995 *Siah Armajani*, MAMCO Musee d'Art Moderne et
Contemporain, Geneva, Switzerland
1994 *Siah Armajani, Sculpture and Public Art Projects*,
Ikon Gallery, Birmingham, UK
Anarchistic Contributions 1962–1994, Villa
Arson, Nice, France
Street Corners I, Max Protetch Gallery, New
York, NY, USA
Recent Works, Wright Museum, Beloit College,
Beloit, WI, USA
Common Houses, Swiss Institute, New York,
NY, USA
Streets, Storm King Art Center, Mountainville,
NY, USA
Streets, Max Protetch Gallery, New York,
NY, USA
1992 *Streets: Sculptures and Notations*, Arts Club
of Chicago, Chicago, IL, USA

The Poetry Garden, Lannan Foundation, Los Angeles, CA, USA

1991 *Elements*, Max Protetch Gallery, New York, NY, USA

1989 *Elements*, Max Protetch Gallery, New York, NY, USA

1988 *Siah Armajani, Sacco and Vanzetti Reading Room No. 2*, Hayden Gallery, List Visual Arts Center, Massachusetts Institute of Technology, Cambridge, MA, USA

1987 *Siah Armajani*, Max Protetch Gallery, New York, NY, USA
Siah Armajani, Kunsthalle Basel, Switzerland; Stedelijk Museum, Amsterdam, Netherlands; Galerie Rudolf Zwirner, Cologne, Germany; Galerie Ghislaine-Hussenot, Paris, France
Siah Armajani: Reading Room Sacco & Vanzetti, Westfälisches Landesmuseum für Kunst und Kulturgeschichte, Münster, Germany; Porikus, Frankfurt, Germany

1985 *Dictionary for Building IV*, Max Protetch Gallery, New York, NY, USA
Siah Armajani: Bridges, Houses, Communal Spaces, Dictionary for Building, Institute of Contemporary Art, University of Pennsylvania, Pennsylvania, PA, USA

1984 *Dictionary For Building III*, Max Protetch Gallery, New York, NY, USA

1983 *Dictionary For Building II*, Max Protetch Gallery, New York, NY, USA

1982 *Siah Armajani Constructions: The Dictionary Series*, Fleisher Galleries, Philadelphia, PA, USA
Poetry Lounge, Baxter Art Gallery, California Institute of Technology, Pasadena, CA, USA
Picnic Garden, Grand Rapids Art Museum, Grand Rapids, MI, USA

1981 *Office for Four*, Hudson River Museum, Yonkers, NY, USA
Dictionary for Building I, Max Protetch Gallery, New York, NY, USA

1980 *Newsstand*, Contemporary Art Center, Cincinnati, OH, USA

1979 *First Reading Room*, Max Protetch Gallery, New York, NY; New Gallery of Contemporary Art, Cleveland, OH; Kansas City Art Institute, Kansas City, MO, USA
Reading Room No. 2, Sullivan Hall Gallery, Ohio State University, Columbus, OH, USA

1978 *Red School House for Thomas Paine*, Philadelphia College of Art, Philadelphia, PA, USA

1977 *Thomas Jefferson's House: West Wing–Sunset House*, Walker Art Center, Minneapolis, MN, USA

Selected Group Exhibitions

2019 *The Spark Is You: Parasol unit in Venice*, Collateral Event of the 58th International Art Exhibition – La Biennale di Venezia, Conservatorio di Musica Benedetto Marcello di Venezia, Venice, Italy

2016 *(INFRA) STRUCTURE: complex, below and further on*, Lannan Foundation Gallery, Santa Fe, NM, USA
Passages in Modern Art: 1946–1996, Dallas Museum of Art, Dallas, TX, USA

2015 *Passage*, Alexander Gray Associates, New York, NY, USA
cycle, Des histoires sans fin, séquence automne-hiver 2015–2016, Musée d'art moderne et contemporain (MAMCO), Geneva, Switzerland
75 Gifts for 75 Years, Walker Art Center, Minneapolis, MN, USA
Bricologie: La Souris et le perroquet, Villa Arson, Nice, France

2014 *Art Expanded, 1958–1978*, Walker Art Center, Minneapolis, MN, USA
Art at the Center: 75 Years of Walker Collections, curated by Olga Viso and Joan Rothfuss, Walker Art Center, Minneapolis, MN, USA

2013 *Iran Modern*, Asia Society, New York, NY, USA
Modern Iranian Art: Selections from the Abby Weed Grey Collection at New York University, Grey Art Gallery, New York, NY, USA
It's New / It's Now, Minneapolis Institute of Art, Minneapolis, MN, USA

2011 *September 11*, MoMA PS1, Long Island City, NY, USA
Site Conditioned, Donna Beam Fine Art Gallery, University of Nevada, Las Vegas, NV, USA
Drawings for the New Century (Mississippi Delta 2005–2006), Minneapolis Institute of Arts (MIA), Minneapolis, MN, USA
The Spectacular of Vernacular, Walker Arts Center, Minneapolis, MN, USA

2010 *Until Now: Collecting the New (1960–2010)*, Minneapolis Institute of Arts, Minneapolis, MN, USA

2009 *Event Horizon*, Walker Art Center, Minneapolis, MN, USA

2008 *Artists and War*, North Dakota Museum of Art, Grand Forks, ND, USA
The Interior: Contemporary Photographic Views, Weinstein Gallery, Minneapolis, MN, USA

2007 *Arte y derechos civiles en el nuevo (des)orden global*, Fundación César Manrique, Lanzarote, Canary Islands

2006 *The Contemporary Persian Scene: The American and European Experience*, LTMH Gallery, New York, NY, USA
Word into Art: Artists of the Modern Middle East, British Museum, London, UK
Between the Lakes: Artists Respond to Madison, Madison Museum of Contemporary Art, Madison, WI, USA

2004 *Gardens of Iran: Ancient Wisdom, New Visions*, Tehran Museum of Contemporary Art, Tehran, Iran
Architecture and Arts: 1900–2000, curated by

Germano Celant, Palazzo Ducale, Genoa, Italy
Far Near Distance: Contemporary Positions of Iranian Artists, House of World Cultures, Berlin, Germany
Symmetries: Armajani, Artschwager, Le Va, LeWitt, Senior & Shopmaker Gallery, New York, NY, USA

2002 *Between Word and Image: Modern Iranian Visual Culture*, Grey Art Gallery, New York, NY, USA
Doors: Image and Metaphor in Contemporary Art, curated by Nancy Cohen and Alice Dillon, Visual Arts Center of New Jersey, Summit, NJ, USA

2001 *Drawing Projects: Drawings by Seven Artists*, Gallery Joe, Philadelphia, PA, USA
New Work: Recent Additions to the Collection, Addison Gallery of American Art, Andover, MA, USA
Follies: Fantasy in the Landscape, Parrish Art Museum, Southampton, NY, USA

2000 *Sculptor's Drawings*, Gallery Joe, Philadelphia, PA, USA

1998 *The Last Room for Noam Chomsky*, MoMA PS1, Long Island City, NY, USA

1997 *National Airport Artists on Paper*, Numark Gallery, Washington, DC, USA
Views from Abroad: European Perspectives on American Art, Museum für Moderne Kunst, Frankfurt, Germany

1996 *Monument et modernité: Etat des lieux: commandes publiques en France, 1990–1996*, Musée du Luxembourg, Paris, France
The House Transformed, Barbara Mathes Gallery, New York, NY, USA

1993 *Unpainted to the Last: Moby-Dick and Twentieth-Century American Art*, Spencer Museum of Art, University of Kansas, Lawrence, KS, USA
Différentes natures: Visions de l'art contemporain, Place de la Défense, Paris, France

1992 *Century of Sculpture*, Stedelijk Museum and Nieuwe Kerk Foundation, Amsterdam, Netherlands
Like Nothing Else in Tennessee, Serpentine Galleries, London, UK

1991 *Green*, Max Protetch Gallery, New York, NY, USA
20th-Century Art, Museum für Moderne Kunst, Frankfurt, Germany
Open Mind: The LeWitt Collection, Wadsworth Atheneum, Hartford, CT, USA
Enclosures and Encounters: Architectural Aspects of Recent Sculpture, Storm King Art Center, Mountainville, NY, USA
Height x Width x Length: Contemporary Sculpture from the Weatherspoon, Weatherspoon Art Museum, Greensboro, NC, USA

1990 *Culture and Commentary: An Eighties Perspective*, Hirshhorn Museum and Sculpture Garden, Washington, DC, USA

1988 *Sculpture Inside Outside*, curated by Martin Friedman, Walker Art Center, Minneapolis, MN, USA
Carnegie International, Carnegie Museum of Art, Pittsburgh, PA, USA
View Points: Post-War Painting and Sculpture, Solomon R. Guggenheim Museum, New York, NY, USA
Thomas Struth and Siah Armajani, Portikus, Frankfurt am Main, Germany

1987 *Avant-Garde in the Eighties*, Los Angeles County Museum of Art, Los Angeles, CA, USA
Emerging Artists 1978–1986: Selections From the Exxon Series, Solomon R. Guggenheim Museum, New York, NY, USA
Skulptur Projekte Münster 1987, Westfälische Landesmuseum für Kunst und Kulturgeschichte, Münster, Germany
Documenta 8, curated by Manfred Schneckenburger, Kassel, Germany

1986 *An American Renaissance: Painting and Sculpture since 1940*, NSU Art Museum, Fort Lauderdale, FL, USA
Bridges, Multicultural Arts Center, Cambridge, USA
Sonsbeek 86, Arnhem, Netherlands
Painting and Sculpture Today, Indianapolis Museum of Art, Indianapolis, IN, USA
Second Sight: Biennial IV, San Francisco Museum of Modern Art, San Francisco, CA, USA
The Artist as Social Designer: Aspects of Public Urban Life Today, Los Angeles County Museum of Art, Los Angeles, CA, USA

1984 *Content: A Contemporary Focus, 1974–1984*, Hirshhorn Museum and Sculpture Garden, Washington, DC, USA
Furniture, Furnishings: Subject and Object, Museum of Art, Rhode Island School of Design, Providence, RI; Wesleyan University, Middletown, CT; Munson-Williams-Proctor Arts Institute, Utica, New York; Berkshire Museum, Pittsfield, MA; Vassar College, Poughkeepsie, NY; Brattleboro Museum and Art Center, Brattleboro, VT; Maryland Institute College of Art, Baltimore, MA, USA
An International Survey of Recent Painting and Sculpture, Museum of Modern Art, New York, NY, USA

1983 *Beyond the Monument*, Hayden Gallery, Massachusetts Institute of Technology, Cambridge, MA; Mandeville Art Gallery, University of California at San Diego, CA, USA
Connections: Bridges / Ladders / Ramps / Staircases / Tunnels, Institute of Contemporary Art, University of Pennsylvania, Philadelphia, PA, USA
Directions 1983, Hirshhorn Museum and Sculpture Garden, Washington, DC, USA

Habitats, curated by Robert Littman, Clocktower Gallery, New York, NY; Klein Gallery, Chicago, IL, USA
New Art, Tate Gallery, London, UK
Objects, Structures, Artifice: American Sculpture 1970–1983, University of South Florida, Tampa, FL, USA

1982 *Documenta 7*, curated by Rudi Fuchs, Kassel, Germany
Postminimalism, Aldrich Contemporary Art Museum, Ridgefield, CT, USA

1981 *Artists' Gardens and Parks: Plans, Drawings and Photographs*, Hayden Gallery, Massachusetts Institute of Technology (MIT), Cambridge, MA; Museum of Contemporary Art, Chicago, IL, USA
Whitney Biennial, Whitney Museum of American Art, New York, NY, USA
Body Language: Figurative Aspects of Recent Art, Hayden Gallery, Massachusetts Institute of Technology, Cambridge, MA; Fort Worth Art Museum, Fort Worth, TX; University of South Florida, Tampa, FL; Contemporary Arts Center, Cincinnati, OH, USA
Metaphor: New Projects by Contemporary Sculptors, curated by Howard Fox, Hirshhorn Museum and Sculpture Garden, Washington, DC, USA

1980 *Architectural Sculpture*, Institute of Contemporary Art, Los Angeles, CA, USA
Drawings: The Pluralist Decade, 39th Venice Biennale, United States Pavilion, Venice, Italy; Henie-Onstad Museum, Oslo, Norway; Biblioteca Nacional, Madrid, Spain; Gulbenkian Museum, Lisbon, Portugal; Kunstforeningen Museum, Copenhagen, Denmark; Institute of Contemporary Art, University of Pennsylvania, Philadelphia, PA; Museum of Contemporary Art, Chicago, IL, USA

1979 *Art and Architecture: Space and Structure*, Protetch-McIntosh, Washington, DC, USA
The Artist's View, Wave Hill, Bronx, NY, USA

1978 *Architectural Analogues*, Whitney Museum of American Art, Downtown Branch, New York, NY, USA
Indoor-Outdoor Sculpture, The Institute for Contemporary Art, MoMA PS1, Long Island City, New York, NY, USA
Dwellings, Institute of Contemporary Art, University of Pennsylvania, Philadelphia, PA, USA
Young American Artists, Exxon National Exhibition, Solomon R. Guggenheim Museum, New York, NY, USA

1977 *Scale and Environment: 10 Sculptors*, Walker Art Center, Minneapolis, MN, USA

1976 *Commissioned Video Works: Skylight at Monticello*, University Art Museum, University of California at Berkeley, Berkeley, CA, USA

1975 *Sculpture for a New Era*, Federal Center, Chicago, IL, USA

1974 *Discussions: Works/Words*, The Institute for Contemporary Art, Clocktower, New York, NY, USA

1972 *Documenta V*, curated by Harald Szeemann, Kassel, Germany

1971 *The Boardwalk Show*, Convention Hall, Atlantic City, NJ, USA
Works for New Spaces, Walker Art Center, Minneapolis, MN, USA

1970 *Art in the Mind*, Allen Art Museum, Oberlin College, Oberlin, OH, USA
Information, Museum of Modern Art, New York, NY, USA
9 Artists / 9 Spaces, Walker Art Center, Minneapolis, MN, USA

1969 *Art by Telephone*, Museum of Contemporary Art, Chicago, IL, USA
Painting and Sculpture Today, Indianapolis Museum of Art, Indianapolis, IN, USA
Towers, Museum of Contemporary Art, Chicago, IL; Finch College Museum of Art, New York, NY; Cranbrook Academy of Art, Bloomfield Hills, MI, USA

Public Collections

Addison Gallery of American Art, Andover, MA, USA
Allen Memorial Art Museum, Oberlin, OH, USA
Art Institute of Chicago, Chicago, IL, USA
Artium de Alava, Vitoria-Gasteiz, Spain
The British Museum, London, UK
The Carnegie Museum of Art, Pittsburgh, PA, USA
CDAN | Centro de Arte y Naturaleza, Huesca, Spain
The Chase Manhattan Bank, New York, NY, USA
Dallas Museum of Art, Dallas, TX, USA
Dayton Art Institute, Dayton, OH, USA
Des Moines Art Center, Des Moines, IA, USA
Fundacion César Manrique, Lanzarote, Canary Islands
Grey Art Gallery, New York University Art Collection, New York, NY, USA
Guggenheim Museum, New York, NY, USA
Hirshhorn Museum and Sculpture Garden, Smithsonian Institution, Washington, DC, USA
Emanuel Hoffmann Stiftung Collection, Basel, Switzerland
The Kemper Museum of Contemporary Art, Kansas City, MO, USA
M+, Hong Kong
Menil Collection, Houston, TX, USA
Minneapolis Institute of Art, Minneapolis, MN, USA
MAMCO | Musée d'art moderne et contemporain, Geneva, Switzerland

Musée d'art moderne et contemporain, Strasbourg, France
Museum für Moderne Kunst, Frankfurt, Germany
Museum Ludwig, Cologne, Germany
Museum of Contemporary Art, Chicago, IL, USA
Museum of Contemporary Art, Los Angeles, CA, USA
The Metropolitan Museum of Art, New York, NY, USA
The Museum of Modern Art, New York, NY, USA
Nationalgalerie, Berlin, Germany
National Gallery of Art, Washington, DC, USA
Nelson-Atkins Museum of Art, Kansas City, MO, USA
Neuberger Museum, College at Purchase, State University of New York, Purchase, NY, USA
New Orleans Museum of Art, New Orleans, LA, USA
Ohio University, Bentley Hall and Annex, Athens, OH, USA
Pennsylvania Academy of Fine Arts, Philadelphia, PA, USA
Philadelphia Museum of Art, Philadelphia, PA, USA
Pratt Institute Sculpture Park, Brooklyn, NY, USA
Speed Art Museum, Louisville, KY, USA
Stedelijk Museum, Amsterdam, Netherlands
Storm King Art Center, Mountainville, NY, USA
University of Iowa Museum of Art, Iowa City, IA, USA
University of Minnesota, Hubert Humphrey Garden, HHH Institute, Minneapolis, MN, USA
Villa Arson, Centre national d'art contemporain, Nice, France
Walker Art Center, Minneapolis, MN, USA
Weatherspoon Art Museum, University of North Carolina, Greensboro, NC, USA
Westfälisches Landesmuseum, Munster, Germany
Wexner Center for the Arts, Ohio State University, Columbus, OH, USA

MITRA FARAHANI
Born 1975, Tehran, Iran
Lives and works in Paris, France, and Rome, Italy

Education

2000 École des Arts décoratifs, Paris, France
1997 BA, Graphic Art, Azad University, Tehran, Iran

Selected Group Exhibitions

2019 *The Spark Is You: Parasol unit in Venice*, Collateral Event of the 58th International Art Exhibition – La Biennale di Venezia, Conservatorio di Musica Benedetto Marcello di Venezia, Venice, Italy
2016 *Peace Treaty*, European Capital of Culture 2016, San Sebastian, Spain

2014 *Unedited History, Iran 1960–2014*, Musée d'Art moderne de la Ville de Paris, France; MAXXI Arte, Rome, Italy
Villa Medici, Rome, Italy

Filmography

2014 *David & Goliath N°45*
2012 *Fifi az Khoshhali Zooze Mikeshad* (Fifi Howls From Happiness)
2006 *Behjat Sadr: Time Suspended*
2004 *Tabous, Zohre & Manouchehr*
2001 *Just une femme* (Just a Woman)

GHAZALEH HEDAYAT
Born 1979, Tehran, Iran
Lives and works in Tehran, Iran

Education

2005 MFA, New Genres, San Francisco Art Institute, CA, USA
2002 BFA, Photography, Tehran Azad University, Tehran, Iran

Selected Solo Exhibitions

2019 *Repetition*, Emkan Gallery, Tehran, Iran
2017 *The Photo Essence*, Emkan Gallery, Tehran, Iran
2015 *Bygones*, AG Galerie, Tehran, Iran
2013 *Crust*, Azad Art Gallery, Tehran, Iran
2008 *The Strand and the Skin*, Azad Art Gallery, Tehran, Iran
2006 *Peepholes*, Silk Road Gallery, Tehran, Iran
2004 *Untitled* (the titles of garden-owning artists of Tehran Museum of Contemporary Art), Khak Gallery, Tehran, Iran

Selected Group Exhibitions

2019 *Nine Iranian Artists in London: The Spark Is You*, Parasol unit foundation for contemporary art, London, UK
Miradas Paralelas/Parallel Looks: Iran-Spain, Photographers in the Mirror, Museo Palau Solterra – Fundació Vila Casas, Girona, Spain
2018 *Miradas Paralelas/Parallel Looks: Iran-Spain, Photographers in the Mirror*, King Juan Carlos I of Spain Center, New York University, New York, USA; Centro Federico García Lorca, Granada, Spain
Genesis of a Latent Vision: A Window onto Contemporary Art Photography in Iran, curated by Mehrdad Nadjmabadi and Reza Sheikh, Fotografia Europea, Reggio Emilia, Italy

Runes: Photography and Decipherment, curated by Geoffrey Batchen and Justine Varga, Centre for Contemporary Photography, Melbourne, Australia

2017 *Miradas Paralelas/Parallel Looks: Iran-Spain, Photographers in the Mirror*, Museo Barjola, Gijón; Fundación Tres Culturas, Seville, Spain
Urban Mapping, IA&A at Hillyer, Washington, DC, USA
Iran: Year 38, Les Rencontres d'Arles, France

2016 *Miradas Paralelas/Parallel Looks: Iran-Spain, Photographers in the Mirror*, Silk Road Gallery, Tehran, Iran; Conde Duque, Madrid, Spain

2015 *SELF: Portraits of Artists in Their Absence*, National Academy Museum, New York, NY, USA
Unseen, Photo Fair, Amsterdam, Netherlands

2014 *Fragile Hands*, University of Applied Arts, Vienna, Austria
Recalling the future: post revolutionary Iranian art, Brunei Gallery at SOAS, London, UK
Exposition: Speaking from the Heart, Castrum Peregrini, Amsterdam, Netherlands

2013 *The Elephant in the Dark*, Devi Art Foundation, India

2012 *The (Iranian) Weltanschauung*, Freies Museum, Berlin, Germany

2011 *MOP CAP 2011 Shortlist Exhibition, Magic of Persia Contemporary Art Prize*, Traffic Art Gallery, Dubai, UAE
I am not half the man I used to be, Dar Al Funoon Gallery, Kuwait

2010 *Fear Land*, Azad Gallery, Tehran, Iran
Time to Time, Southern Exposure, San Francisco, CA, USA
Interior, Homa Gallery, Tehran, Iran
One day: Narratives from Tehran, Intersection for the Arts, San Francisco, CA, USA

2009 *Tehran Inside Out*, Forum Schlossplatz, Aarau, Switzerland
Auto Portraits, Azad Art Gallery, Tehran, Iran
Tiny Conceptual, Azad Art Gallery, Tehran, Iran

2008 *Made in Tehran*, Cicero Gallery, Berlin, Germany

2007 *Thirty years of Solitude*, New Hall, Cambridge, UK
Ey! Iran, Tour Show, Australia
Retracing Territories, FRI-ART Centre d'Art, Fribourg, Switzerland

2006 *Peepholes*, Silk Road Gallery, Tehran, Iran

2005 *7 photographes de ce temps*, Baudoin Lebon Gallery, Paris, France
Cross Connection, CCA Gallery, Oakland, CA, USA
Fine Arts Exhibition, Herbst Pavilion, San Francisco, CA, USA
Of past and present, Intersection for the Arts, San Francisco, CA, USA

2004 *Untitled*, Khak Gallery, Tehran, Iran
Murphy Fellowship Award Exhibition, San Francisco Arts Commission Gallery, CA, USA

Artist Book Exhibition, Walter and McBean Galleries, San Francisco, CA, USA
KIDsmART Benefit, Arthur Roger Gallery, New Orleans, LA, USA

2003 *Identity*, Swell Gallery, San Francisco, CA, USA

2002 *Young Photographers Exhibition*, Silk Road Gallery, Tehran, Iran

2001 *A Window to Contemporary Photography*, Asar Gallery, Tehran, Iran
24 Sights, Haft Samar Gallery, Tehran, Iran

SAHAND HESAMIYAN
Born 1977, Tehran, Iran
Lives and works in Tehran, Iran

Education

2007 BFA Sculpture, Tehran University, Tehran, Iran

Selected Solo Exhibitions

2017 *Majaz*, BLOK Art Space Çukurcuma, Istanbul, Turkey
Majaz (site-specific project in collaboration with Busra Tunc), BLOK Art Space Buyuk Valide Han, Istanbul, Turkey

2015 *Frame Reference*, Sam Art, Dastan's Outside the Basement, Tehran, Iran
Tavizeh, Dastan's Basement, Tehran, Iran

2014 *Khalvat*, The Third Line, Dubai, UAE

2013 *Sulook*, The Third Line, Dubai, UAE

2011 *Memory Lives on*, Aun Gallery, Tehran, Iran

2008 *Do You See Me!*, Ave Gallery, Tehran, Iran

Selected Group Exhibitions

2019 *The Spark Is You: Parasol unit in Venice*, Collateral Event of the 58th International Art Exhibition – La Biennale di Venezia, Conservatorio di Musica Benedetto Marcello di Venezia, Venice, Italy
Nine Iranian Artists in London: The Spark Is You, Parasol unit foundation for contemporary art, London, UK

2018 *Retexture, 8th Annual of Contemporary Art | Persbook 2018*, Yazd, Iran
International Contemporary Art Exhibition: Armenia 2018, Yerevan, Armenia
Modern-Contemporary, Bijan Saffari & Contemporary Artists, V-Gallery, A Dastan Outside Project, Tehran, Iran
Black & White, E1 Art Gallery, Tehran, Iran
Art & Jewelry: Artists from the 20th and 21st Centuries, Custot Gallery, Dubai, UAE

2017 *Jameel Prize 4 Exhibition Tour*, Kasteyev State Museum of Arts, Almaty, Kazakhstan; Asia Culture Centre, Gwangju, Korea

The 10th Annual Exhibition of 'Small' Sculptures, Aaran Projects in Collaboration with Iranian Association of Sculptors, Tehran, Iran
Update 5.0, Dastan+2 and V-Gallery, A Dastan Outside Project, Tehran, Iran
The 2nd Ceramic-Based Exhibition 'Frontier', House of Artists, Tehran, Iran
Trans-Trans-Figuration: Sheikh Safi's Anecdote & Any Expandable Thing, Lajevardi Foundation, Tehran, Iran
Geometry, V-Café, A Dastan Outside Project, Tehran, Iran
Beyond Boundaries: Art by Email, Yorkshire Sculpture Park (YSP), Wakefield, UK
RTL : LTR, A Joint Exhibition between Iran and Austria, Esfahan Museum of Contemporary Art, Esfahan, Iran

2016 *Bunyan,* 19th Sharjah Islamic Art Festival, Sharjah, UAE
Visage/Image of Self, Aaran Projects, Tehran, Iran
Update, Dastan+2, Tehran, Iran
Culture City of East Asia 2016, Nara: Art Celebration in Nara Beyond Time and Space, Nara, Japan
Time Machine, Nicolas Flamel Gallery, Paris, France
tehran. capital in CAPITAL letters, Triumph Gallery, Moscow, Russia
Jameel Prize 4 Exhibition, Pera Museum, Istanbul, Turkey
LTR : RTL, A Joint Exhibition between Iran and Austria, Galerie Forum, Wels, Austria
Remembering Tomorrow, Niavaran Cultural Centre, Tehran, Iran
Iran Art Now!, Setareh Gallery, Dusseldorf, Germany

2015 *Suspended,* Aaran Projects, Tehran, Iran
Firefly, Azad Art Gallery, Tehran, Iran
Made in Iran, AB Gallery, Lucerne, Switzerland
Less is More, Aaran Projects, Tehran, Iran
Imago Mundi, Private Collection of Luciano Benetton, Venice, Italy
Centrefold: Spring of Recession, Sazmanab Centre, Tehran, Iran
Persian Garden Party, Nicolas Flamel Gallery, Paris, France
Iran Pavilion, 56th Venice Biennale, Venice, Italy
Group Sculpture Exhibition, Aseman Gallery, Mashhad, Iran
13 Artists for a New Day, Lajevardi Collection, Tehran, Iran
Culture of Peace, Lajevardi Collection, Tehran, Iran
4th Sculpture Biennial for Urban Space, Ghasr Museum, Tehran, Iran

2014 *Approaches to Tradition, Neo-Traditionalism in Contemporary Iranian Art,* Tehran Museum of Contemporary Art, Tehran, Iran

The Language of Human Consciousness, Athr Gallery, Jeddah, Saudi Arabia
The Blue Route, Musée national Adrien Dubouché, Limoges, France
Art for Peace, Mohsen Gallery, Tehran, Iran

2013 *Paykan Iranian Automobile,* Aun Gallery, Tehran, Iran
The Blue Route, Fondation Boghossian, Villa Empain, Brussels, Belgium
Summer Exhibition, AB Gallery, Lucerne, Switzerland
The Scope of Meaning: the Encounter of Calligraphy and Sculpture, Mellat Gallery, Tehran, Iran
Sculpture by the Sea, Tangkrogen, Aarhus, Denmark

2012 *Summer Exhibition,* Royal Academy of Arts, London, UK
Group Sculpture Exhibition, Garden of the Belgium Ambassador in Iran, Tehran, Iran

2011 *Undone,* Mohsen Gallery, Tehran, Iran
My Super Hero, shown concurrently at Morono Kian Gallery, Los Angeles, CA, USA, and Aaran Art Gallery, Tehran, Iran
Selfdom, Haftsamer Gallery, Tehran, Iran

2010 *The Fourth Year,* Mohsen Gallery, Tehran, Iran
Three Generations of Iranian Sculptors, Fravahr Art Gallery, Tehran, Iran
Iran diVERSO: Black or White?, VeRSO Gallery, Turin, Italy

2009 *Magic of Persia Contemporary Art Prize (MOP CAP),* Royal College of Art, London, UK
The Seed of Baobab, Aaran Art Gallery, Tehran, Iran
Manifest, Azad Art Gallery, Tehran, Iran

2008 *Five Artists X 3 Dimensions,* XVA Gallery, Dubai, UAE
Group Exhibition, House of Artists, Tehran, Iran
1st Sculpture Biennial for Urban Space, Barg Gallery, Tehran, Iran

2007 *Meraaj & Molavi,* Imam Ali Museum, Tehran, Iran
Small Sculptures, House of Artists, Tehran, Iran
Selected Models of the 1st Tehran International Sculpture Symposium, Imam Ali Museum, Tehran, Iran
3rd Art, Sport, Olympic Biennial, Olympic Academy, Tehran, Iran
5th Tehran Contemporary Sculpture Biennial, Tehran Museum of Contemporary Art, Tehran, Iran
8th Contemporary Iranian Ceramic and Glass Biennial, Saba Cultural Centre, Tehran, Iran

2006 *Art of Resistance,* Tehran Museum of Contemporary Art, Tehran, Iran
Group Exhibition, House of Artists, Tehran, Iran
Group Exhibition, Sooreh Gallery, Tehran, Iran.
Installation Group Exhibition, Tehran Gallery, Tehran, Iran

Iranian Sculptures in Mexico, Mexico City, Mexico
Group Exhibition, House of Artists, Tehran, Iran
2005 *1st Exhibition of the Youth Handcrafts Arts*,
Saba Cultural Center, Tehran, Iran
Fajre Noor Exhibition, Osveh Gallery, Tehran, Iran
*Group Exhibition for Granting the Handcrafts
Week*, Ghanbeigi Gallery, Tehran, Iran
2nd Art, Sport, Olympic Biennial, Olympic
Academy, Tehran, Iran
4th Tehran Contemporary Sculpture Biennial,
Saba Cultural Centre, Tehran, Iran
2004 *Group Exhibition*, Atashzad Gallery, Tehran, Iran
2002 *Group Exhibition of the Khavaran Cultural
Centre*, Khavaran Gallery, Tehran, Iran
1999 *Group Exhibition of the Graduated Individuals
of the Art Workshop Institute*, Laleh Gallery,
Tehran, Iran

Y.Z. KAMI

Born 1956, Tehran, Iran
Lives and works in New York, NY, USA

Education

1982 Conservatoire Libre du Cinéma, Paris, France
1976– BA and MA, University of Paris-Sorbonne,
1981 Paris, France
1974– University of California, Berkeley, CA, USA
1975
1973 Holy Name College, Oakland, CA, USA

Selected Solo Exhibitions

2018 *Y.Z. Kami: Geometry of Light*, Gagosian,
Paris, France
2016 *Y.Z. Kami: Endless Prayers*, Los Angeles County
Museum of Art (LACMA), Los Angeles, CA, USA
2015 *Y.Z. Kami: Paintings*, Gagosian Gallery, Britannia
Street, London, UK
2014 *Y.Z. Kami: Paintings*, Gagosian Gallery, Madison
Avenue, New York, NY, USA
2009 *Y.Z. Kami: Beyond Silence*, National Museum of
Contemporary Art (EMST), Athens, Greece
2008 *Y.Z. Kami: Endless Prayers*, Parasol unit
foundation for contemporary art, London, UK
Perspectives: Y.Z. Kami, Arthur M. Sackler Gallery,
Smithsonian Institution, Washington, DC, USA
Y.Z. Kami, John Berggruen Gallery, San Francisco,
CA, USA
Y.Z. Kami, Gagosian Gallery, Beverly Hills, CA, USA
2003 *The Watchful Portraits of Y.Z. Kami*, Herbert F.
Johnson Museum of Art, Cornell University,
Ithaca, NY, USA
2002 Martin Weinstein, Minneapolis, MN, USA
2001 Deitch Projects, New York, NY, USA
1999 *Dry Land*, Deitch Projects, New York, NY, USA

1998 *Y.Z. Kami*, Deitch Projects, New York, NY, USA
1996 Holly Solomon Gallery, New York, NY, USA
1993 Barbara Toll Fine Arts, New York, NY, USA
1992 Long Beach Museum of Art, CA, USA
Barbara Toll Fine Arts, New York, NY, USA
1984 L.T.M. Gallery, New York, NY, USA

Selected Group Exhibitions

2019 *The Spark Is You: Parasol unit in Venice*, Collateral
Event of the 58th International Art Exhibition –
La Biennale di Venezia, Conservatorio di Musica
Benedetto Marcello di Venezia, Venice, Italy
2017 *The Garden of Mystery*, Asia House, London, UK
*Rebel, Jester, Mystic, Poet: Contemporary
Persians*, Aga Khan Museum, Toronto, Canada;
Museum of Fine Arts, Houston, TX, USA
*A Closer Look: Portraits from the Paul G. Allen
Family Collection*, Pivot Art + Culture, Seattle,
WA, USA
2016 *Mass Individualism: A Form of Multitude*,
Ab-Anbar Gallery, Tehran, Iran
Échos, Presented by Kering from the collection
of François-Henri Pinault on the occasion of
Journées Européenes du Patrimoine, Paris, France
2015 *The Rainbow Serpent*, Gagosian, Athens, Greece
2014 *One Way: Peter Marino*, Bass Museum of Art,
Miami, FL, USA
*Seeing Through Light: Selections from the
Guggenheim Abu Dhabi Collection*, Guggenheim
Abu Dhabi, UAE
Horror Vacui, Gagosian Gallery, Geneva,
Switzerland
2013 *Safar/Voyage: Contemporary Works by Arab,
Iranian and Turkish Artists*, Museum of
Anthropology, University of British Columbia,
Vancouver, Canada
2012 *Contemporary Iranian Art from the Permanent
Collection*, Metropolitan Museum of Art,
New York, NY, USA
2011 *The Mask and the Mirror: Curated by Shirin
Neshat*, Leila Heller Gallery, New York, NY, USA
2010 *Be Blue*, Laleh June Galerie, Basel, Switzerland
2009 *A Certain State of the World? Works from the
François Pinault Foundation*, Garage Center for
Contemporary Culture, Moscow, Russia
Raad O Bargh, 17 Artists from Iran, Group Show,
Galerie Thaddaeus Ropac, Paris, France
2008 *Mobile Art: Chanel Contemporary Art Container
by Zaha Hadid*, Hong Kong; Tokyo, Japan;
New York, NY, USA; Paris, France
2007 *All the More Real*, curated by Eric Fischl & Merrill
Falkenberg, Parrish Art Museum, Southampton,
NY, USA
*52nd International Art Exhibition, La Biennale
di Venezia: Think with the Senses, Feel with the
Mind*, Campo della Tana, Venice, Italy

2006 *The Grand Promenade*, National Museum of
Contemporary Arts, Athens, Greece
Eye to Eye, Cornell Fine Arts Museum, Winter
Park, FL, USA
Without Boundary: Seventeen Ways of Looking,
Museum of Modern Art, New York, NY, USA

2005 *9th International Istanbul Biennial*, Istanbul,
Turkey
After the Revolution, Kunstforeningen,
Copenhagen, Denmark

2004 *Beyond East and West*, Krannert Art Museum,
Champaign, IL, USA

1997 *Architecture as Metaphor*, Museum of Modern
Art, New York, NY, USA

1996 *The Inaugural Exhibition*, Hosfelt Gallery,
San Francisco, CA, USA
Portraits, James Graham & Sons, New York,
NY, USA
Center for Curatorial Studies, Bard College,
New York, NY, USA

1995 Cargo, Marseilles, France

1994 *It's How to Play the Game*, Exit Art, New York /
White Columns, New York, NY, USA

1992 Barbara Toll Fine Arts, New York, NY, USA

1991 Barbara Toll Fine Arts, New York, NY, USA

1986 Centre Culturel Boulogne-Billancourt, Paris, France

1985 Pasadena Museum of Art, CA, USA

Public Collections

Public collections containing Y.Z. Kami's work
include Metropolitan Museum of Art, New York;
Whitney Museum of American Art, New York;
Solomon R. Guggenheim Museum, New York, USA;
and British Museum, London, UK.

FARIDEH LASHAI
Born 1944, Rasht, Iran
Died 2013, Tehran, Iran

Education

BFA, Glass Design, Academy of Decorative Arts,
Vienna, Austria
BA, German Literature, University of Frankfurt,
Frankfurt, Germany

Selected Solo Exhibitions

2019 *Farideh Lashai: A Land Called Ideology*, Curated
by Paloma Martin Llopis, Tabacalera, Madrid, Spain

2016 *Farideh Lashai*, Curated by Hoor Al Qasimi,
Sharjah Art Foundation, Sharjah, UAE

2015 *Farideh Lashai: Towards the Ineffable*, Curated
by Germano Celant, and Faryar Javaherian
Tehran Museum of Contemporary Art, Tehran, Iran

2013 *Thus in Silence in Dreams' Projections*, Leila Heller
Gallery, New York, NY, USA
...It Is It and It Is Only Now, Edward Tyler Nahem
Fine Art, New York, NY, USA
In Memory of Farideh Lashai, The Farjam
Foundation, Dubai, UAE

2010 *Rabbit in Wonderland*, Gallery Isabelle van den
Eynde, Dubai, UAE
Rafia Gallery, Damascus, Syria

2009 Albareh Gallery, Manama, Bahrain

2007 XVA Gallery, Dubai, UAE

2005 MAH Gallery, Tehran, Iran

2004 XVA Gallery, Dubai, UAE

2003 Villa Ramponé, Milan, Italy

2001 Cultural Center, Barcelona, Spain

2000 Pouya Centre, Paris, France

1998 Espace Galant, Avignon, France
Chapelle de l'Hôtel de Ville, Vesoul, France
Hunar Gallery, Dubai, UAE
Goletsan Gallery, Tehran, Iran

1997 Château de Lascours, Laudun, France

1996 Golestan Gallery, Tehran, Iran

1995 Gallery Nouste Henric, Pau, France

1994 Golestan Gallery, Tehran, Iran

1993 Gallery Aum Hufeisen, Dusseldorf, Germany

1992 Golestan Gallery, Tehran, Iran

1990 Hill Gallery, London, UK

1988 Berkeley University, Berkeley, CA, USA
Gallery Demenga, Basel, Switzerland
Libertas Gallery, Dusseldorf, Germany

1987 National Museum of Fine Arts, Lavalta, Malta
Demenga Gallery, Basel, Switzerland
Golestan Gallery, Tehran, Iran
Classic Gallery, Tehran, Iran

1984 Clark Gallery, Bakersfield, CA, USA

1977 Cultural Centre of the National Iranian Oil
Company, Khoozestan, Iran

1976 Tehran Gallery, Tehran, Iran

1975 Iran–America Society, Tehran, Iran

1974 Tehran Gallery, Tehran, Iran

1973 Sayhoon Gallery, Tehran, Iran

1968 Studio Rosenthal, Selb, Germany
Galleria Duomo, Milan, Italy

Selected Group Exhibitions

2019 *The Spark Is You: Parasol unit in Venice*, Collateral
Event of the 58th International Art Exhibition –
La Biennale di Venezia, Conservatorio di Musica
Benedetto Marcello di Venezia, Venice, Italy

2017 *Multiplicity Vol. 1, Modern and Contemporary
Prints and Multiples*, Dastan: Outside, V-Gallery,
Tehran, Iran

2016 *Group Exhibition by Iranian Masters*, e1 art
gallery, Tehran, Iran

2013 *5th Moscow Biennale*, Moscow, Russia

Calligraffiti: 1984–2013, Leila Heller Gallery, New York, NY, USA

Nowruz Celebration, LACMA|Los Angeles County Museum of Art, Farhang Foundation, Los Angeles, CA, USA

2012 *The Rule and its Exception*, Leila Heller Gallery|Deborah Colton Gallery, Houston, TX, USA

2011 *Identity Crisis, Authenticity, Attribution and Appropriation*, The Heckscher Museum of Art, Huntington, NY, USA
6 Visions from Nature, Hoor Gallery, Tehran, Iran
Regarding Iran the apparent acquiescence of conceptual poetic, The Guild Art Gallery, Mumbai, India

2010 *Tehran – New York*, Leila Heller Gallery, New York, NY, USA
Painting, Mah Art Gallery, Tehran, Iran

2009 *Painting*, Mah Art Gallery, Tehran, Iran
Iran Inside Out, DePaul University Art Museum, Chicago, IL, USA
101: Oil & Its Aftermath – Politics, Modernism, Society, Environment-Group, Assar Art Gallery, Tehran, Iran
Iran Inside Out, Chelsea Art Museum, New York, NY, USA
Selseleh/Zelzeleh: Movers & Shakers in Contemporary Iranian Art, Leila Heller Gallery, New York, NY, USA

2008 *Just Paper*, Leila Heller Gallery, New York, NY, USA
Mah Gallery, Tehran, Iran

2007 Warsaw Museum, Warsaw, Poland

2006 *Persja*, 2 Światy Art Gallery, Kraków, Poland
Cultural Foundation, Abu Dhabi, UAE

2005 Ludwig Museum, Koblenz, Germany

2004 *Persian Gardens*, Tehran Museum of Contemporary Art, Tehran, Iran
Institute for Advanced Studies in Basic Sciences, Zanjan, Iran

2003 Liu Haisu Art Museum, Shanghai, China
Yan Huang Art Museum, Beijing, China
Hubei Art Museum, Wuhan, China
Kokkola Museum, Kokkola, Finland
Festival Femmes en Iran, Evry City Hall, Evry, France
European parliament building, Brussels, Belgium
Contemporary Iranian Art, Italian School of Tehran, Iran
Haagse Kunstkring Gallery, The Hague, Netherlands
Caisa Cultural Centre, Helsinki, Finland
Sala Uno Gallery, Rome, Italy
City Hall Gallery, Radhuset, Oslo, Norway
Esfahan Museum of Contemporary Art, Esfahan, Iran
Artists House of Yazd, Yazd, Iran

2002 *Iranian Contemporary*, Christie's King Street, London, UK

Villa del Cardinale, Naples, Italy
Institute for Advanced Studies in Basic Sciences, Zanjan, Iran
Fabien Fryns Fine Arts, Marbella, Spain
Palazzo Reale di Napoli, Naples, Italy
United Nations building, Geneva, Switzerland
Vigado Gallery, Budapest, Hungary
Amber Gallery & Caro Gallery, Leiden, Netherlands
Cultural Centre, Berlin, Germany

2001– *A Breeze from the Gardens of Persia, New Art*
2003 *from Iran*, Touring exhibition, Meridian International Center, Washington, DC; Queens Public Library, New York; Belleville, Illinois; Los Angeles, CA; Atlanta, GA; Texas; Florida, USA

2001 Amber Gallery, East–West Foundation, Leiden, Netherlands
Classic Gallery, Esfahan, Iran
Kavir Gallery, Rafsanjan, Iran

2000 Museum of Fine Arts, Caracas, Venezuela
Rome Expo, Rome, Italy Art Expo, Washington, DC, USA
Art Expo, New York, NY, USA
International Drawing Biennial, Tehran, Iran

1997 Shilpakala Academy, Biennial, Dhaka, Bangladesh

1996 Meeting of Korea–Germany, Korea

1978 *International Expo*, Basel, Switzerland

1977 Tehran Museum of Contemporary Art, Tehran, Iran

1975 *Four Women Artists Exhibition*, Iran–America Society, Tehran, Iran

1973 *Iranian Women Artists International*, *Exhibition of Tehran*, Tehran, Iran

1971 *International Exhibition of Tehran* (as a member of the Austrian Pavilion), Tehran, Iran

1968 *International Young Artists*, Ostend, Belgium

Selected Public Collections

Centre Georges Pompidou, Paris, France
Demenga Galleries – Public Collection, Basel, Switzerland
Christie's Showroom, Christie's Private Collection, New York, NY, USA
National Museum of Fine Arts, Valetta, Malta
Tehran Museum of Contemporary Art, Tehran, Iran
Deutsche Bank, Berlin, Frankfurt, Düsseldorf, Germany
Credit Suisse, Geneva, Switzerland

KOUSHNA NAVABI
Born 1962, Tehran, Iran
Lives and works in London, UK

Education

1995 MA Fine Art, Goldsmiths College, University of London, UK
1994 Postgraduate Diploma, Fine Art, Goldsmiths College, University of London, UK
1988 Santa Monica College, Los Angeles, CA, USA

Selected Solo Exhibitions

2009 *Koushna Navabi*, Xerxes Gallery, London, UK
2001 *Koushna Navabi*, Percy Miller Gallery, London, UK

Selected Group Exhibitions

2019 *The Spark Is You: Parasol unit in Venice*, Collateral Event of the 58th International Art Exhibition – La Biennale di Venezia, Conservatorio di Musica Benedetto Marcello di Venezia, Venice, Italy
Nine Iranian Artists in London: The Spark Is You, Parasol unit foundation for contemporary art, London, UK
2008 *Dubai Art Fair*, Xerxes Fine Arts, Dubai, UAE
2006 *Hiroshima Art Document*, Hiroshima, Japan
1999 *Frankfurt Art Fair*, Frankfurt, Germany
Richard Heller Gallery, Los Angeles, USA
1998 *Craft*, Richard Salmon Gallery, London; University of Wales, Aberystwyth, Wales; Vardy Gallery, University of Sunderland; Kettle's Yard, Cambridge, UK
Strangely Familiar, Ikon Gallery, Birmingham, UK
1996 *The Whitechapel Open*, London, UK
Whitechapel Commercial Too Gallery, London, UK
1995 *Goldsmiths College Group Show*, Chisenhale Gallery, London, UK

NAVID NUUR
Born 1976, Tehran, Iran
Lives and works in The Hague, Netherlands

Education

2004 MFA, Plymouth University, Plymouth, UK
2003 Piet Zwart Institute, Rotterdam, Netherlands
2001 Hogeschool vor de Kunsten (HKU), Utrecht, Netherlands

Selected Solo Exhibitions

2019 *I am because of You*, Gemeente Museum Den Haag, The Hague, Netherlands
When Doubt Turns into Destiny, Galerie Max Hetzler, Paris, France

2018 *RE/FLECT/OR (2008–2018)*, permanent installation, The Sculpture Gallery, The Hague, Netherlands
The After Glow III, NDSM-WERF, Amsterdam, Netherlands
Paintpusher, Galeria Plan B, Berlin, Germany
2017 *FUNNELFLUX*, Be-Part, Platform for Contemporary Art, Waregem, Belgium
Sandman's Sand, Martin Van Zomeren, Amsterdam, Netherlands
A&N&D, Galerie Max Hetzler, Berlin, Germany
2016 *THE GIFT* (permanent installation), International Criminal Court premises, The Hague, Netherlands
2015 *CONTEXT IS THE NEW CONTENT*, Galerie Martin van Zomeren, Amsterdam, Netherlands
MINING MEMORY, Galerie Max Hetzler, Berlin, and Galeria Plan B, Berlin, Germany
About a Work #3, Galleria Zero, Milan, Italy
2014 *The Main Remain*, Galerie Max Hetzler, Paris, France
Renderender, Dundee Contemporary Arts (DCA), Dundee, Scotland
Color Me Closely, Trafó House of Contemporary Arts, Budapest, Hungary
2013 *Treasured Tensions*, Club Electroputere – Centre for Contemporary Culture, Bucharest, Romania
Lube Love, Bonnefantenmuseum, Maastricht, Netherlands
Unified Not Uniformed, Martin van Zomeren, Amsterdam, Netherlands
TA-DA !, Galerie des Enfants, Centre Pompidou, Paris, France
Phantom Fuel, Parasol unit foundation for contemporary art, London, UK
Track&Trace, Watersnoodmuseum, Ouwerkerk, Netherlands
Smokebombsmoke, OUI Center of Contemporary Art, Grenoble, France
2012 *Bergamo*, Heden, The Hague, Netherlands
Hocus Focus, Matadero, Madrid, Spain
2011 *Conductorconductor*, Plan B, Berlin, Germany
It's No Crime To Tickle Time, Martin van Zomeren, Amsterdam, Netherlands
Post Parallelism, Kunst Halle Sankt Gallen, St Gallen, Switzerland
2010 *Glow (Re-)discovering Eindhoven*, Van Abbe Museum, Eindhoven, Netherlands
The Other Another, Galleri Christina Wilson, Copenhagen, Denmark
Phantom Fuel, Plan B, Cluj, Romania
2009 *The Value of Void*, Stedelijk Museum voor Actuele Kunst (S.M.A.K.), Ghent, Belgium; Kunsthalle Fridericianum, Kassel, Germany; De Hallen Museum, Haarlem, Netherlands
(No) Norms Forgotten, 10m² Project Space, Sarajevo, Bosnia and Herzegovina
Aass Wwee bbccoommee Oonnee, Klerkx, Milan, Italy

Within Your Worlds, Martin van Zomeren, Amsterdam, Netherlands
In Your World, Galeria Plan B, Berlin, Germany

2008 *Where It's At*, Fries Museum/Bureau, Leeuwarden, Netherlands
Lost Licks, 1646, The Hague, Netherlands
Solo booth, Art Amsterdam, Martin van Zomeren, Amsterdam, Netherlands

2007 *The Rise of Re*, Project Space Stroom, The Hague, Netherlands
INSIDEOUT, Moira Gallery, Utrecht, Netherlands

2004 Galerie De5er, Rotterdam, Netherlands

Selected Group Exhibitions

2019 *The Spark Is You: Parasol unit in Venice*, Collateral Event of the 58th International Art Exhibition – La Biennale di Venezia, Conservatorio di Musica Benedetto Marcello di Venezia, Venice, Italy
Nine Iranian Artists in London: The Spark Is You, Parasol unit foundation for contemporary art, London, UK
₡ U R ₹ € ₦ ₡ ¥, Nome, Berlin, Germany
Freedom – The Fifty Key Dutch Artworks Since 1968, Museum De Fundatie, Zwolle, Netherlands
Yarat Contemporary Art Centre, Baku, Azerbaijan

2018 *Untitled (Monochrome)*, 1958–2018, New York, NY, USA
Out of Office, Museum Singer, Laren, Netherlands
Møenlight Sonata – A homage to the starry sky of Møn, Kunsthal Møen, Denmark
Painting The Night, Centre Pompidou Metz, Metz, France
Chinese Whispers #2, Meessen-Declercq, Brussels, Belgium
Entrelacs, Navid Nuur with Victor Man, Centre d'édition contemporaine, Geneva, Switzerland
Eruption from the Surface. The Origami Principle in Art, MARTa Herford, Herford, Germany
Eugenia Pop and Navid Nuur, Galeria Plan B, Berlin, Germany
UNTITLED (MONOCHROME), 1957–2017, Richard Taittinger Gallery, New York

2017 *Het Zalig Nietsdoen*, Kranenburgh Museum, Bergen, Netherlands
Matière Grise, Galerie Max Hetzler, Paris, France
Radicale Sociale Animale Talen, CoBrA Museum of Modern Art, Amstelveen, Netherlands
THREE POSITIONS. SIX DIRECTIONS. | CHAPTER I: THE BRUTALIST IDEAL, König Galerie, Berlin, Germany
All Paintings Are Uneven, ABN AMRO Art Collection, Amsterdam, Netherlands
Where do we go from here?, 6 Galleries in the Jordaan Area, Amsterdam, Netherlands
Back in 5 minutes, Martin van Zomeren, Amsterdam, Netherlands

2016 *Lube Love*, Bonnefantenmuseum @pinkpop-up museum, Landgraaf, Netherlands
La mia ceramica, Galerie Max Hetzler, Paris, France
Cher(e)s Ami(e)s: Hommage aux Donateurs des Collections Contemporaines, Centre Pompidou, Paris, France
Hacking Habitat. Art of Control, Utrecht, Netherlands
Illegibility. The Contexts of the Script, Art Stations Foundation, Poznan, Poland
A.N.T.H.R.O.P.O.C.E.N.E., Meessen De Clercq, Brussels, Belgium

2015 *Back To The Future*, Billytown, The Hague, Netherlands
Lekker Licht, Centraal Museum, Utrecht, Netherlands
Addition: Schenking Pieter en Marieke Sanders, Stedelijk Museum, Amsterdam
Let Us Meet Inside You, Trendbeheer, De Garag Rotterdam, Netherlands
Mountains With A Broken Edge, Bienal de la Habana, Havana, Cuba
PASS, Hisk – Higher Institute for Fine Arts, Ghent, Belgium
Eppur si muove, MUDAM, Musée d'Art Moderne Grand-Duc Jean, Luxembourg
When I Give, I Give Myself, Van Gogh Museum, Amsterdam, Netherlands
Playing Future, Kunsthalle Kiel, Kiel, Germany
Fa Fa Fa, Martin van Zomeren, Amsterdam, Netherlands
The Dutch Connection, S.M.A.K., Municipal Museum of Contemporary Art, Ghent, Belgium
Too early, too late. Middle East and Modernity, Pinacoteca Nazionale, Bologna, Italy
Enge Gelände, Martin van Zomeren, Amsterdam, Netherlands
Obsession, Maison Particuliere, Brussels, Belgium
Signs & Symbols, Jessica Bradley, Toronto, Canada
Branched. Trees in Contemporary Art, Altana Kulturstiftung, Bad Homburg, Germany

2014 *Animal Mineral Vegetable*, Andrew Kreps Gallery, New York, USA
Allegory of the Cave Painting, Extra City Kunsthal, Antwerp, Belgium
Alchemy, NEST, The Hague, Netherlands
Size Matters, Foundation for Art Fort at Vijfhuizen, Vijfhuizen, Netherlands
Picture This, SALTS, Birsfelden, Switzerland
Halftone: Through the Grid, Galerie Max Hetzler, Berlin, Germany
Beating around the bush Episode #1, Bonnefantenmuseum, Maastricht, Netherlands
Objects in mirror are closer than they appear, Lugar a Dudas, Cali, Colombia

RE: Painted, S.M.A.K., Municipal Museum of Contemporary Art, Ghent, Belgium
Video screening 25, Zero, Milan, Italy
Amnesia, Nadácia – Centrum súčasného umenia, Bratislava, Slovakia
Behind Images, Garage Rotterdam, Rotterdam, Netherlands

2013 *Traces*, Stedelijk Museum, s-Hertogenbosch, Netherlands
Agora, 4th Athens Biennale, Athens, Greece
On the Road to... Tarascon, Adrian Ghenie and Navid Nuur, Plan B, Berlin, Germany
Passion de l'Art en Finistère / Collection #4, Centre d'art contemporain de Quimper, France
(T)HERE, Bonnefanten Hedge House, Wijlre, Netherlands
Flex-Sil Reloaded, Kunst Halle St Gallen, St Gallen, Switzerland
MIND IS OUTER SPACE, Casey Kaplan, New York, NY, USA
The Image in the Sculpture, curated by Christine Macel and Navid Nuur, Centre Pompidou, Paris, France
Time, Trade and Travel, Stedelijk Museum Bureau, Amsterdam, Netherlands
Small Gestures, MU / Strijp S, Eindhoven, Netherlands
Mesures et disparition / Over maat en verdwijning, Institut Néerlandais, Paris, France
It wasn't there yesterday, Raster Gallery, Warsaw, Poland

2012 *This Title is an Artwork of Mine*, Motto Charlottenborg, Copenhagen, Denmark
The Castle in the Air. Séance of Imagination, Centre of Culture ZAMEK, Poznan, Poland
Through an open window, Institut Néerlandais, Paris, France
A Battle for Narrative, Bonnefanten Hedge House, Wijlre, Netherlands
Papierwelten, Galerie Nächst St Stephan Rosemarie Schwarzwälder, Vienna, Austria
Utopraxia, TAF|the Art Foundation, Athens Greece
Sint-Jan, Sint-Baafskathedraal, Ghent, Belgium
SummerNest, Nest, The Hague, Netherlands
On Geometry and Speculation, official parallel project during the Marrakech Biennale, ESAV, Marrakech, Morocco
Rollercoaster. The Image in the 21st Century, MOTI Museum of the Image (now Stedelijk Museum), Breda, Netherlands
Un paisaje holandés / A Dutch Landscape, La Casa Encendida, Madrid, Spain
Ashes and Gold. A World's Journey, MARTa Herford Museum, Herford, Germany
People have the power, Zero, Milano, Italy

2011 *Villa Tokyo*, Tokyo, Japan

SLAA, De Balie, Amsterdam, Netherlands
De Nederlandse identiteit? De Kracht van Heden, Museum De Paviljoens, Almere, Netherlands
Recently unpacked. How art ages, MARTa Herford Museum, Herford, Germany
Royal Awards for Painting 2011, Royal Palace, Amsterdam, Netherlands
ILLUMInations, The 54th Venice Biennale, Venice, Italy
Too late, too little, (and how) to fail gracefully, Kunstfort Asperen, Langedijk, Netherlands
Image to be projected until it vanishes, MUSEION, Bolzano, Italy
Radical Autonomy, Netwerk | centrum voor hedendaagse kunst, Aalst, Belgium
Inside Installations | Collectietentoonstelling, S.M.A.K, Municipal Museum of Contemporary Art, Ghent, Belgium
Falten, Searching for White, Rise above Reason, Martin van Zomeren, Amsterdam, Netherlands

2010 *Taking Place*, Stedelijk Museum, Amsterdam, Netherlands
Invisible Shadows, Images of Uncertainty, MARTa Herford Museum, Herford, Germany
Benefit Exhibition, Kunst Halle Sankt Gallen, St Gallen, Switzerland
Starter, Arter, Istanbul, Turkey
History of Art, David Roberts Art Foundation, London, UK
Performative Attitudes, Kunsthaus Glarus, Glarus, Switzerland
Up to You, Stroom, The Hague, Netherlands

2009 *The Knight's Tour*, De Hallen Museum, Haarlem, Netherlands
Sculptural – Collection, S.M.A.K, Municipal Museum of Contemporary Art, Ghent, Belgium
Broken English, Seiler + Mosseri-Marlio Galerie, Zurich, Switzerland

2008 *Portfolio 1*, Plan B, Berlin, Germany
Schilders, DCR, The Hague, Netherlands
Geoair, residency in Georgia, Tbilisi

2007 *Billy town*, Rijswijk, Netherlands
Voorstel voor, DCR Project Space, The Hague, Netherlands
Drawing the line somewhere, Nederlandse Cacaofabriek, Helmond, Netherlands
Lumiere, Galerie Blaak 10, Rotterdam, Netherlands

2006 *For a(n) relation(s)*, ADA Gallery, VA, USA

2005 *Rebound*, HKU Gallery Utrecht, Utrecht, Netherlands
Jack of Hearts, Project Space Stroom, The Hague, Netherlands

2004 *The Art of Management*, Ecole Supérieure de Commerce, Paris, France

Selected Public Collections

Bonnefantenmuseum, Maastricht, Netherlands
De Hallen Museum, Haarlem, Netherlands
Koç, Istanbul, Turkey
Kunsthalle, Zurich, Switzerland
Musée National d'Art Moderne, Centre Georges
Pompidou, Paris, France
Neuer Berliner Kunstverein, Berlin, Germany
S.M.A.K. Municipal Museum of Contemporary
Art, Ghent, Belgium
Stedelijk Museum, Amsterdam, Netherlands

SAM SAMIEE

Born 1988, Tehran, Iran
Lives and works in Amsterdam, Netherlands, and
Tehran, Iran

Education

2014– Rijksakademie van Beeldende Kunsten,
2015 Amsterdam, Netherlands
2013 BFA Painting, Fine Art Faculty, AKI ArtEZ Academy
for Art & Design, Enschede, Netherlands
2006– Painting, Fine Art Faculty, Art University of Tehran,
2010 Tehran, Iran
Painting at the Studio of Pantea Rahmani, Tehran,
Iran
2005– Industrial Design, Art University of Tehran,
2006 Tehran, Iran

Selected Solo Exhibitions

2019 *Sam Samiee: Le Gymnasium sacré*, curated by
Petra Boonstra, Concordia, Enschede, Netherlands
2018 *De Liefde raakte ontheemd, het Verstand
ernaar op zoek* (Love became displaced, the
Mind searched for it), curated by Benno Tempel,
Gemeentemuseum Den Haag, Netherlands
*10th Berlin Biennale: We Don't Need Another
Hero*, curated by Gabi Ngcobo, solo presentation
at ZK/U Zentrum für Kunst und Urbanistik,
Berlin, Germany
Casino Copernicus, Galerie Fons Welters,
Amsterdam, Netherlands
Bedroom Posters, Art Basel Hong Kong, Dastan's
Basement, Hong Kong, China

Selected Group Shows

2019 *Nine Iranian Artists in London: The Spark Is You*,
Parasol unit foundation for contemporary art,
London, UK
Feast of Fools, paying homage to Pieter Bruegel,
curated by Luk Lambrecht, Gaasbeek Castle,
Gaasbeek, Belgium

2018 *Robot Love*, Campina Melkfabriek, curated by Ine
Gevers, Eindhoven, Netherlands
The Oil of Pardis, Modern Iranian painters,
curated by Hormoz Hematian, Galerie Balice
Hertling, Paris, France
2017 *The Painted Bird | Dreams and Nightmares of
Europe*, directed by Gijs Frieling, Marres-House
for Contemporary Culture, Maastricht,
Netherlands
A CAMP, curated by Sam Samiee, Dastan's
Basement, Tehran, Iran
A CAMP, curated by Sam Samiee, No Man's Art
Gallery, Amsterdam, Netherlands
Art Brussels, presented by (re)D. Gallery,
Antwerp, Belgium
Still Light, Narcisse Tordoir/Sam Samiee, curated
by Narcisse Tordoir, (re)D. Gallery, Antwerp, Belgium
2016 *BAROQUE*, curated by Laurie Cluitmans, Galerie
Fons Welters, Amsterdam, Netherlands
*Exhibition of the Royal Award for Modern
Painting 2016*, (awarded to Sam Samiee),
Dam Royal Palace, Amsterdam, Netherlands
Doré-Hami, No Man's Art Gallery, Amsterdam,
Netherlands.
Waiting For Self-Seduction, performance with
Kris Dittel and Sara Gianni, Witteveen Visual Art
Centre, Amsterdam, Netherlands
2015 *RijksakademieOpen, Bedroom Posters*, curated
by Isabelle Cornaro, Amsterdam, Netherlands
2014 *Sensory War: 1914–2014*, curated by Dr Ana
Carden-Coyne, David Morris and Tim Wilcox,
Manchester Art Gallery, Manchester, UK
RijksakademieOPEN, curated by Narcisse Tordoir,
Amsterdam, Netherlands
*From Borders of Perception to Destination:
Unknown*, curated by Sam Samiee, W139,
Amsterdam, Netherlands

HADI TABATABAI

Born 1964 in Mashhad, Iran
Lives and works in San Francisco, CA, USA

Education

1995 BA, Painting, San Francisco Art Institute, CA, USA
1985 BS, Industrial Technology, California State
University, Fresno, CA, USA

Selected Solo Exhibitions

2018 *Blue Nights*, Inde/Jacobs, Marfa, TX, USA
To Find Rest, Lannan Foundation, Santa Fe,
NM, USA
2017 *wats:ON? Festival*, Carnegie Mellon University,
Pittsburgh, PA, USA
Transitional Spaces, Miller Gallery, Carnegie

Mellon University, Pittsburgh, PA, USA
2015 *New Work*, Inde/Jacobs, Marfa, TX, USA
2014 *New Work*, Peter Blake Gallery, Laguna Beach,
CA, USA
2013 *Aus der Sache heraus – From the thing itself*,
Kunstgaleriebonn, Bonn, Germany
2011 *Portals*, Brian Gross Fine Art, San Francisco,
CA, USA
2010 *New Work*, Danese, New York, NY, USA
Silence and Abundance, Inde/Jacobs, Marfa,
TX, USA
2009 Inde/Jacobs, Marfa, TX, USA
The Space of a Line, Brian Gross Fine Art,
San Francisco, CA, USA
2006 *Daruni*, Stephen Wirtz Gallery, San Francisco,
CA, USA
2005 *Interior Spaces*, Anthony Grant Gallery,
New York, NY, USA
2004 *New Work*, James Nicholson Gallery,
San Francisco, CA, USA
2000 *Introductions*, Stephen Wirtz Gallery,
San Francisco, CA, USA

Selected Group Exhibitions

2019 *Nine Iranian Artists in London: The Spark Is You*,
Parasol unit foundation for contemporary art,
London, UK
2018 *Way Bay II*, Berkeley Art Museum, Berkeley,
CA, USA
Way Bay, Berkeley Art Museum, Berkeley,
CA, USA
Ruminate, Begovich Gallery, California State
University, Fullerton, CA, USA
2017 *In Conversation – Hadi Tabatabai + Lucie Noel
Thune*, College of Marin, Kentfield, CA, USA
The Box Project: Uncommon Threads, Racine Art
Museum, Racine, Wisconsin, USA; Textiles Museum
@ George Washington University, Washington,
DC, USA
2016 *The Box Project: Uncommon Threads*, Fowler
Museum, University of California, Los Angeles,
CA, USA
2015 *Intro*, Kunstgaleriebonn, Bonn, Germany
2014 *Extending the Line 3D*, C. Grimaldis Gallery,
Baltimore, MD, USA
2013 *The Sound of the Surface. A Drawing Project –
William Anastasi, Frank Gerritz, Hadi Tabatabai*,
Galerie Kim Behm, Frankfurt, Germany
Indian Tantric + Western Contemporary, Bartha
Contemporary, London, UK
Never Underestimate a Monochrome, Wignall
Museum of Contemporary Art, Rancho
Cucamonga, CA, USA
2012 *Abstraction: A Dialogue between Colombian and
International Artists*, Beatriz Esguerra Art,
Bogota, Colombia

Never Underestimate a Monochrome, University
of Iowa Museum of Art, Iowa City, IA, USA, and
online
*Notations: Contemporary drawing as idea and
process (selections from the Sally and Wynn
Kramarsky collection)*, Kemper Art Museum,
St Louis, MO, USA
Cool Calm Collected, Danese Corey, New York,
NY, USA
Papier/paper II, Kunstgaleriebonn, Bonn, Germany
2011 *Drift of Summer*, RM Gallery, Auckland,
New Zealand
Papier/paper, Kunstgaleriebonn, Bonn, Germany
Different Abstractions, Green Cardamom,
London, UK
Drawn / Taped / Burned, Katonah Museum of
Art, Katonah, NY, USA
Works on Paper, Danese, New York, NY, USA
2010 *Touch*, Paris CONCRET, Paris, France
IRAN diVERSO: Black or White?, Verso
Artecontemporanea, Turin, Italy
By A Thread, San Jose Institute for Contemporary
Art, San Jose, CA, USA
Accrochage1, Gallery Dora Bassi, Gorizia, Italy
Works on Paper, Danese, New York, NY, USA
2009 *At 21: Gifts and Promised Gifts in Honor of The
Contemporary Museum's 20th Anniversary*,
The Contemporary Museum, Honolulu, HI, USA
*Metaphysical Abstraction: Contemporary
Approaches to Spiritual Content*, Berkeley Art
Center, Berkeley, CA, USA
Mashq: Repetition Meditation Mediation, Green
Cardamom, London, UK
Yield, Schmidt Contemporary Art, St Louis,
MO, USA
2008 *Banned and Recovered*, San Francisco Center for
the Book, CA, USA
East of the West, SOMARTS, San Francisco,
CA, USA
Out of the Fog / Artists from Headlands, Art
Works Downtown, San Rafael, CA, USA
2006 *Gridlock*, Gallery Joe, Philadelphia, PA, USA
2005 *Series*, Gallery Joe, Philadelphia, PA, USA
Drawings & Works on Paper II, Selected artists
from the US, Patrick Heide Art Projects,
London, UK
Repeat Performance, Anthony Grant Gallery,
New York, NY, USA
2004 *Woodwork*, Anthony Grant Gallery, New York,
NY, USA
2001 *Current Holdings: Bay Area Drawing / Bay Area
Collections*, Palo Alto Art Center, Palo Alto,
CA, USA
Kiyo Higashi Gallery, Los Angeles, CA, USA
2000 Triangle Gallery, San Francisco, CA, USA

Public Collections

Achenbach Foundation, Fine Arts Museums of
San Francisco, CA, USA
Berkeley Art Museum, Berkeley, CA, USA
Delaware Art Museum, Wilmington, DE, USA
The Contemporary Museum, Honolulu, HI, USA
Colby College Museum of Art, Waterville, ME, USA
Balton Museum of Art, University of Texas,
Austin, TX, USA
Davis Museum, Wellesley College, Wellesley,
MA, USA
Bowdoin College Museum of Art, Brunswick,
ME, USA
Lannan Foundation, Santa Fe, NM, USA

HOSSEIN VALAMANESH
Born 1949 in Tehran, Iran
Emigrated to Australia, 1973
Lives and works in Adelaide, Australia

Education

1977 Graduate, South Australian School of Art,
 Adelaide, Australia
1970 Graduate, School of Fine Art, Tehran, Iran

Selected Solo Exhibitions

2018 *Passing*, Turner Gallery, Perth, Australia
2017 *Where do I come from?* Aaran Projects, Tehran,
 Iran
 Hossein Valamanesh & Angela Valamanesh:
 New Work, GAGPROJECTS, Adelaide, Australia
 Angela & Hossein Valamanesh, Karen Woodbury
 Gallery, Melbourne, Australia
2015 *Char Soo*, Carriageworks, Adelaide Film Festival;
 Samstag Museum of Art, University of South
 Australia; Sydney Film Festival 2016, Australia
 Assemblage: 1980–1985, Grey Noise Gallery,
 Dubai, UAE
 Hossein Valamanesh & Angela Valamanesh,
 Greenaway Art Gallery, Adelaide, Australia
2014 *Angela & Hossein Valamanesh*, Karen Woodbury
 Gallery, Melbourne, Australia
 Binns + Valamanesh, Casula Powerhouse, Sydney,
 Australia
2013 *Hossein & Angela Valamanesh*, Breenspace,
 Sydney, Australia
 Breath, Rose Issa Project, London, UK
 Hossein Valamanesh: Selected Works 1992–2013,
 Grey Noise Gallery, Dubai, UAE
2012 *Hossein Valamanesh*, Greenaway Art Gallery,
 Adelaide, Australia
2011 *In my mother's hands*, GRANTPIRRIE Gallery
 Sydney, Australia

2010 *Hossein Valamanesh*, Greenaway Art Gallery,
 Adelaide, Australia
2009 *Hossein Valamanesh*, AMA Gallery, Helsinki,
 Finland
 NO LOVE LOST, GRANTPIRRIE Gallery, Sydney,
 Australia
2008 Turner Galleries, Perth, Australia
2007 *This will also pass*, Greenaway Art Gallery,
 Adelaide, Australia
2006 *Hossein Valamanesh*, Sherman Galleries, Sydney,
 Australia
2002 *Tracing the Shadow: Hossein Valamanesh*,
 Museum of Contemporary Art, Sydney, Australia
2001 *Hossein Valamanesh: A Survey*, Art Gallery of
 South Australia, Adelaide, Australia
1997 *Tracing the Shadow*, Art Front and Hillside
 Galleries, Tokyo, Japan
1996 *Hossein Valamanesh*, Sherman Galleries
 Goodhope, Sydney, Australia
1993 *The Lover Circles His Own Heart*, Centre for
 Contemporary Art, Warsaw, Poland
1991 Kunstlerhaus Bethanien, Berlin, Germany
1990 *Hossein Valamanesh 1980–1990*, Contemporary
 Art Centre of South Australia, Adelaide, Australia
 Luba Bilu Gallery, Melbourne, Australia
1988 Macquarie Galleries, Sydney, Australia
1984 Macquarie Galleries, Sydney, Australia
1981 Bonython Gallery, Adelaide, Australia

Selected Group Exhibitions

2019 *Nine Iranian Artists in London: The Spark Is You*,
 Parasol unit foundation for contemporary art,
 London, UK
2018 *Echigo–Tsumari Art Triennial*, Japan
 Drawing Exchange, Adelaide Central School of
 Art, Adelaide, Australia
2017 *LETTRES OUVERTES, de la calligraphie au street*
 art, L'Institut des Cultures d'Islam, Paris, France
2016 *Where / between*, Equinox Gallery, Vancouver,
 Canada
2015 *Suspended*, Aaran Gallery, Tehran, Iran
2013 *AUSTRALIA*, Royal Academy of Arts, London, UK
 HEARTLAND, Art Gallery of South Australia,
 Adelaide, Australia
2012 Kochi-Muziris Biennale, Kerala, India
 On collaboration: Angela & Hossein Valamanesh,
 Raafat Ishak & Tom Nicholson, Breenspace,
 Sydney, Australia
2009 *Great Collections*, Museums & Galleries of New
 South Wales, touring exhibition
2008 *Handle with Care, 2008 Adelaide Biennial of*
 Australian Art, Art Gallery of South Australia,
 Adelaide, Australia
2006 *Prism: Contemporary Australian Art*,
 Bridgestone Museum of Art, Tokyo, Japan

Clemenger Contemporary Art Award, National Gallery of Victoria (NGV), Melbourne, Australia

2000 *Echigo-Tsumari Art Triennial*, Japan
CHEMISTRY: Art in South Australia 1990–2000, Art Gallery of South Australia, Adelaide, Australia

1999 *The Rose Crossing*, Brisbane City Gallery, Australia; Hong Kong Arts Centre, HK; Singapore Art Museum (2000), Singapore

1997 *Other Stories: Five Australian Artists*, Asialink exhibition; Bangladesh Biennale, Dhaka, Bangladesh

1997 *Australian Perspecta: Between Art and Nature, Temple of Earth Memories*, Museum of Contemporary Art (MCA), Sydney, Australia

1993 *Inner Land*, Gallery Soko, Tokyo, Japan
Identities: Taipei Fine Arts Museum, Taiwan

1987 *Australian Contemporary Art*, Museum of Modern Art, Saitama, Japan

1985 *Australian Perspecta*, Art Gallery of New South Wales, Sydney, Australia

1983 *Survey of Recent South Australian Sculpture*, Art Gallery of South Australia, Adelaide

Public Collections

National Gallery of Australia, Canberra, Australia
Museum of Contemporary Art, Sydney, Australia
Art Gallery of New South Wales, Sydney, Australia
Art Gallery of South Australia, Adelaide, Australia
Art Gallery of Western Australia, Perth, Australia
National Gallery of Victoria, Melbourne, Australia
Queensland Art Gallery, Brisbane, Australia
National Art Gallery of New Zealand, Wellington, NZ
Alice Springs Art Centre, Alice Springs, Australia
Artbank, Melbourne, Australia
University of Melbourne, Australia
National Portrait Gallery, Canberra, Australia
University of Queensland, Brisbane, Australia
University of South Australia, Adelaide, Australia
University of Western Australia, Perth, Australia
Wagga Wagga Regional Art Gallery, Wagga Wagga, Australia
Western Australian Institute of Technology, Perth, Australia
Aomori Contemporary Art Centre, Aomori, Japan
City of Melville, WA, USA
Edith Cowan University, Perth, Australia
Wesfarmers Collection, Perth, Australia
Parliament House Canberra, Australia
Sara Hildén Art Museum, Tampere, Finland
Kadist Art Foundation, Paris, France
Los Angeles County Museum of Art, CA, USA

196
List of Works

Unless stated otherwise, each work in the exhibition is shown courtesy of and copyright to the respective artist and/or their named representative. All images, unless stated otherwise, are copyright to the individual artists. Dimensions: height × width × depth

Works in the Exhibition
The Spark Is You: Parasol unit in Venice

37–41
Morteza Ahmadvand
Becoming, 2015
Video installation: 3 single-channel videos, fibreglass sphere
Dimensions variable
Courtesy the artist and Mohammed Afkhami Foundation
Installation view at Conservatorio di Musica Benedetto Marcello di Venezia, Venice, Italy
Photography: Francesco Allegretto

45–48
Nazgol Ansarinia
Article 52, Pillars, 2017
Paper paste, cardboard and paint
Each part: 65 × 75 × 33 cm (25½ × 29½ × 13 in)
Collection Olivier G. Mestelan
Courtesy the artist and Green Art Gallery, Dubai
Installation view at Conservatorio di Musica Benedetto Marcello di Venezia, Venice, Italy
Photography: Francesco Allegretto

45–47, 49
Nazgol Ansarinia
Article 44, Pillars, 2016
Paper paste, cardboard and paint
80 × 100 × 100 cm (31½ × 39½ × 39½ in)
Courtesy the artist, Collezione Righi, Bologna, Galleria Raffaella Cortese, Milan, and Green Art Gallery, Dubai
Installation view at Conservatorio di Musica Benedetto Marcello di Venezia, Venice, Italy
Photography: Francesco Allegretto

45–47, 51
Nazgol Ansarinia
Article 55, Pillars, 2016
Paper paste, cardboard and paint
Each part: 80 × 108 × 50 cm (31½ × 42½ × 19¾ in)
Private collection, Berlin
Courtesy the artist, Green Art Gallery, Dubai, and Galleria Raffaella Cortese, Milan
Installation view at Conservatorio di Musica Benedetto Marcello di Venezia, Venice, Italy
Photography: Francesco Allegretto

52
Nazgol Ansarinia
Membrane, 2014
Paper, paste and glue
550 × 500 cm (216½ × 196¾ in)
Courtesy the artist and Green Art Gallery, Dubai
Installation view at Conservatorio di Musica Benedetto Marcello di Venezia, Venice, Italy
Photograph: Francesco Allegretto

57–60
Siah Armajani
Edgar Allan Poe's Study, 2008
Wood, glass, fabric, lamps, bronze
289.5 × 488 × 244 cm (114 × 192 × 96 in)
Courtesy the artist and Rossi & Rossi
Installation view at Conservatorio di Musica Benedetto Marcello di Venezia, Venice, Italy
Photography: Francesco Allegretto

61
Siah Armajani
Hall Mirror with Table, 1983–1984
Bronze, mirror, painted wood
213.4 × 62.2 × 77.5 cm (84 × 24½ × 30½ in)
Collection Max Protetch, New York
Installation view at Conservatorio di Musica Benedetto Marcello di Venezia, Venice, Italy
Photograph: Francesco Allegretto

64–65
Mitra Farahani
We are never sufficiently sad to improve the world. For E. Canetti. Signed by Jean-Luc Godard, 2019
Golden sheet and oil on canvas
230 × 155 cm (90½ × 61 in)
Installation view at Conservatorio di Musica Benedetto Marcello di Venezia, Venice, Italy
Photography: Francesco Allegretto

66–67
Mitra Farahani
David & Goliath N°45, 2014
Video, 14:23 minutes
Cinematographer: Luca Bigazzi
Producer: Nader Mobargha
Installation view at Conservatorio di Musica
Benedetto Marcello di Venezia, Venice, Italy
Photography: Francesco Allegretto

70–75
Sahand Hesamiyan
Forough, 2016
Stainless steel, gold leaf, electrostatic coating
Each of two parts:
290 × 248 × 248 cm (114¼ × 97¾ × 97¾ in)
Installation view at Conservatorio di Musica
Benedetto Marcello di Venezia, Venice, Italy
Photography: Francesco Allegretto

79
Y.Z. Kami
Untitled, 2018
Oil on linen
91.4 × 56.5 cm (36 × 22¼ in)
Courtesy the artist and Gagosian Gallery
Installation view at Conservatorio di Musica
Benedetto Marcello di Venezia, Venice, Italy
Photograph: Francesco Allegretto

80
Y.Z. Kami
Untitled, 2018–2019
Oil on linen
121.9 × 91.4 cm (48 × 36 in)
Courtesy the artist and Gagosian Gallery
Installation view at Conservatorio di Musica
Benedetto Marcello di Venezia, Venice, Italy
Photograph: Francesco Allegretto

81
Y.Z. Kami
Chartres III, 2018
Oil on linen
182.9 × 114.3 cm (72 × 45 in)
Courtesy the artist and Gagosian Gallery
Installation view at Conservatorio di Musica
Benedetto Marcello di Venezia, Venice, Italy
Photograph: Francesco Allegretto

84–85
Farideh Lashai
When I Count, There Are Only You …
But When I Look, There Is Only a Shadow, 2012–2013
Suite of 80 photo-intaglio prints with projection
of animated images
3:51 minutes | 191.8 × 309.9 cm (75½ × 122 in)
Courtesy the Estate of Farideh Lashai
Projection courtesy of the Farideh Lashai Foundation,
Museo del Prado and The British Museum
Installation view at Conservatorio di Musica
Benedetto Marcello di Venezia, Venice, Italy
Photography: Francesco Allegretto

88–93
Koushna Navabi
Biskweet-e Mādar (Mother Biscuit), 2019
Mixed-media installation
Dimensions variable
Box: 190 × 260 × 44 cm (74¾ × 102¼ × 17¼ in)
Installation view at Conservatorio di Musica
Benedetto Marcello di Venezia, Venice, Italy
Photography: Francesco Allegretto

97–102
Navid Nuur
The Tuners, 2005–2019
PVC coated fabric, mixed media
Each of three pieces:
500 × 400 cm | 700 × 400 cm | 500 × 400 cm
(197 × 157½ in | 275½ × 157½ in | 197 × 157½ in)
Courtesy the artist, Galerie Max Hetzler, Galeria Plan B,
Galerie Martin van Zomeren and Galerie Jahn und Jahn
Installation view at Conservatorio di Musica
Benedetto Marcello di Venezia, Venice, Italy
Photography: Francesco Allegretto

Works in the Exhibition
Nine Iranian Artists in London: The Spark Is You

106–107
Morteza Ahmadvand
Flight, 2008
Video, 2:48 minutes
Installation view at Parasol unit foundation for
contemporary art, London
Photography: Benjamin Westoby

109
Morteza Ahmadvand
Cradle of Religions, 2019
Mild steel, oak
280 × 165 × 54 cm (110¼ × 65 × 21¼ in)
Installation view at Parasol unit foundation for
contemporary art, London
Photograph: Benjamin Westoby

110–115
Nazgol Ansarinia
*The Mechanisms of Growth, Demolishing Buildings,
Buying Waste*, 2017
Plaster, PVC glue, pigment
Dimensions variable
Courtesy the artist and Green Art Gallery, Dubai
Installation view at Parasol unit foundation for
contemporary art, London
Photography: Benjamin Westoby

116
Nazgol Ansarinia
Fragment 1, Demolishing Buildings, Buying Waste, 2017
Video, 6:15 minutes
Courtesy the artist, Green Art Gallery, Dubai, and
Galleria Raffaella Cortese, Milan
Installation view at Parasol unit foundation for
contemporary art, London
Photography: Benjamin Westoby

117
Nazgol Ansarinia
Fragment 2, Demolishing Buildings, Buying Waste, 2017
Video, 6:15 minutes
Courtesy the artist, Green Art Gallery, Dubai,
and Galleria Raffaella Cortese, Milan
Installation view at Parasol unit foundation for
contemporary art, London
Photography: Benjamin Westoby

120–126
Ghazaleh Hedayat
The Strand and the String, 2008–2018
Human hair and linen thread on cloth
Each of five pieces: 60 × 60 cm (23½ × 23½ in)
pp. 120–121: Installation view at Parasol unit
foundation for contemporary art, London
Photography: Benjamin Westoby

128–133
Ghazaleh Hedayat
(un)threading, 2018
C-print, scratched C-prints
Each of four pieces: 96 × 66 cm (37¾ × 26 in)
pp. 128–129: Installation view at Parasol unit
foundation for contemporary art, London
Photography: Benjamin Westoby

134–139
Sahand Hesamiyan
Nahankhane, 2017
Stainless steel, gold leaf, electrostatic coating
212 × 212 × 412 cm (83½ × 83½ × 162¼ in)
Installation view at Parasol unit foundation for
contemporary art, London
Photography: Benjamin Westoby

140–145
Koushna Navabi
Untitled (Tree Trunk), 2017
Mixed media
45 × 150 × 38 cm (17¾ × 59 × 15 in)
Installation view at Parasol unit foundation for
contemporary art, London
Photography: Benjamin Westoby

146
Navid Nuur
The Tuners, 2005–2018
Unprepared linen, mixed media
184 × 138 cm (72½ × 54¼ in)
Courtesy the artist and Plan B Cluj, Berlin
Installation view at Parasol unit foundation for
contemporary art, London
Photograph: Benjamin Westoby

147
Navid Nuur
The Tuners, 2005–2017
Prepared linen canvas, solid marker on stretcher
170 × 130 cm (67 × 51¼ in)
Courtesy the artist and Plan B Cluj, Berlin
Installation view at Parasol unit foundation for
contemporary art, London
Photograph: Benjamin Westoby

148–149
Navid Nuur
Broken Blue Square, 2017
Glass, crushed glass (put inside the tube from the ends),
argon gas
189 × 151 cm (74½ × 59½ in)
Courtesy the artist, Galerie Max Hetzler and
Galeria Plan B
Installation view at Parasol unit foundation for
contemporary art, London
Photography: Benjamin Westoby

152–157
Sam Samiee
The Fabulous Theology of Koh-i-noor
(Theologia Theatrica de Koh-i-noor), 2019
Acrylic on Japanese rice paper, canvas, paper,
balsa sticks, ceramic
Dimensions variable
Installation view at Parasol unit foundation for
contemporary art, London
Photography: Benjamin Westoby

158–163
Sam Samiee
The Fabulous Theology of Darya-i-noor
(Theologia Theatrica de Darya-i-noor), 2019
Acrylic on Japanese rice paper, canvas, paper,
balsa sticks, ceramic
Dimensions variable
Courtesy the artist and Mr Fereydoun Ave
Installation view at Parasol unit foundation for
contemporary art, London
Photography: Benjamin Westoby

166–169
Hadi Tabatabai
Transitional Spaces, 2017
Thread, acrylic paint, aluminium frame,
wooden platform
213 × 122 × 305 cm (84 × 48 × 120 in)
Courtesy the artist and wats:ON?
Festival, Carnegie Mellon University
Installation view at Parasol unit foundation for
contemporary art, London
Photography: Benjamin Westoby

172–175
Hossein Valamanesh
Lotus Vault #2, 2013
Lotus leaves on paper on plywood
210 × 525 cm (82¾ × 206¾ in)
Courtesy the artist and Grey Noise, Dubai
Installion view at Parasol unit foundation for
contemporary art, London
Photography: Benjamin Westoby

Other Images

55
Siah Armajani
Bridge Over Tree, 1970/2019
Wood, steel, evergreen tree
Courtesy Public Art Fund, NY
Photograph: Timothy Schenck

55
Siah Armajani
Irene Hixon Whitney Bridge, 1988
Steel, paint, wood
115.5-metre (379-ft) steel-truss construction
Minneapolis Sculpture Garden, Gift of the Minneapolis
Foundation/Irene Hixon Whitney Family Founder-
Advisor Fund, the Persephone Foundation, and Wheelock
Whitney, with additional support and services from
the Federal Highway Administration, the Minnesota
Department of Transportation, the City of Minneapolis,
and National Endowment for the Arts, 1988
Courtesy the artist and Rossi & Rossi
Photograph: Courtesy Walker Art Center

56
Siah Armajani
Fallujah, 2004–2005
Glass, wood, paint, copper, steel, rug, chair, table,
light fixture, fabric
Overall installed:
505.5 × 331.5 × 381 cm (199 × 130½ × 150 in)
Collection Walker Art Center, Minneapolis
Gift of Lannan Foundation, 2011
Courtesy the artist and Rossi & Rossi
Photograph: Courtesy Walker Art Center

77
Y.Z. Kami
White Dome IV, 2010
Acrylic on linen
177.8 × 195.6 cm (70 × 77 in)
Collection of Peter Marino
© Y.Z. Kami. Courtesy Gagosian

87
Koushna Navabi
Crows, 2006
Taxidermy crows, textile, sand, bare tree
Dimensions variable
Installation view at Hiroshima Art Document,
Hiroshima, Japan, 2006
Photograph: Kunio Oshima

87
Koushna Navabi
Jen (Ogre), 2001
Taxidermy llama, textile, foam
150 × 90 × 20 cm (59 × 35½ × 8 in)

151
Sam Samiee
The Unfinished Copernican Revolution, 2018
Acrylic on wood and paper
135 × 100 × 80 cm (53¼ × 39½ × 31½ in)
Installation view at 10ᵗʰ Berlin Biennale, ZK/U
Zentrum für Kunst und Urbanistik, Berlin
Photograph: Timo Ohler

151
Sam Samiee
*Untitled: A Map of USA, Seven Designs for
a Money Note, Nr. 7*, 2018
Acrylic on canvas
275 × 327 cm (108¼ × 128¾ in)
Photograph: Timo Ohler

171
Hossein Valamanesh
Untitled, 1995
Lotus leaves on gauze, synthetic polymer paint
60 × 145 × 3.5 cm (23½ × 57 × 1½ in)
Faulding 150 Anniversary Fund for South Australian
Contemporary Art, 1995, Art Gallery of South
Australia, Adelaide
Photograph: M. Kluvanek

171
Kwementyaye (Kathleen) Petyarre
*Mountain Devil Lizard Dreaming (with Winter
Sandstorm)*, 1996
Synthetic polymer paint on canvas
184 × 184.5 cm (72½ × 72¾ in)
Aileen Thompson Bequest Fund through the Art
Gallery of South Australia Foundation, 1996
Art Gallery of South Australia, Adelaide
© Kathleen Petyarre/Copyright Agency.
Licensed by DACS 2019

171
Hossein Valamanesh
Longing Belonging (detail), 1997
Direct colour positive photograph
99 × 99 cm (39 × 39 in)
Art Gallery of New South Wales, Sydney
Photograph: Rick Martin

Parasol unit
foundation for contemporary art

Limited Edition of 1,000

First published in Great Britain 2019
on the occasion of the two exhibitions
The Spark Is You: Parasol unit in Venice
9 May – 23 November 2019
Nine Iranian Artists in London: The Spark Is You
22 May – 8 September 2019

Copyright © 2019 Parasol unit
foundation for contemporary art, London,
the artists and individual authors.

Editor: Ziba Ardalan for Parasol unit
foundation for contemporary art, London
Copy editor: Helen Wire
Design by Moiré: Marc Kappeler, Simon Trüb, Zurich
Typeface: GT Flexa
Paper: RecyStar Nature 150 g/m², Munken Lynx 170 g/m²
Printing: Druckerei Odermatt, Dallenwil
Binding: Schumacher AG, Schmitten

Printed in Switzerland

Front Cover
Morteza Ahmadvand, *Becoming*, 2015
Back Cover
Hadi Tabatabai, *Transitional Spaces*, 2017

pp. 204–215
Installation views at Parasol unit, London, 2019

Image Credits
Unless otherwise stated all images are reproduced courtesy of the individual artists and respectively of: Art Gallery of New South Wales, Sydney, p. 171 (*btm right*); Art Gallery of South Australia, Adelaide, p. 171 (*top, btm left*); Collection Max Protetch, New York, p. 61; Collection of Peter Marino, p. 77; Collection Olivier G. Mestelan, pp. 45–48; Collection Walker Art Center, Minneapolis, p. 56; Collezione Righi, Bologna, Galleria Raffaella Cortese, Milan, and Green Art Gallery, Dubai, pp. 45–47, 49; DACS, p. 171 (*btm left*); Estate of Farideh Lashai, pp. 84–85; Farideh Lashai Foundation, Museo del Prado and British Museum, pp. 84–85; Gagosian, pp. 77–81; Galerie Max Hetzler and Galeria Plan B, pp. 148–149; Galerie Max Hetzler, Galeria Plan B, Galerie Martin van Zomeren and Galerie Jahn und Jahn, pp. 97–102; Green Art Gallery, Dubai, pp. 52, 110–115; Green Art Gallery and Galleria Raffaella Cortese, Milan, pp. 45–47, 51, 116–117; Grey Noise, Dubai, p. 172–175; Hiroshima Art Document, Japan, p. 87 (*left*); Minneapolis Sculpture Garden, p. 55 (right); Mohammed Afkhami Foundation, pp. 37–41; Mr Fereydoun Ave, pp. 158–160; Parasol unit, London, cover, pp. 37–53, 57–75, 79–85, 88–121, 128–129, 134–149, 152–169, 172–215; Kathleen Petyarre, p. 171 (btm left); Plan B Cluj, pp. 146–147; Private collection, Berlin, pp. 45–47, 51; Public Art Fund, NY, p. 55 (*left*); Rossi & Rossi, pp. 55 (*right*), 56, 57–60; wats:ON? Festival, Carnegie Mellon University, pp. 166–169; Zentrum für Kunst und Urbanistik, Berlin, p. 151 (*left*).

Photography
Francesco Allegretto, front cover, pp. 37–53, 57–75, 79–85, 88–102; M. Kluvanek, p. 171 (*top*); Rick Martin, p. 171 (*btm right*); Timo Ohler, p. 151; Kunio Oshima, p. 87 (*left*); Timothy Schenck, p. 55 (*left*); Walker Art Center, pp. 55 (*right*), 56; Benjamin Westoby, back cover, pp. 106–121, 128–129, 134–149, 152–169, 172–215.

The Spark Is You exhibitions have been generously supported by:
Cockayne – Grants for the Arts and The London Community Foundation, Soudavar Memorial Foundation, Farah Asemi and Hassan Alaghband, Marwan and Tatiana Shakarchi, Kambiz and Nazgol Shahbazi, Claudia Steinfels and Christian Norgren, Berna and Tolga Tuglular, Massimo and Ilaria Tosato, Laura Colnaghi Calissoni, Key Capital, Kevin and My Phuong Lecocq, Mohammed Afkhami Foundation, General Atlantic Foundation, Iran Heritage Foundation, Cyrus Ardalan and Juni Farmanfarmaian, KayhanLife, Dr Yvonne Winkler, Petri and Jolana Vainio, Haro Cumbusyan and Bilge Ogut-Cumbusyan, Ruth Whaley, Iran Society, and Simon Trollope.

Parasol unit foundation for contemporary art
14 Wharf Road
London, N1 7RW
T +44 (0)20 7490 7373
E info@parasol-unit.org
www.parasol-unit.org

Distribution | UK and Eire
Cornerhouse Publications
HOME, 2 Tony Wilson Place
Manchester, M15 4FN
United Kingdom
T +44 (0)161 212 3466
F +44 (0)161 200 1504
E publications@cornerhouse.org

ISBN 978-09-9351-959-8

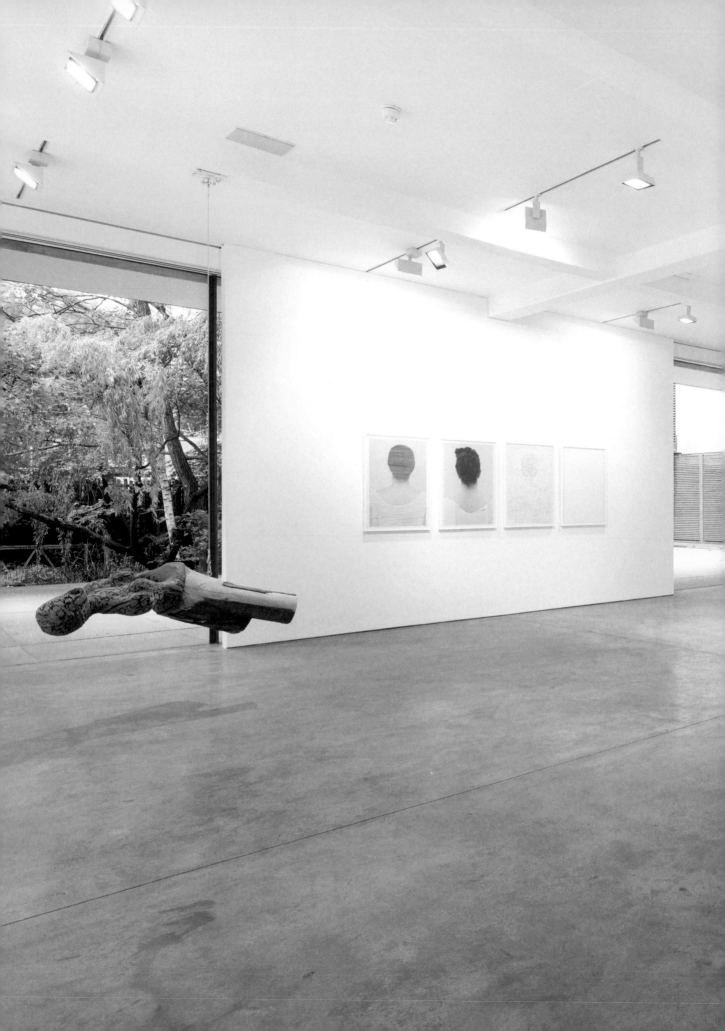

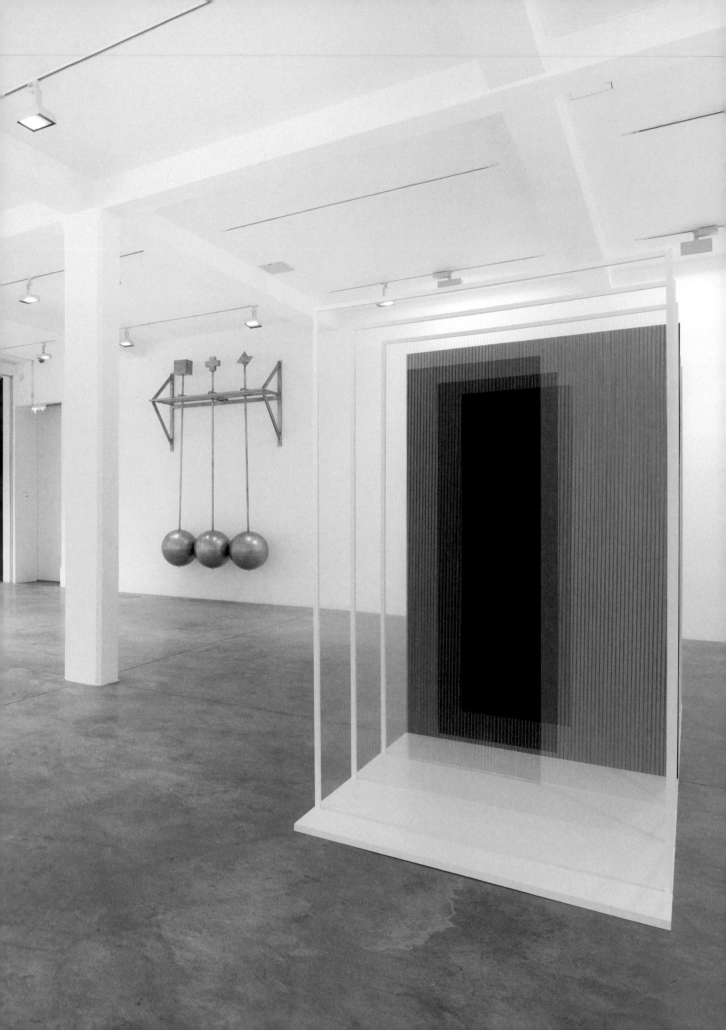

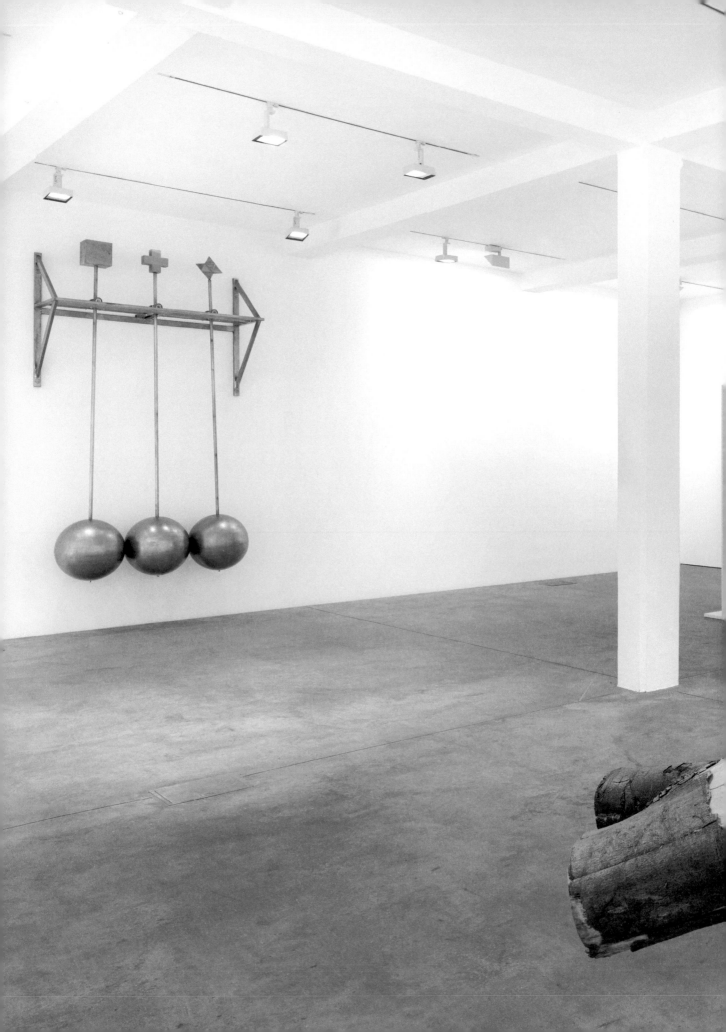

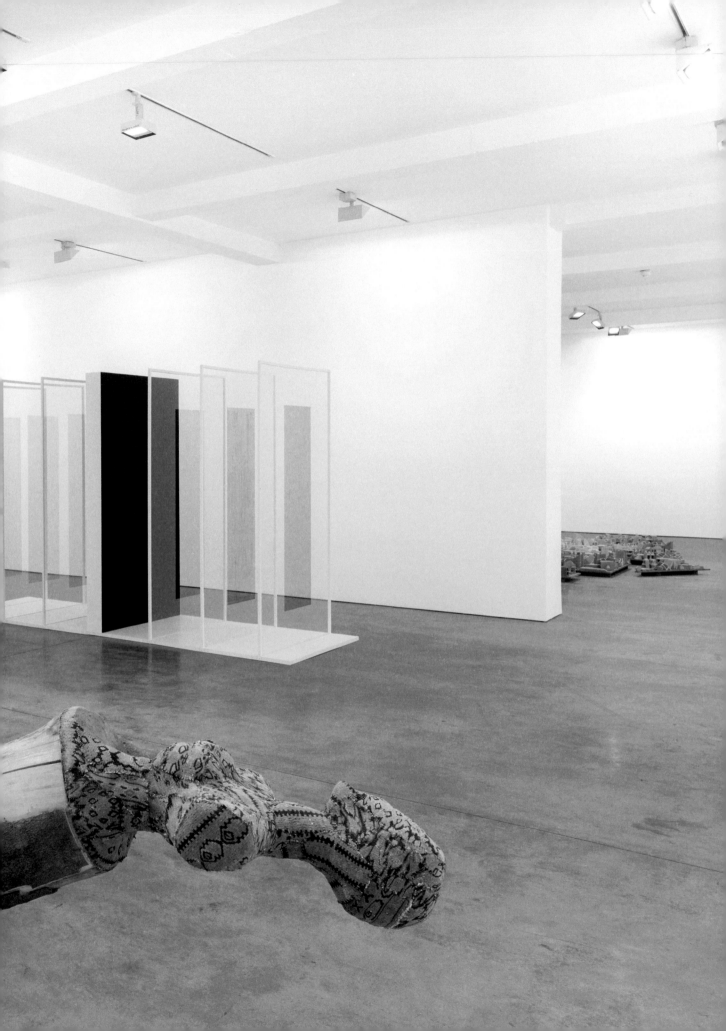

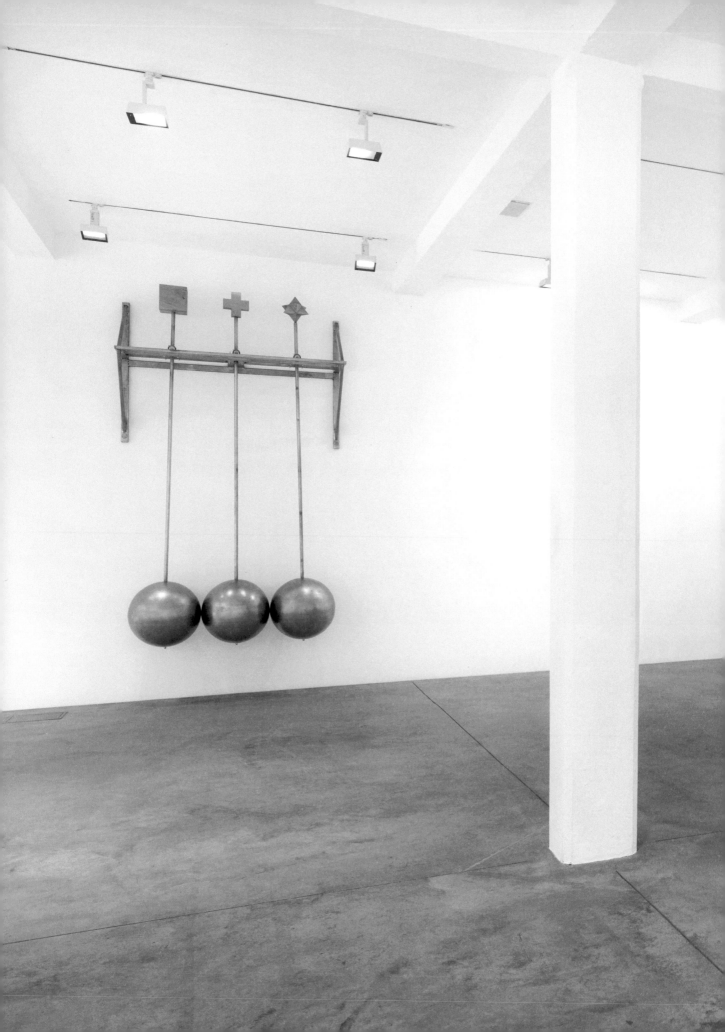

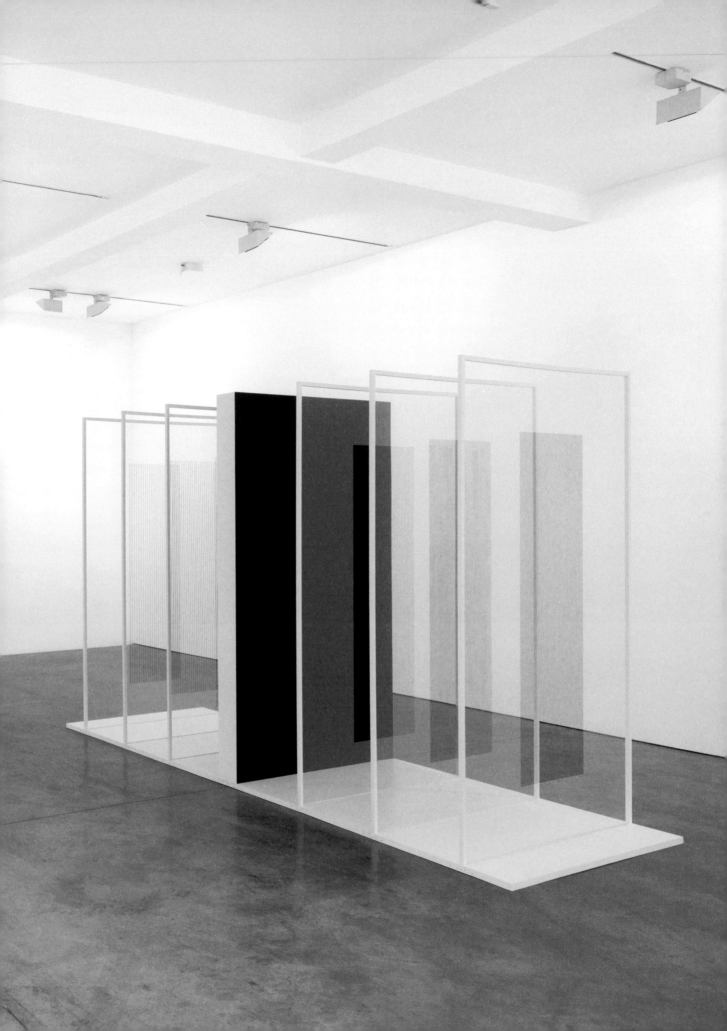

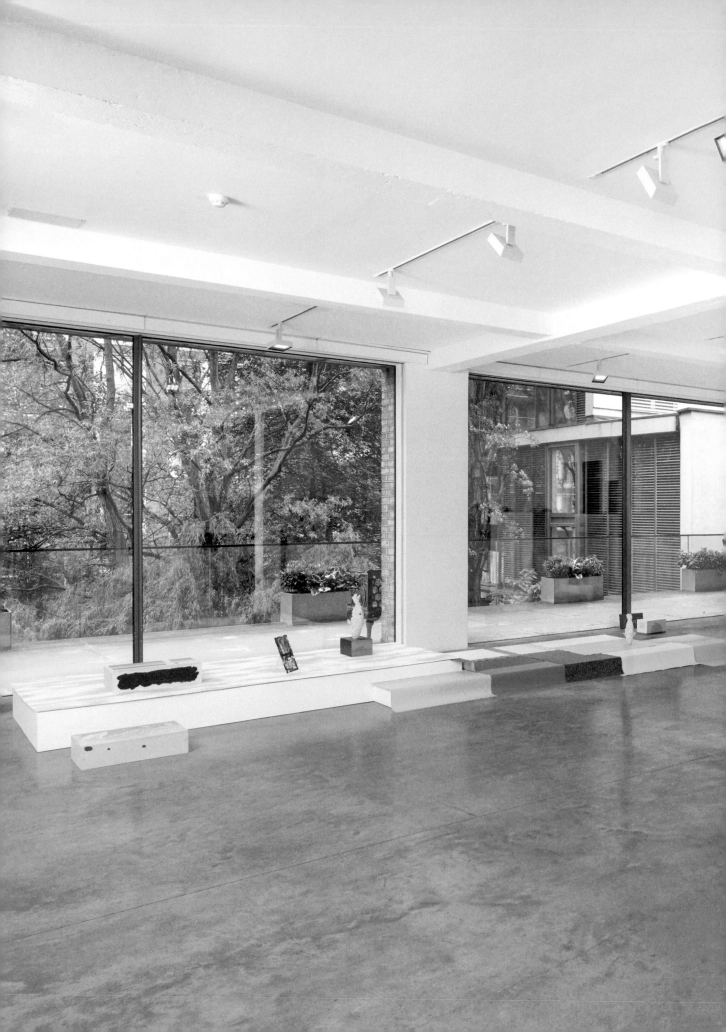

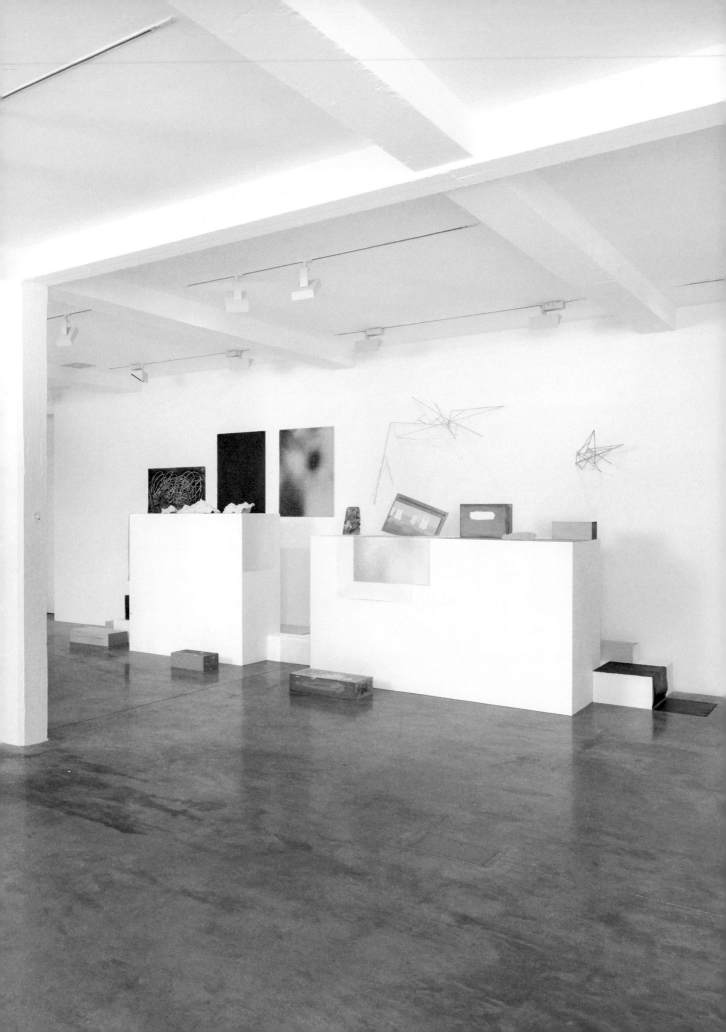

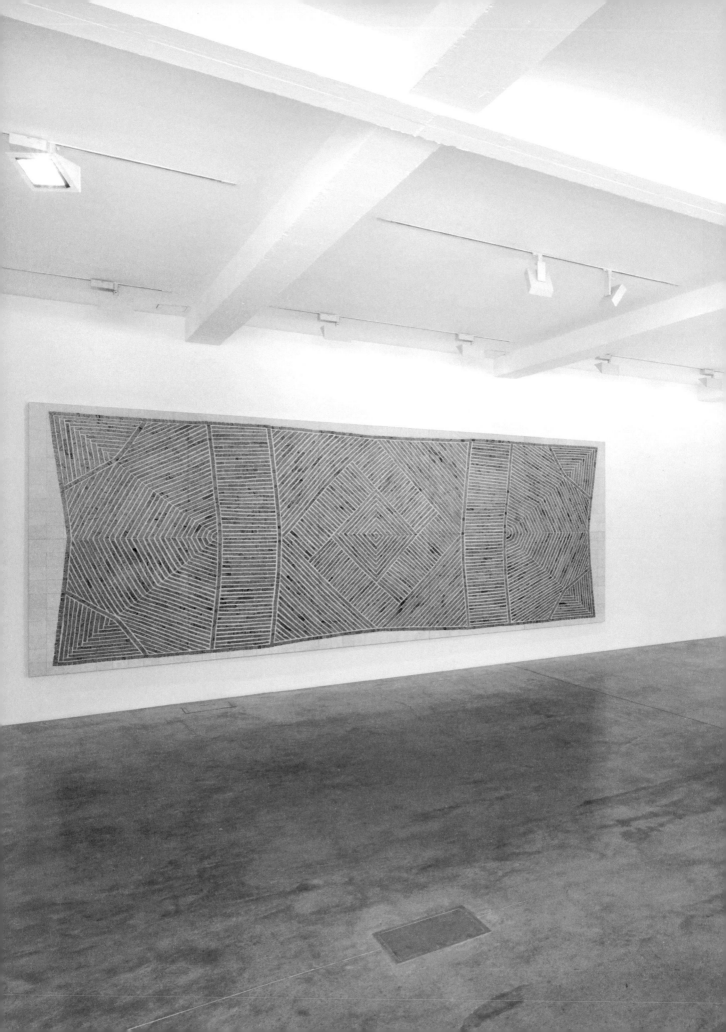

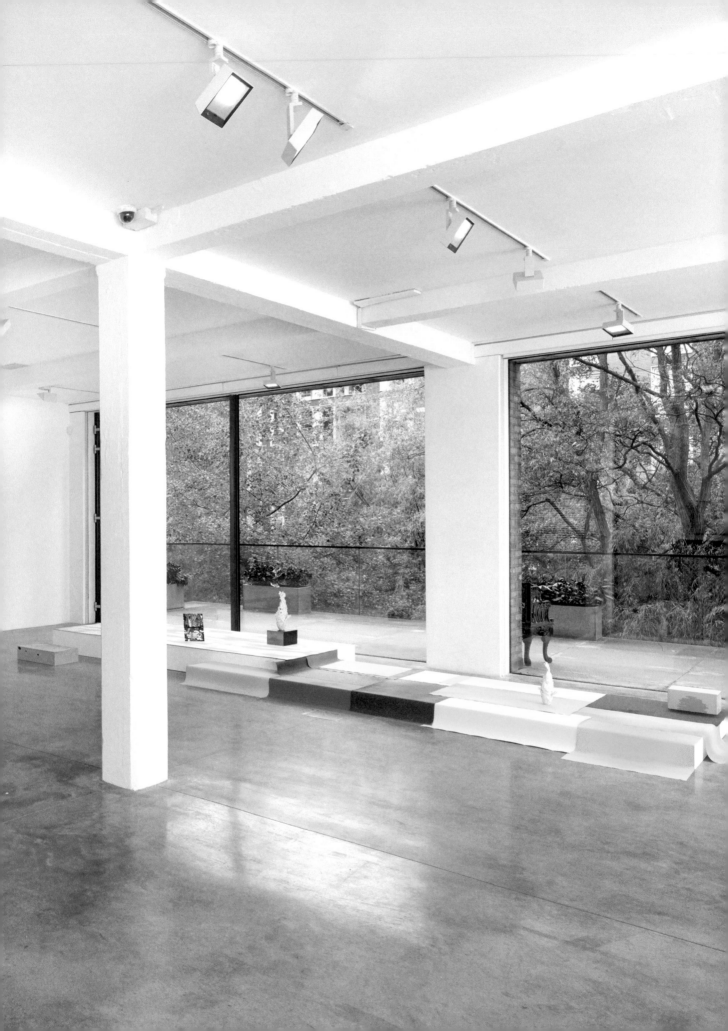